ASIAN ART

Publisher and Creative Director: Nick Wells
Development and Picture Research: Melinda Révész
Project Editor: Polly Willis
Editor: Sarah Goulding
Designer: Lucy Robins
Production: Chris Herbert, Claire Walker

Special thanks to: Geoffrey Meadon, Sara Robson and Helen Tovey

FLAME TREE PUBLISHING
Crabtree Hall, Crabtree Lane
Fulham, London, SW6 6TY
United Kingdom

www.flametreepublishing.com

First published 2005

05 07 06 04

1 3 5 7 9 10 8 6 4 2

Flame Tree is part of the Foundry Creative Media Company Limited

ISBN 1 84451 263 0

Every effort has been made to contact copyright holders. We apologize in advance for any omissions
and would be pleased to insert the appropriate acknowledgement in subsequent editions of this publication.

While every endeavour has been made to ensure the accuracy of the reproduction of the images in this book,
we would be grateful to receive any comments or suggestions for inclusion in future reprints.

Printed in China

ASIAN ART

Author: Michael Kerrigan Foreword: Michael Robinson

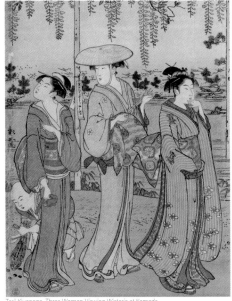

Torii Kiyonaga, *Three Women Viewing Wisteria at Kameido*

**FLAME TREE
PUBLISHING**

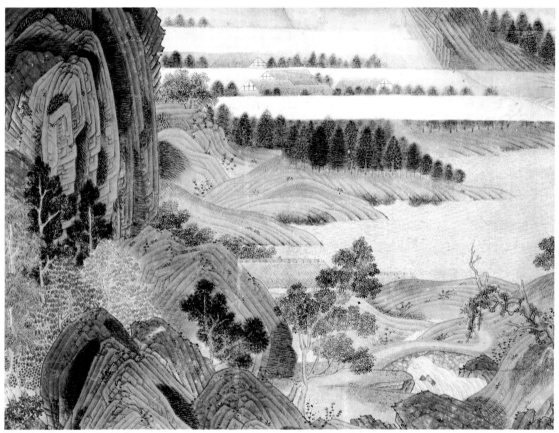

Chiu Ying, *Saying Farewell at Hsung Yang* (detail)

Contents

Ogata Korin, *The Thirty-Six Poets*; Fujiwara Nobuzane, *A Boat Ride by Moonlight* ; Yuan Yunfu, *Red Lotus*

China, glazed dish; China, garden seats; Japan, Fukagawa dish

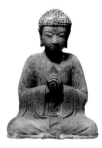
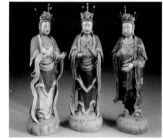
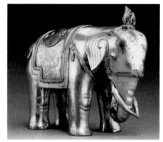

China, bronze Buddha; China, Buddhist trinity; Tibet/China, elephant

Tibet, butter lamp; Korea, document box; China, raft cup

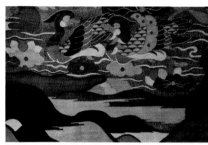
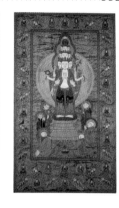

Tibet/China, *chuba*; China, bird and flower *k'ossu*; Tibet, tapestry depicting Chenrezik

How To Use This Book

The reader is encouraged to use this book in a variety of ways, each of which caters for a range of interests, knowledge and uses.

- The book is organized into five sections: **Paintings, Prints & Screens**; **Ceramics**; **Statues & Figures**; **Objets d'Art** and **Textiles & Accessories**. The text in all these sections provides the reader with a brief background to the work, and gives greater insight into how and why it was created.
- **Paintings, Prints & Screens** is an introduction to the artists, styles and techniques that have produced such extraordinary Asian art over the years.
- **Ceramics** takes a look at the wealth of stunning ceramic art that still survives today, from delicate plates and figurines to magnificent jars and vases.
- **Statues & Figures** shows us the amazing Buddhas, gods and goddesses made of metal, wood and stone that are such an important aspect of Asian heritage.
- **Objets d'Art** includes exquisite pieces made out of every medium from ivory and bamboo to jade and rhinoceros horn.
- **Textiles & Accessories** showcases beautiful hangings, drapes, panels, embroideries and even items of clothing in all their stunning colour and detail.

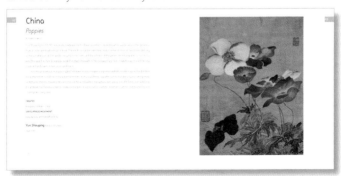

2. Country of origin

1. Title of work

3. Information about the work and the context in which it was created

10. Picture credit

Japan

A Boat Ride by Moonlight

9. Place where the work was created (if known)

CREATED

MEDIUM

SERIES/PERIOD/MOVEMENT

8. Medium in which the work was created (if relevant)

Fujiwara Nobuzane (attrib.)

4. Date of artist's birth and place of birth (if known)

7. Series, period or movement to which the work belongs

6. Name of artist by forename, then surname (if known)

5. Date of artist's death (if known)

Foreword

In 1978, the late Edward Said wrote the book *Orientalism*, a seminal work justifiably critical of a Western tradition that falsely depicted the 'Orient' in both visual representations and literature as an integral part of European culture. Since then, art historians have been involved in the subsequent discourse, with new evaluations of European art executed during the various periods of colonial power. However, much of this discourse is within academia and today many people outside of that clique still see the 'Orient' through Western depictions of its 'otherness', through appropriation and often misappropriation of Asian art. Perhaps more importantly, they are still blissfully unaware of the contribution non-western artists have made to civilization, and the influence they have had on Western culture.

When the Venetian Marco Polo arrived at the court of the Chinese emperor Kublai Khan in 1275 he was not the first European to have travelled East beyond Asia Minor, but his own records of the travels, written for posterity, make him its seminal adventurer. Having spent his formative years at the court, Polo became the emperor's diplomatic emissary, providing a valuable link between East and West. From his highly descriptive accounts and the artefacts he brought back to Venice, medieval Europe began its long love affair with the 'Orient'. Unfortunately by the middle of the next century the Khan's Mongols had been expelled from China by the Ming, closing the northern trade routes. It was not until the sixteenth century that trade was once again established directly with China, following the Portuguese explorer Vasco da Gama's successful voyage around the Cape of Good Hope. In consequence of reaching India in 1524, the Indian Ocean as a trade route to the East was open, not just for the Portuguese, but the Dutch and English, who in the early years of the seventeenth century established their own respective East India Trading Companies. By this time, Europe had begun trading with Japan, as well as India and China.

In subsequent years the taste for 'Oriental' artefacts began in Europe at the highest levels of society including the various royal families, with imports of Ming Dynasty porcelain being a particular favourite. Valued in the West as very fine ware, it was seen somewhat ironically by the Chinese as rather coarse and unsuited to their home markets. Nevertheless it inspired a whole new industry in Europe, with the reproduction of these porcelain wares at Delft in Holland, Rouen in France and Bristol in England. By the eighteenth century many of these items became pastiche, as

the high demand taste for 'Chinoiserie' became fashionable, particularly at royal courts and among the aristocracy of Europe. Such taste was no longer confined to porcelain. Lacquered furniture, various objets d'art in wood and metalwork, whole interior designs and even gardens adopted the so-called Anglo-Chinese style. The most extreme examples of Chinoiserie are to be found in William Chambers 'Pagoda' at Kew Gardens (1763) and the interiors of the Royal Pavilion at Brighton (1815–23).

Following the fall of the feudal Tokugawa Shogunate in 1867, Japan opened its doors once again to trade after a self-imposed virtual isolation from the rest of the world for over 200 years. The European cognoscenti were aware of Japanese prints and other artefacts prior to that, but the taste for Japonisme began in earnest at about the same time following the Japanese exhibits at the 1867 Exposition Universelle in Paris. There followed a period of avid collecting of Japanese prints by large numbers of Europeans, including its artists such as Monet, Van Gogh and Whistler, in turn inspiring many of their paintings as they sought to recreate something of the *Ukiyo-e* or 'floating world' of Japan. However, as with Chinoiserie, the recreated Japanese motifs became something of a pastiche, satirized so brilliantly by Gilbert and Sullivan in *The Mikado* (1884–85). Ironically, its satirical relevance was lost, and the pastiche continued to inform Western notions of 'Orientalism' for the first three quarters of the twentieth century.

The late twentieth century has, with the radical rethinking of visual culture, allowed us another chance to bury those demons of our colonial past in terms of the appropriation and misappropriation of other cultures: African, South American and, of course, Asian. If we are to fully understand our own Western culture, we need to rediscover the other civilizations that make up our heritage, civilizations that are as diverse, but no less important to us as the Roman Empire. *Asian Art* is a contribution to that process.

Michael Robinson, *2005*

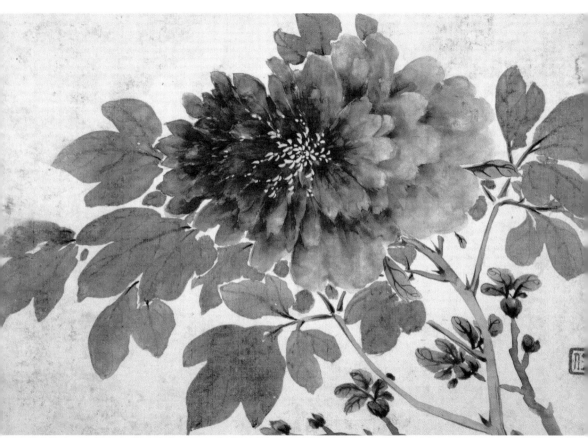

Introduction

Almost 3,000 years ago on the muddy plains of the Huang He (Yellow) River, up to a hundred tiny kingdoms were taking form. They knew of each other's existence and indeed were at war a good deal of the time as they jostled for advantage. Nevertheless they had little sense of any world beyond. They called themselves *Zhongguo*, or 'middle' (soon to become a single 'Middle Kingdom' under the Zhou dynasty), because they believed they were at the centre of the earth. To the north they knew the open steppes were ranged by barbaric nomads, and in the forests to the south lay savage tribes. Neither of these wild peripheries could reasonably be considered to be part of the world: these people would speak of 'all things under heaven' and mean only their own country.

Today their solipsism seems laughable, as their domains did not even extend over anything like the whole of modern China, but it offers several lessons for modernity. For far too long, westerners dismissed the cultures of the Far East as not just different but irredeemably alien, taking the conventions of western civilization as some sort of divinely sanctioned norm. Oriental art was never despised or discounted as 'primitive' in quite the way other exotic traditions were, but it was and still is often seen in stereotypical terms, through a reductive prism of western expectations. We cannot help but bring our own cultural values to bear on the artworks we consider – nor, indeed, should we try to fight this – but it makes sense to acknowledge that other traditions exist, with their own assumptions and integrity.

Beyond the pieties, though, it has to be admitted that a history of mutual incomprehension has meant that Oriental art does present certain challenges to the westerner. The question of just where the world ends and what realms it is considered to encompass dogged relations between East and West well into modern times. For much of history, both China and Japan have been more or less completely closed to outsiders; westerners, when admitted at all, have often been unwelcome, viewed with suspicion and fear. After contacts first began in the sixteenth century, both cultures increasingly defined themselves against a modernity that was seen as originating in the West and, far from embracing change, became more conservative in their attitudes.

Yet the history of relations between East and West has been nothing if not paradoxical. Western wealth appealed even where western domination understandably did not. This explains the boom in art-for-export that began towards the end of the seventeenth century and has continued unabated ever since. In accommodating European tastes, Oriental

art was inevitably modified, although again, paradoxically, its westernization was manifest at least in part in a tendency to pursue an exaggeratedly 'Oriental' exoticism. Meanwhile, Japan's embrace of western industrial and military technology towards the end of the nineteenth century led not to a better rapport with the West, but to competition and ultimately conflict. For the rest of the region it had unpleasant consequences too, first in Korea and then in China on the way to the all-engulfing inferno of the Pacific War.

Seen from a longer historical perspective, however, fighting is just another form of human contact: wars are ways of bringing peoples together, however reluctantly and destructively. Chinese culture, typically urban, agrarian, 'civilized', may always have defined itself against what it saw as the wild state in which the steppe nomads existed as pastoralists and raiders, but it has been profoundly invigorated by their influence down the ages. Kublai Khan's conquest of the country in 1279 ushered in the artistic and economic golden age of the Yuan dynasty. Genghis's grandson, nobody's fool, fell in love with his conquest without being seduced by it, helping Chinese culture to rediscover and redefine itself. The impact of the Qing dynasty, the rule of 'Manchus' from Manchuria, who invaded China and took power in 1644, has been more controversial, yet to begin with at least they rescued the culture that had so reviled them. Late Qing art and culture have been much abused by modern western criticism, yet it is hard to escape a suspicion that this is in part a result of historical hindsight. Qing China's complete collapse in Sun Yat-Sen's nationalist revolution of 1911 may be a matter of incontrovertible fact, but cultural developments before that are far more open to interpretation. How far have these been influenced by western assumptions, based on Edward Gibbon's 'Roman' model of imperial history in his 1776 book *The History of the Decline and Fall of the Roman Empire*, that so definitive a 'fall' must have been preceded by 'decline'?

The Yuan and Qing dynasties both in their different ways took China to historic turning points, but earlier waves of invading nomads were arguably more influential in the longer term. For it was with the Tartar tribes, whose raids and conquests continued on and off throughout the first millennium AD, that Buddhism had become widespread in the country. Originating in Nepal around the sixth century BC, the dream of the young prince Siddhartha Gautama, the Buddha or 'Enlightened One', had been of putting aside all earthly preoccupations in order to attain a mystic and time-transcending nirvana. It sounds like a rarefied, even abstract theology, but precisely because its ideas were so elusive, it accrued an elaborate and extensive iconography. Buddhism would be suppressed in its native India as the centuries went by, but farther east it went from strength to strength. In Tibet it became the dominant spiritual force, and in China its impact was profound, but complicated over time by its dynamic interaction with home-grown philosophies such as

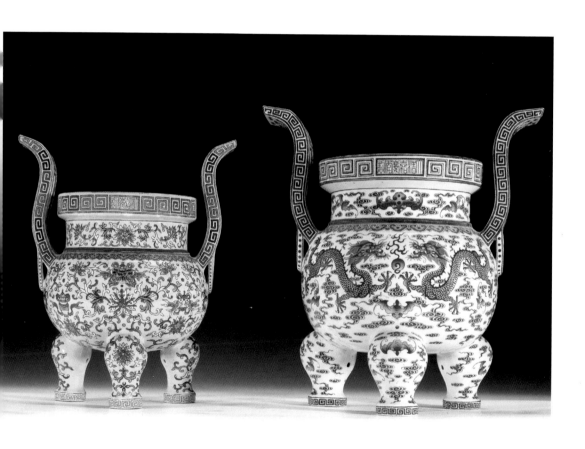

China, rose and yellow tripod censers, © Christie's Images Ltd

Confucianism and Taoism. The first of these, Confucianism, was not so much a faith as a code of conduct, a civic sense involving responsibility for others and respect for authority, whose presence persists in China to this day. Kng-fu-zi or Confucius, the official who propounded the doctrine, seems to have been a contemporary of the Buddha, although in many ways they could hardly have been more different. The second, Taoism, a mystic philosophy, takes its name from the word Tao or Dao, 'The Way', and emerged towards the end of the first millennium BC.

Much the same happened in Japan, where Chinese missionaries took Buddhism in the sixth century AD. There, the raft of local traditions known collectively as Shinto was for a while marginalized by the new religion and the Indian and Chinese ideas and imagery it brought with it. In Korea, too, Buddhism carried all before it to begin with, but was forced into retreat under the early reigns of the (aggressively Confucian) Choson dynasty from the fourteenth century on. In both countries as time went on, however, Buddhism would force its way back into the cultural mainstream to some extent, and as in China the different creeds co-existed, exerting their own influence on one another. Once more, stereotypes are unhelpful here: the clichéd western view has been that of Far Eastern societies being locked into unchanging traditions. While it is true that the sense of continuity has been strong, looked at over the longer term we

Cambodia, archers. © The Art Archive/Dagli Orti

see a dynamic panorama of cultural collision and theological ferment. Syncretism, the deliberate or unconscious grafting of aspects of one religion on to another, has been the rule rather than the exception. The result has been an enormous and ever-changing variety in religious art, with a secondary yet still overwhelming impact on secular culture. And not long after, to add still further complexity to the cultural cocktail, in about the fifteenth century, Islam started to make its presence felt in Java and the other islands of Indonesia.

Buddhism itself had emerged within the Hindu traditions of India and borrowed freely from its philosophy and pantheon, so can be seen as having been a syncretic religion from the very start. Hinduism proper was also to have its own impact on the Far East from as early as the first century AD, having arrived there with traders. Here the Funan culture was the first in Southeast Asia's illustrious line of Hindu civilizations. The most famous of these, Cambodia's Khmer kingdom, had its heyday towards the twelfth century when the famous capital at Angkor Wat was built, although this was just one of many cities built in an extensive empire. With its centre in the highlands of upland Vietnam, Khmer's neighbour and rival Champa was another Hindu kingdom. In Java too the Indian religion was taking root. Everywhere, however, it interacted not only with local traditions, but also with the growing influence of Buddhism: the rulers of Angkor eventually embraced this faith. The thirteenth century saw the rise of the Sukhothai State, the Buddhist kingdom that would eventually become Thailand.

Static, conservative, convention-bound: there are times when these criticisms of eastern art may appear to ring true to those educated in western art history with its many movements and many schools. That is, however,

Cambodia: bronze conch shell. © Christie's Images Ltd

largely because change in eastern art has followed its own rhythms, informed by very different historical experiences and ideas. As this book sets out to show, the Far East has produced an exhilarating variety of artistic forms, with works of stunning beauty and unfathomable depth. You could explore its endless diversity for ever: Oriental art really is in that sense a world in itself, which does indeed encompass just about all things under heaven.

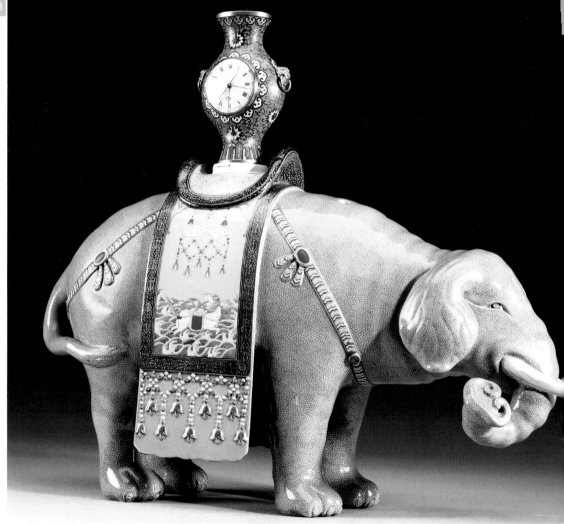

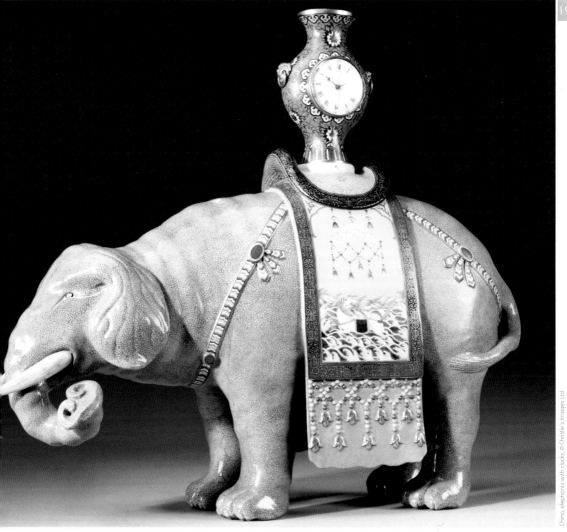

Asian Art

Paintings, Prints & Screens

China

Deer in Autumn Forest

This work from the Five-dynasty period of the tenth century shows the breathtaking effects available to Chinese artists painting in ink on screens of silk. The limitations of the media were turned to advantage: the misty diaphanous nature of the silk, the unruly 'bleeding' together of the inks combined to produce a soft explosion of russets, reds and whites. In the midst of it all the deer themselves, just discernible between the trees, all effortlessness of movement and natural grace.

It is hard to imagine a work of such ease and accomplishment being the product of an age of chaos, yet the tenth century was a time of great upheaval across the whole of China. After almost three centuries of buoyant stability under the Tang dynasty, the empire fell apart after AD 907. The 'Five dynasties', who followed in squabbling succession over the next 53 years managed to establish a shaky authority, but only in the northern part of China, the southern realms breaking up into the 'Ten States'.

CREATED

Northern China

MEDIUM

Ink on silk

SERIES/PERIOD/MOVEMENT

Five-dynasty period, tenth century

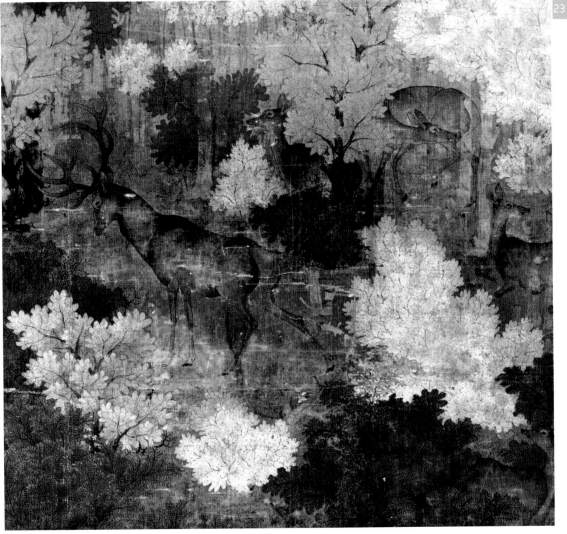

Japan

A Boat Ride by Moonlight

Fujiwara Nobuzane (c.1177–1265) came from a famous dynasty of Japanese painters, politicians and scholars, a dominant artistic force at the courts of the Heian period. As a courtly artist, his stock in trade was formal portraiture, but he also produced more spontaneous-seeming scenes of palace life. He was capable of achieving a strong sense of romantic mystery and romantic urgency in such works, as in this wonderfully evocative illustration to the diary of Murasaki-Shikubu, the tenth-century author of the famous fiction of love and intrigue, the *Tale of the Genji.*

Murasaki-Shikubu's real name isn't known for sure, but she too is believed to have belonged to a minor branch of the Fujiwara clan, so Nobuzane would have regarded her as a kinswoman and creative forebear. He himself was a writer of repute and his poetry is still respected in Japan. His imaginative enterprise is exemplified in the series of imaginary portraits he painted, showing important poets and other personages from his country's past.

CREATED

Kamakura, Japan

MEDIUM

Painting

SERIES/PERIOD/MOVEMENT

Kamakura period, twelfth/thirteenth century

Fujiwara Nobuzane (attrib.) *Born c.1177 China*

Died 1265

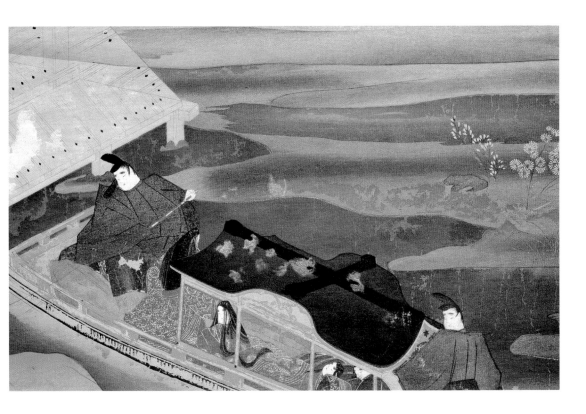

China

Kublai Khan

Captured here by an unknown artist, Kublai Khan (1215–94) was grandson of the great warlord Genghis Khan and a redoubtable military leader in his own right, yet his love for the land he conquered in 1279 was immediately evident. Crowning himself emperor, he ruled as an explicitly Chinese monarch, renouncing the other possessions of the Mongols. He named his dynasty the *Yuan*, 'first', but this represented no scorched-earth 'Year-Zero': he preserved the best of ancient Chinese tradition, whilst invigorating the country with his administrative and economic reforms.

It was in Kublai's reign, of course, that the famous Venetian traveller Marco Polo was welcomed to China (1275–92) and a vital window opened up on the West. It would be wrong, however, to assume that the Yuan period was experienced by the Chinese as a golden age. Whatever benefits they may have brought, the Mongols were always regarded as invaders. Perhaps on that account the Yuan dynasty was to be short-lived, ending after less than a century in 1368.

CREATED

China

MEDIUM

Painting

SERIES/PERIOD/MOVEMENT

Yuan dynasty, 1279–1368

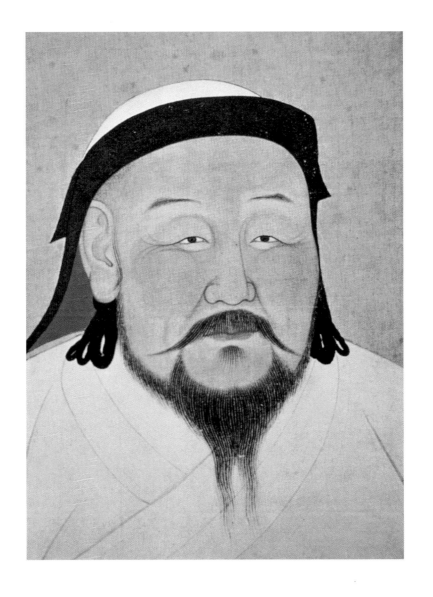

China
Three Bodhisattvas

This fresco, done at speed on drying stucco, appears to have been made some time during the late Yuan or early Ming dynasties, roughly between 1368 and 1644. Solid, even stolid-looking by the standards of paintings on parchment or silk, its subject is apparently a triad of *bodhisattvas*, Buddhist 'saints' or holy men. There's a bold opacity about the colours here, which reminds us that this was the great age of *cloisonné* enamelling. It is striking nevertheless how successfully the unknown artist has striven to give an impression of their swirling forms floating free in a shimmering space, only half-embodied against an elaborately abstract background.

Chinese Buddhism had been experiencing mixed fortunes: Kublai Khan had given it great impetus when he made it the official state religion. His decision made political sense for an incomer, whatever his spiritual feelings: Confucianism was a deep-rooted and ultimately nationalistic Chinese creed. Yet, as the Mongols came to see, its ethic of public service and respect for authority was appealing from their point of view as governors and they encouraged it at Buddhism's expense.

CREATED

China

MEDIUM

Paint on stucco

SERIES/PERIOD/MOVEMENT

Late Yuan/early Ming period, *c.* 1340–1644

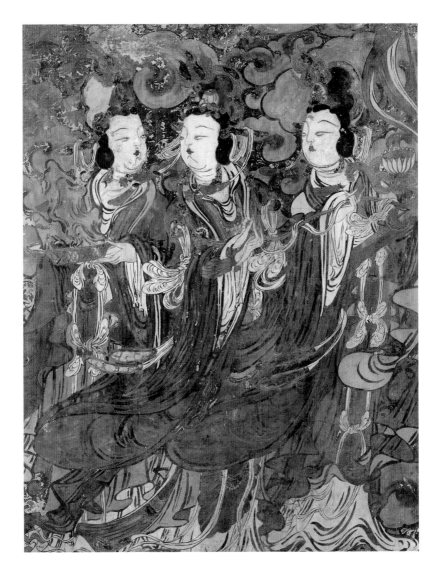

Japan
Horseman and Galloping Horse

© The Art Archive/Private Collection, Paris/Dagli Orti

A sense of surging dynamism fills this silk painting created by an unknown artist of the thirteenth-century Kamakura period, capturing an unexpected aspect of Japanese life. Despite all its blacks and greys, it is anything but drab: sometimes movement may be best evoked in monochrome. Animals and 'nature' are often assumed to be the preoccupations of a relatively modern, western tradition but animal forms have been one of the glories of eastern art. Medieval Japanese artists reproduced everything from rabbits to tigers with a breathtaking vividness and energy.

The Kamakura period is so called because that city was then Japan's capital. Yoritomo, who had sidelined the emperor to set himself up as the country's first Shogun, essentially a military dictator, had made his base there in 1185. With the Shogunate much disputed and fought over in the century or so that followed, it was a time for men of action. This is something that is reflected in the age's art, most strikingly perhaps in the *e-maki-mono* silk hand scrolls, which show frame by crowded frame of the country's best-known narratives of love and war.

CREATED

Japan

MEDIUM

Painting on silk

SERIES/PERIOD/MOVEMENT

Kamakura period, thirteenth century

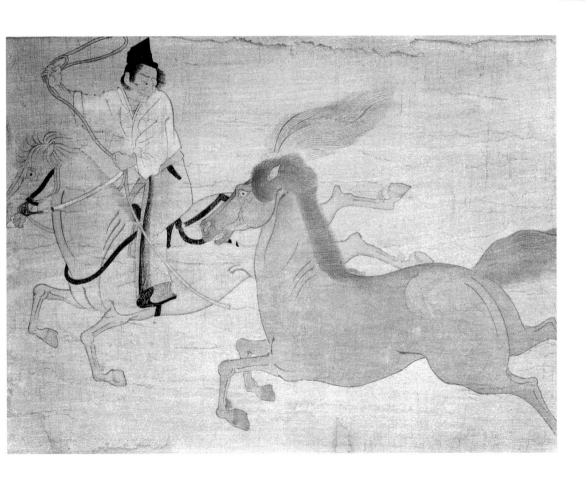

China

Regal Procession

A female dignitary holding a sceptre is led in procession in this Chinese painting of the Ming dynasty, created some time in the sixteenth or seventeenth century. A circular frame encloses a miniature masterpiece of composition, in which the figures of the crowd seem to throw the main subject into focus. Their bowing postures lend fluidity and rhythm to a scene that might well have been stiff and stilted in its stateliness, proof that the most formal 'court' art may have its own graceful beauty.

The time of the Ming emperors was welcomed by the Chinese as being a return to native rule after the foreign domination of the Yuan dynasty. Expectations had been high for a golden age of culture: in 1368 the first Ming emperor Hongwu had attempted to establish an academy of art at his Nanjing court. This had broken up amid factionalist carping and backbiting, as had subsequent 'official' attempts to foster painting. However, the artistic anarchy that resulted was arguably no bad thing as we see here.

CREATED

China

MEDIUM

Polychrome fresco

SERIES/PERIOD/MOVEMENT

Ming period, sixteenth/seventeenth century

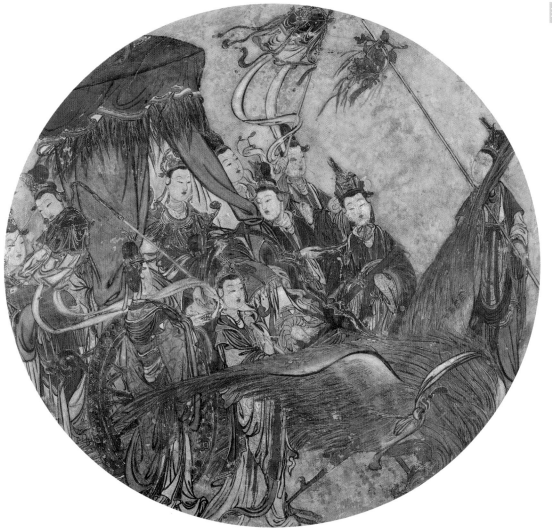

Tibet/China

Vajradhara, Manjushri and Shadakshari

Vajradhara, the 'supreme Buddha', is attended by two of his greatest *bodhisattvas* or 'saints' and an array of smaller sacred figures in this Tibetan *thangka* from 1479. A painted panel with textile borders, the three-dimensional *thangka* was a feature of Tibeto-Chinese art of the Chenghua period: it was an object of prayerful contemplation designed to be rolled up for ready transportation by its nomadic owner. There were many *bodhisattvas*, but Manjushri and Shadakshari were particularly popular in Tibet: the former was associated with wisdom, the latter with compassion.

One of the hardest things for the westerner to appreciate about a magnificent work such as this is the extent to which Tibetan art places aesthetic beauty in the service of religious worship. Even the stained-glass window in a European cathedral invests its figures with narrative interest, artistic life, but these *bodhisattvas* and their surrounding designs are essentially distilled doctrine. These figures were intended as the vehicles to spiritual transcendence. Tradition ordained the ideal forms for contemplation and there was very little scope for individual interpretation on the artist's part.

CREATED

Tibet/China

MEDIUM

Paint on wood and textile

SERIES/PERIOD/MOVEMENT

Chenghua period, 1479

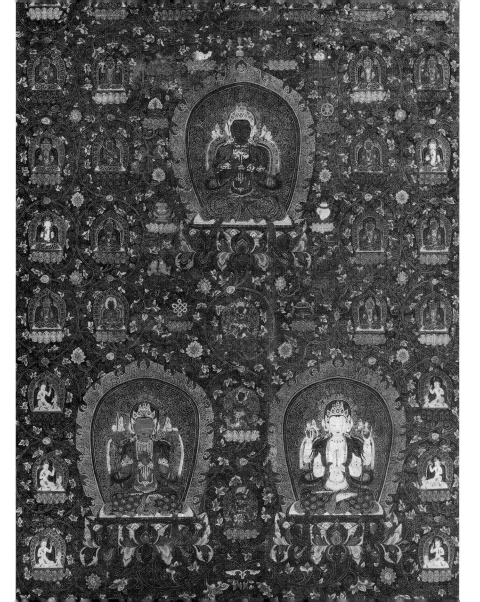

Japan
Landscape by lake or seashore

The Japanese painter Sesshu Toyo (1420–1506), one of the most famous artists of the Muromachi period, created landscapes of heart-stopping beauty and transcendent spirituality. A Zen monk, he evidently saw painting as a form of meditation, and the misty voids in his work communicate as profoundly as the exquisite lines. Here a shore-side village scene becomes a moment of eternal eloquence: all human existence seems to be summed up in an old man's weary walk over a rickety wooden bridge.

Fifteenth-century Japan drew inspiration not just from Chinese Buddhism but also from Chinese art, and Sesshu Toyo himself was crucial to that process. Based in Yamaguchi in southwest Honshu, a trading centre, he had already been exposed to Chinese art when he was called to join a trade mission to Beijing (1467–69). He returned strongly influenced by the principles of classic Chinese art, with a new sense of the importance of balance and of solid mass. The implications for his work and for subsequent Japanese artists would be profound.

CREATED

Japan

MEDIUM

Ink and watercolour

SERIES/PERIOD/MOVEMENT

Fifteenth/early sixteenth century

Sesshu Toyo *Born* 1420 Akahama, Japan

Died 1506

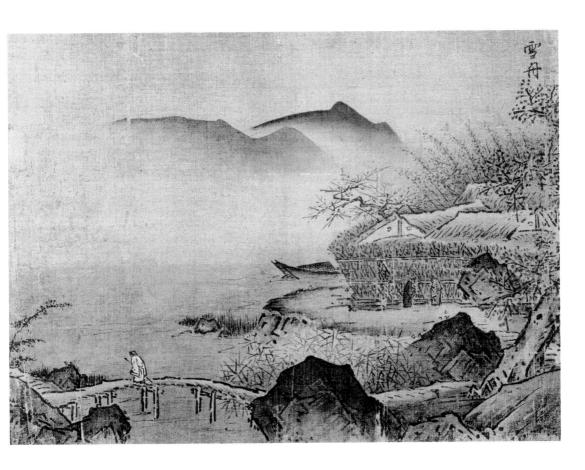

China

Saying Farewell at Hsung Yang (detail)

Just when we think we've come to know Oriental art, it springs another surprise: this time in an extraordinary play of parallel lines and a palette of startling colours. Despite his humble birth, Chiu Ying (1494–1552) was one of the most revered artists of Ming China: the 'blue and green' style was one of several older traditions that he mastered. Technical virtuosity and lyric poetry came together to give his work a wide and enduring appeal: he is the most-forged painter in the history of Chinese art.

In the West, however, he has arguably been the most misunderstood, especially in more recent times when something akin to a modern 'Expressionism' has been detected in his work. The suggestion is misleading, intriguing as it is. Chiu Ying stylizes the scene: the jagged angles and parallel lines of his mountains, and the clouds that seem to 'rhyme' with him. There are also the horizontal bars of mist interrupting the middle distance and designed to show the connection and interpenetration of all things in the Tao universe.

CREATED

China

MEDIUM

Ink and watercolour

SERIES/PERIOD/MOVEMENT

Ming dynasty, sixteenth century, 'blue and green' style

Chiu Ying *Born* 1494 China

Died 1552

China

Children Worshipping at a Shrine

An older sibling helps keep a younger child in line; a toddler is coached in observance in the rear. This is just one image from the 'Hundred Children Scroll', painted by an unknown artist of the Ming dynasty (sixteenth to seventeenth century). Its cartoon strip simplicity is appropriate to the humanity, even humour, it embodies. Western stereotypes of Oriental 'inscrutability' have been applied as much to art as to people; on closer consideration the most apparently stylized works often reveal a lighter side.

The warmth in this wonderful scene comes not just from cheery subject matter but also from colour: the terracotta background, the richer reds of the rug and of the gowns worn by toddler and figurine. The symmetry struck between those two smallest figures, along with the straight diagonal line that links the entire grouping, helps to bring together in balance a scene that might otherwise have erred on the side of being too informal.

CREATED

China

MEDIUM

Scroll

SERIES/PERIOD/MOVEMENT

Ming dynasty, sixteenth/seventeenth century

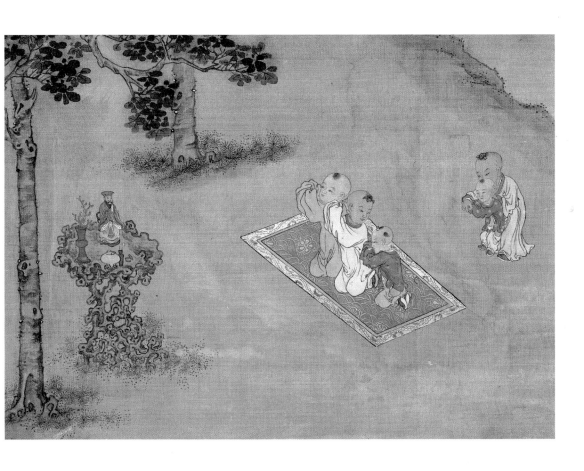

China

Poppies

Yun Shouping (1633–90) was justly celebrated for his flower paintings, created in what was known as the 'boneless' style, in other words without an outline. The result, as can be seen here, was a sense at once of the utmost delicacy and of tangible texture, the gentle swaying of the stalks and the softness of the petals almost palpable. So successful was this aspect of Yun Shouping's work that the full breadth of his achievement has tended to be missed: he also produced landscapes of rare accomplishment.

Yun Shouping was an early example of what we tend to imagine is a quintessentially modern figure, the dissident artist. Having the misfortune to have been born the son of a loyal Ming supporter just as that dynasty was being swept aside by the Manchu invaders, he spent most of his working life in Hangzhou, well away from the Qing court at Beijing. It is probably too fanciful to see his lovely landscapes as some sort of patriotic statement, yet his love for the Chinese countryside is very clear.

CREATED

Hangzhou, southern China

SERIES/PERIOD/MOVEMENT

Qing dynasty, seventeenth century

Yun Shouping *Born* 1633 China

Died 1690

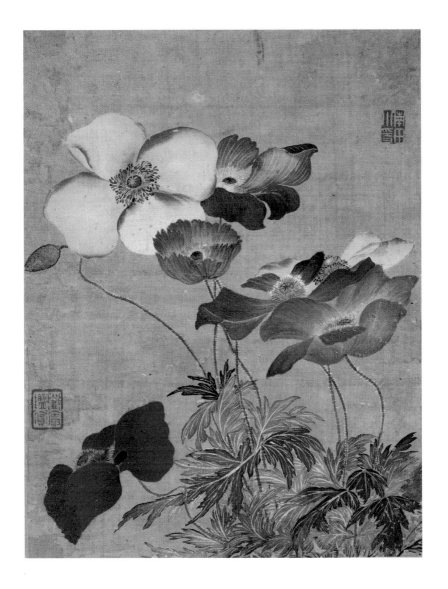

Japan
The Thirty-Six Poets

The 36 immortal poets of Japanese tradition, as shown here, are inimitably portrayed by Ogata Korin (1658–1716). Left wealthy when his father died, Korin began a carefree career as a fashionable playboy until, his money all spent, he was forced to paint to earn a living. But the swaggering flamboyance of his youth shows through unmistakably in his work as an artist, which is exhilarating in its technical virtuosity and formal daring. Typically he plays fast and loose with established formal symmetries and the 'tilted' appearance of this work is as characteristic as its crowded complexity.

So too is the bold irreverence with which these grave old worthies are depicted: many have the look of caricature, yet the overall air is solemn. Korin's youthful privilege had not only gained him the fullest possible access to Japanese artistic tradition and the best possible instruction in conventional techniques, but had also given him the self-assurance to break with the past or reinterpret it at will.

CREATED

Japan

MEDIUM

Painting

SERIES/PERIOD/MOVEMENT

Edo period, seventeenth/eighteenth century

Ogata Korin *Born* 1658 Japan

Died 1716

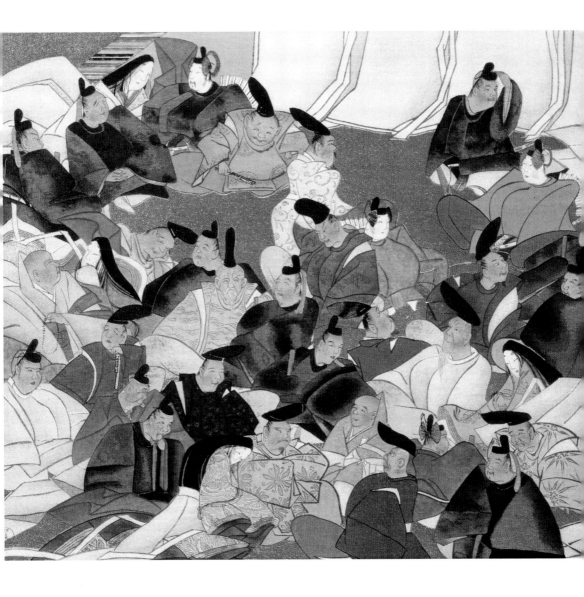

Tibet

Tsong Kha-Pa

Tsong Kha-Pa (1357–1419) was founder of the Geluk or 'Yellow Hat' school of Tibetan Buddhism and thus the intellectual and spiritual forefather of the later Dalai Lamas. The spiritual approach his followers fostered involved years of intensive study, contemplation and self-purification. It took up to 20 years, with regular examinations, for the student even to attain the status of *geshe*, which would allow him to undertake training in yoga and meditation at the highest level.

For such a system to work, an extensive supporting infrastructure needs to be in place, a monastic system in other words. It has been the tragic irony of Tibetan history that this particular religious tradition, and the large-scale institutionalization of society it encouraged, should also have suited China's long-term goal of domination so perfectly. Even so, Tsong Kha-Pa, at once a historical and sacred figure, is uniquely revered in the Tibetan tradition. Inevitably his image is at the centrepiece of many *thangkas*. This one dates from the seventeenth century. A richly colourful work, it shows its subject surrounded by many other *bodhisattvas*.

CREATED

Tibet

MEDIUM

Paint on wood and textile

SERIES/PERIOD/MOVEMENT

Seventeenth century

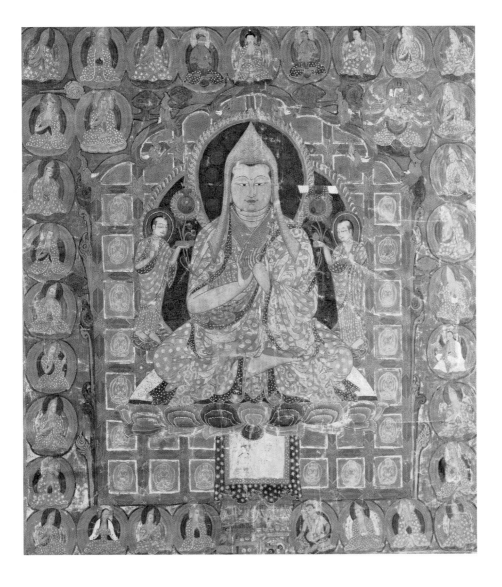

China

Contemplating the Yin-Yang Symbol

The famous Yin-Yang sign represented a symbolic coming together of all the universe's oppositions, from female and male to moon and sun and water and fire. It was already ancient when its properties were formulated for the first time by the sage Zou Yan in the fourth century BC. Under the Han dynasty, which became established in 221 BC and ruled in China for over four centuries, Taoist mysticism and Confucianist social thinking were fused with other traditional beliefs. Half state religion, half ideology, the resulting system saw creation as comprising three states: heaven, earth and humanity. All three states functioned in conformity with the cycles of the Yin and the Yang, with the emperor as the figure in which all oppositions were revolved.

By the time this painting was produced in the seventeenth century such beliefs were much diluted, but the symbol was still an inseparable part of Chinese tradition. Here individuals of every age group gather to consider a sacred emblem that summed up human existence in all its complexity and contradiction.

CREATED

China

MEDIUM

Painting

SERIES/PERIOD/MOVEMENT

Ming dynasty, seventeenth century

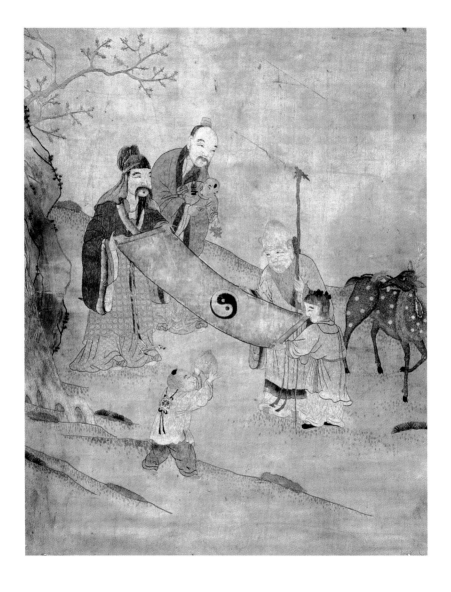

China

Scholar Official and Attendant

Everything about this picture suggests order and regularity, from the full-frontal formality of the sitter's pose to the symmetry of the carpet squares beneath him to his belt ornaments, his sprawling sleeves and his black-brimmed hat. Everything, that is, except a face full of warm personality and feeling – just compare it with the identikit attendant in the background. A scroll, painted in ink and colour on silk, this anonymous painting dates from the seventeenth century when the idea of individualism was gaining ground in China.

Previously, like that of many other cultures, Chinese art had tended to deal not in individual characters but in 'types'. Called on to paint an official, the artist depicted the formalized ideal summation of what an official should be. Confucian thinking in any case encouraged the individual to subject his personality to his social role and such attitudes were almost certainly 'internalized' in the way men and women saw themselves. They are certainly evident in art, hence the startling aspect of a portrait that really does seem to be hinting at the presence of a living personality.

CREATED

China

MEDIUM

Ink and colour on silk scroll

SERIES/PERIOD/MOVEMENT

Seventeenth century

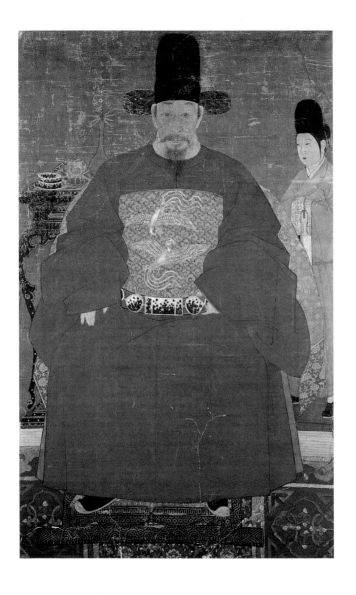

Japan
A Game of Shogi

Demi monde, *beau monde*, *dolce vita*, *jeunesse dorée*: Japan's 'floating world' was all these things and more. The phrase 'floating world' was introduced by writer Asai Ryoi in 1661: his *Ukiyo-e Monogotari* ('Tales from the Floating World') mercilessly sent up the idle hedonism of his country's aristocracy and the futile pointlessness of their day-to-day lives.

As is often the way with such scathing labels, it was co-opted by its intended victims. Stripped of its satirical connotations, it came to represent a nostalgically hankered-after ideal of gracious living. That yearning has persisted into modern times, but the 'floating world' is still best evoked in the works of seventeenth-century painters such as Iwasa Matabei (1578–1650). The golden age of *Ukiyo-e* came in this, the 'Edo Period', so-called because the Shogun Tokugawa Ieyasu had made Edo (later Tokyo) the capital of Japan. Iwasa Matabei is, in fact, traditionally credited with having originated the *Ukiyo-e* school and while this was disputed for a time in the post-war period it is generally accepted now.

CREATED

Edo, Japan

MEDIUM

Painting

SERIES/PERIOD/MOVEMENT

Edo period, seventeenth century

Iwasa Matabei *Born* 1578 Japan

Died 1650

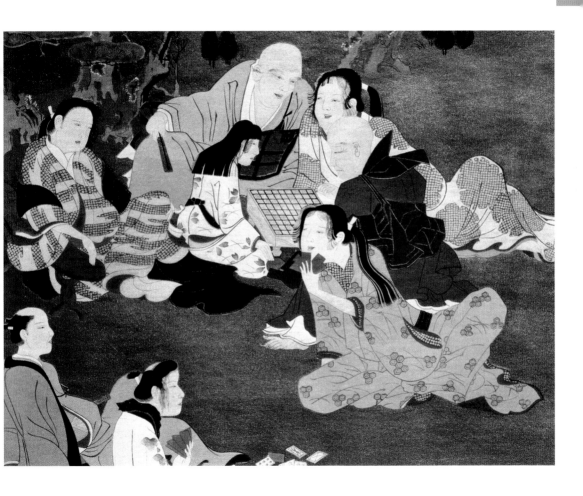

China

The Preparation of Silk

In showing the cultivation of silkworms and the manufacture of silk cloth, this seventeenth-century picture is quintessentially Chinese in its subject matter. But its (slightly slavish) use of perspective gives it an unmistakeably westernized feel. What might be called a sense of perspective is evident in Chinese painting from very early on, but most artists achieved the impression of three-dimensional depth by other means. The idea of 'scientific' perspective was a western introduction, brought with the first Jesuit missionaries in the late sixteenth century.

In this flawed but fascinating picture, scientific principles have been painstakingly set to work, although the result has been not realism but an uncomfortably diagrammatic feel. There are slight mistakes: the leading post holding up the shelter where the women are working has wandered from its 'true' position. More problematic, however, is the fact that the Chinese artists, whilst following their system for each individual structure, have given their setting depth in the traditional way, spacing its river, rocks and trees by instinct.

CREATED

China

MEDIUM

Drawing

SERIES/PERIOD/MOVEMENT

Seventeenth century

練絲

建邨煮繭香解
事誰家娘盆盆
意媚竈拍拍手
探湯上盆顏色
好斡軸頭緒長
晚來得少休女
伴語隔墻

Korea

Birds and Flowers

Kim Hong-Do (1745–1816) was one of Korea's greatest painters, famed especially for his vividly overcrowded scenes of village life. When he wasn't painting, he was serving as a local magistrate: the experience clearly gave him a special insight into the ways of the Korean countryside.

In their jostling energy and humour, these famous works have a Brueghel-like feel, yet Kim Hong-do was as much at home producing quieter, more reflective pieces. This enchanting landscape with birds and flowers is a study in verticality, with the beetling crag, the shrub struggling skyward and the rushing stream. Then there are those magnificent tail feathers: the bird at the centre of the picture is all pert elegance and energy contained. In a note beside one of his quicker nature sketches, Kim Hong-do acknowledges his admiration for the bird paintings of Lin Liang, a famous Chinese artist of the fifteenth century. Like many another artist who on the face of it seems *sui generis*, he clearly found sustenance in the works of past masters, even if their influence is not immediately apparent in his own.

CREATED

Korea

MEDIUM

Ink and colour on silk scroll

SERIES/PERIOD/MOVEMENT

Choson dynasty, eighteenth/early nineteenth century

Kim Hong-Do *Born* 1745 Korea

Died 1816

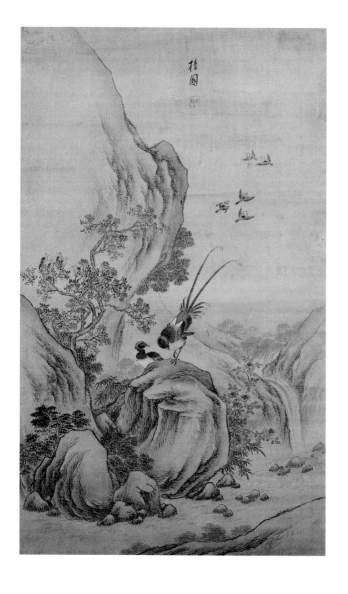

Burma (Myanmar)
Women at Work

This fresco comes from the famous Ananda temple at Pagán, the capital of Myanmar's kings from the eleventh century. The splendid shrine itself was built *c.*1105 by Kyanzittha, the second king, but this appealing work is far more recent.

Like any other fresco, it would have had to be done in a rush before the plaster dried, yet the artist has still succeeded in filling it with delightful detail. A bustling everyday scene, it shows women making pottery while they laugh and joke together; one covers a co-worker's mouth, as though to prevent her repeating some joke or passing on some gossip. To the right of centre another figure, perhaps selling to a customer, holds a set of scales in one hand and a jar in the other. In the background can be seen a store of finished pots and beside them rushes or branches (fuel for a kiln?); two slaves carry more of these in the right-hand foreground.

CREATED

Burma (Myanmar)

MEDIUM

Fresco, paint on plaster

SERIES/PERIOD/MOVEMENT

Eighteenth century

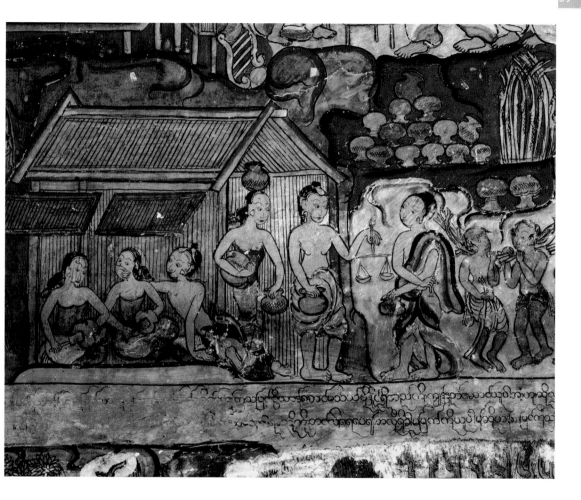

မတ်ကျဘဒ္ဒဟပြီးသာစကော်ဒဝသသယဗျ ဖြင့်ပြအလျာကင်းကွန်တာမလျုပ်တယ်သိပ်ဘာစယ်သို့
ပြင်းတလ်ဂျာဧဝေသွ့အလ္ဟပ္ပဉ်ပဉ်လ္ပက်ကိုယ့်ပြဖ်ယ်ဆဆ၆ဆ၉ယ်ပြကော်

Thailand

Scene from the *Ramakian*

In its translation, the *Ramakian*, the famous Hindu epic the *Ramayana*, became as much a part of Thai culture as of India's. This is one of a series of scenes from the poem in Wat Phra Keo, the Temple of the Emerald Buddha, at the Royal Palace complex in Bangkok. Dating from the reign of King Rama I, 1782–1809, it shows the moment at which a mighty stone, moved by Rama's army as a show of strength, falls to earth upon the doomed city of Lanka.

The series of murals to which this picture belongs have some claim to be the founding images of modern Thailand: the Temple of the Emerald Buddha was the first structure to be built when the kings of the new Chakri dynasty moved the capital to Bangkok. The old capital, Ayutthaya, had been sacked by the Burmese in 1767 (which would have given an ironic significance to this particular scene, of course). The circumstances of their creation gave the Wat Phra Keo murals a special status in Thai tradition and they have exerted a powerful influence ever since.

CREATED

Bangkok, Thailand

MEDIUM

Fresco, paint on plaster

SERIES/PERIOD/MOVEMENT

Bangkok period, Chakri dynasty, late eighteenth/early nineteenth century

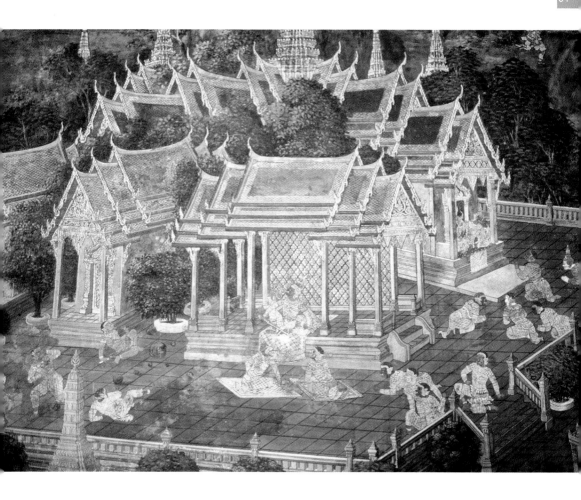

Japan

Three Women Viewing Wisteria at Kamedo

This picture actually forms just half of a two-part work or 'diptych'. It is the creation of Torii Kiyonaga (1752–1815). A leading printmaker in the Japanese *Ukiyo-e* or 'floating world' tradition, he was a portraitist of outstanding quality, but was most renowned for his representations of elegant actresses and courtesans.

What became known as the 'Kiyonaga beauty' was an instantly recognizable physical type: strikingly tall, her torso exaggeratedly long and alluringly curved. It would be quite wrong, of course, to suggest that Kiyonaga was some sort of pornographer, but his prints clearly attained the immense popularity they did in his day because he had learned how to give artistic form to a fantasy of feminine beauty. Here, the slight swing of the kimono-clad female figures gives a little flick to the vertical lines introduced by the trellis post and hanging blossoms. The overall effect is of a nonchalance and effortless grace that still seem seductive today, almost two centuries after this picture was created.

CREATED

Japan

MEDIUM

Print

SERIES/PERIOD/MOVEMENT

Edo period, late eighteenth/early nineteenth century

Torii Kiyonaga *Born* 1752

Died 1815

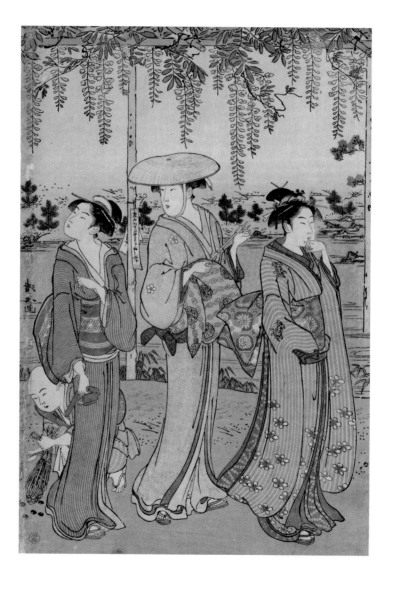

Japan

Young Woman Writing

A young woman sits at a desk while a girl with a book looks on in this characteristic work by Kitagawa Utamaro (1753–1806). Another important artist in Japan's *Ukiyo-e* tradition, Utamaro specialized in this sort of intimate snapshot-scene, catching a fashionable young woman in a private, off-duty moment. Prints like this caught the international imagination: western artists like Vincent Van Gogh (1853–90) and Henri de Toulouse-Lautrec (1864–1901) were strongly influenced by what they had seen of the 'floating world' tradition.

Within Japan itself, the impact of Utamaro was less obvious but more far-reaching: his beauties were real women and not just idealized feminine forms. The 'eavesdropping' effect Utamaro went for may have invaded their privacy but it also acknowledged the fact of its existence: his women had lives, reflective moments, psychological depth. So too did the experience of looking at them: these prints were not designed for walls or screens but were published in albums to be browsed alone and at leisure. It was a new way of looking, not only at women but also at art.

CREATED

Japan

MEDIUM

Print

SERIES/PERIOD/MOVEMENT

Edo period, late eighteenth century

Kitagawa Utamaro *Born* 1753 Japan

Died 1806

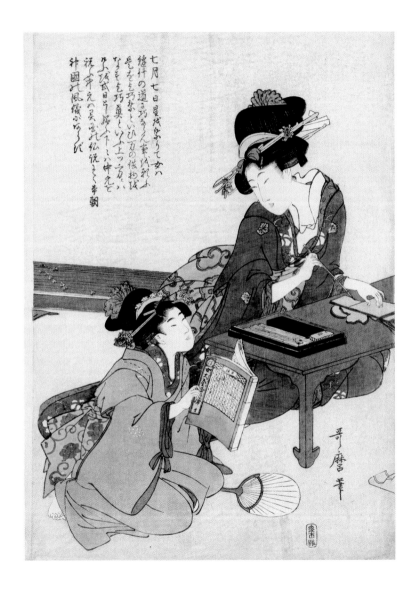

China

Chinese Ladies Playing Go

Is it soft-focus sentimentality or humanity and warmth? The Chinese art of the Qing or Manchu dynasty does not meet with unalloyed approval from traditionalists. This eighteenth-century work could not be claimed to have the austere chastity of classic Chinese art, but it would be a hard judge indeed who refused to find compensations. There's a quiet intimacy about this scene, a feeling that we're looking in on a private moment shared between friends, which gives it a profoundly moving sense of emotional depth.

Far older than chess or any other known board game, *go* or *weiqi* is a trial of tactical finesse: it is famously straightforward in its basics, but difficult to play well. Black and white pieces or 'stones', sometimes said to represent the Yin and the Yang, are moved about a board nineteen spaces square. The object is to section off parts of the board as territory for oneself. Seen as a metaphor for military action, it has found favour with Chinese men from Confucius to Mao Zedong, but has always been popular among women as well.

CREATED

China

MEDIUM

Painting

SERIES/PERIOD/MOVEMENT

Qing dynasty, eighteenth century

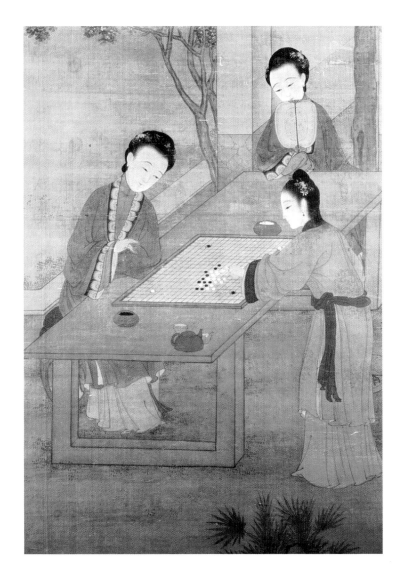

China

Mei Fu Flies on a Phoenix to Feihong

A scene from Taoist tradition is enacted in this Chinese work of the eighteenth century, but is the tale any more than the pretext for a bravura rhapsody in blue and green? Although the forms of classic Chinese art are present as a memory, all pretence of restraint or order has been cast aside: the left side is a topsy-turvy riot of mountain tops, clouds and in one case fallen trees.

For all its flamboyance, in fact, there is a little bit more to all this extraordinary anarchy than an artist showing off his extravagant imagination and technique. This work depicts a dream sequence, a religious vision, and there is a mystic logic to its composition even if there may not be a realistic one. The lurid colour scheme could hardly be more eerily oneiric and there is method in the apparent madness of the composition. The jumbled juxtaposition of earth and heaven, rocks and houses, trees and water, mountains and clouds dramatizes the interconnected nature of all things in the Taoist universe.

CREATED

China

SERIES/PERIOD/MOVEMENT

Qing dynasty, eighteenth century

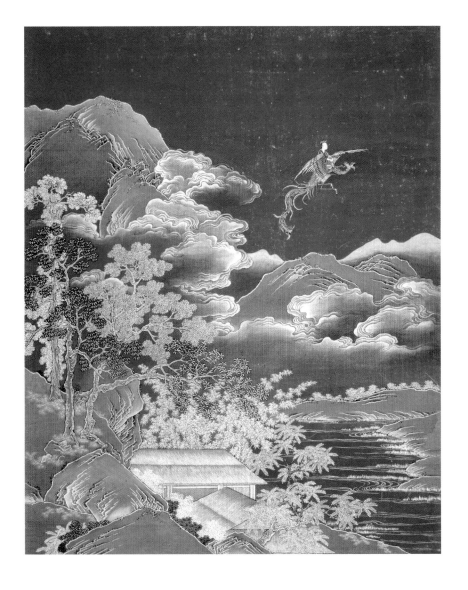

Japan

The Match Between Tanikaze Kajinosuke and Kimenzan Tanigoro

Japanese *Ukiyo-e* printmaker Katsukawa Shunsho (1726–92) was especially famous for his pictures of actors and sumo wrestlers: here, faces rapt in concentration, two well-matched *sumotori* seek to upset one another's equilibrium. A marvellous piece of composition, it captures to perfection the opposition of physical mass and directed strength that gave sumo wrestling its excitement and improbable beauty. The balance of this picture is extraordinary: the out-of-kilter foot to bottom left counterpoised with the crouching form of the *gyoji* or referee in the background.

The referee carries a fan, his symbol of authority: he would also have had a dagger so as to be able to disembowel himself, it was said, if he made a wrong ruling. Shunsho's wrestling prints thus tapped into an age-old tradition of masculinity, strength and honour, but they also show a very modern interest in individuals under stress. Altogether it may not really be so surprising that for a few years in the 1770s, Shunsho's wrestlers had the muscle to push theatrical prints out of the ring, outselling even the beautiful women of the *Ukiyo-e* school.

CREATED

Japan

MEDIUM

Print

SERIES/PERIOD/MOVEMENT

Edo period, eighteenth century

Katsukawa Shunsho *Born* 1726 Tokyo, Japan

Died 1792

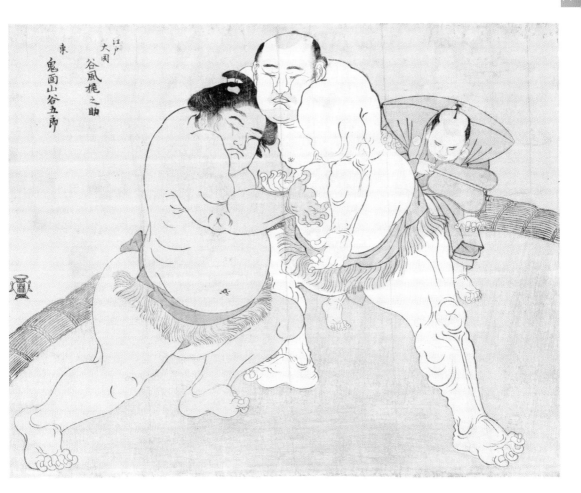

China

Peonies

In Oriental as in western art, the simplest images may be the most attractive: this lovely spray of peonies was painted by the Chinese painter Jiang Yu some time around the 1770s. Entrancingly executed in watercolour on paper, the translucency of the pigment and absorbency of the background are exploited to the full by the artist's use of the 'boneless' or 'un-outlined' style. The resulting picture is at once a semi-abstract eruption of colour and an almost tangibly realistic depiction of these most delicately beautiful of flowers.

Jiang Yu created this work for his *Album of Paintings of Flowers, Fruits, Birds and Animals*: it was made for poring over at close quarters, not for seeing at a distance displayed on a wall. The texture of the paper and the strong sense the viewer would have had of the watercolour's interaction with it would both have contributed to what by modern western standards would have been a very different sort of artistic experience.

CREATED

China

MEDIUM

Watercolour on paper

SERIES/PERIOD/MOVEMENT

Qing dynasty, c.1774

Jiang Yu *Born* c.1774 China

Died unknown

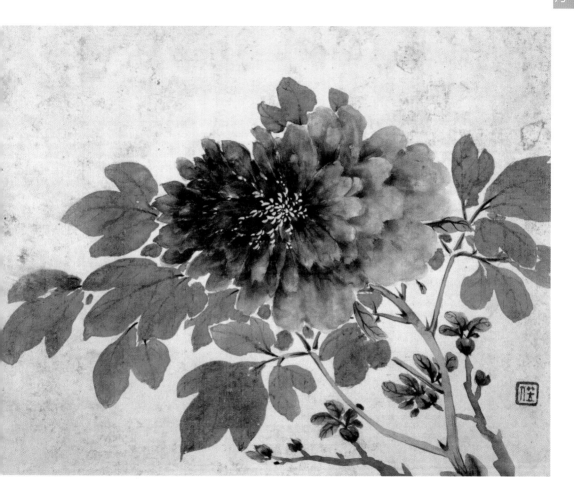

Japan

In the Well of the Great Wave of Kanagawa

Foam-topped waves frame the snowcapped cone of Mount Fuji in the far distance in this, one of the most celebrated images of Japanese art. Katsushika Hokusai (1760–1849) has contrived a scene in which the violent energy is married with perfect balance — see how the smaller wave in the foreground 'rhymes' with the form of the mountain on the horizon. There is wit here then, as well as majesty and a hint of mystery: who is in the boat beneath the rearing wave and what will become of them?

Intriguingly Japan's most famous landscape artist started out as a cartoonist, creating the *manga*, or comic sketches, so popular at the time. He is more interesting than the over familiarity of certain of his works may make him seem. Not just because he did other things but also because even the more famous things were not designed to be seen and canonized singly the way that they have been. The big print series he produced of views of Mount Fuji, for instance, can be read as ingenious sets of variations, often light-hearted ones, on a theme.

CREATED

Japan

MEDIUM

Print

SERIES/PERIOD/MOVEMENT

Edo period, late eighteenth/early nineteenth century

Katsushika Hokusai *Born* 1760 Tokyo, Japan

Died 1849

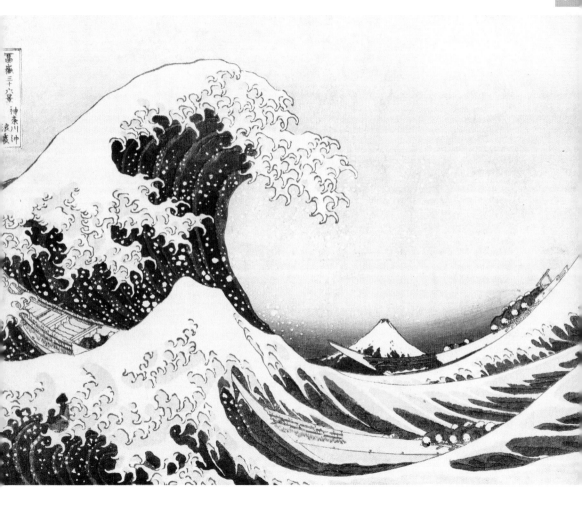

Japan
The Mie River, near Yokkaichi

The *Ukiyo-e* printmaker Ando Hiroshige (1797–1858) started out producing pictures of beautiful women, but switched to landscapes under the inspiration of Hokusai. As this haunting picture shows, he was no mere imitator but had his own highly individual contribution to make: here extraordinary bleakness coexists with mischievous humour. The hat apart, there's a playfulness about the way waving reeds and branches are contrasted with the crookedness of the tree trunk and by the unabashedly artificial angles made by embankment, bridge and billowing cloak.

This print was one of a series, 'The Fifty-three Stations of the Tokaido', published to great acclaim between 1830 and 1844: between them they showed the beauties of nature at every different time of year. They seem to have appealed to people not just for their wit and lyricism but also for the air of peace that hangs over every scene, making them a welcome refuge from the more or less incessant political tensions of the last decades of the Edo period.

CREATED

Japan

MEDIUM

Print

SERIES/PERIOD/MOVEMENT

Edo period, late eighteenth/early nineteenth century

Ando Hiroshige *Born* 1797 Tokyo, Japan

Died 1858

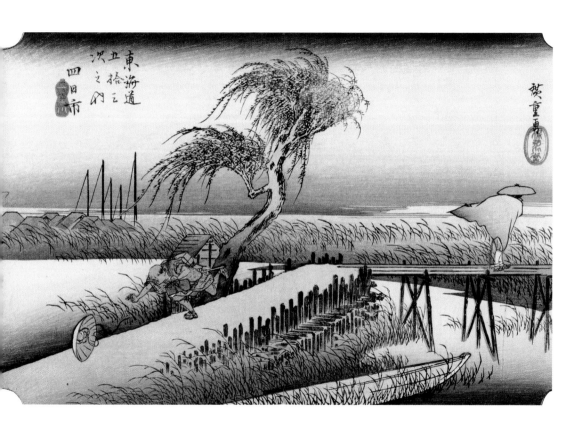

Japan

The Strong Woman, Okane, Subduing a Wild Horse

In addition to portraits of rather more conventional beauties, Utagawa Kuniyoshi (1797–1861) produced a whole series of popular prints devoted to the brave women of the folk tradition. Some are simply fashionable pin-ups, but others show a feistier side to Japanese womanhood than we are accustomed to seeing in courtly art. The figure of Okane, 'the Strong Woman of Omi Province' was known to all Japanese. When a stallion ran amok in her village, this redoubtable peasant woman, the story went, promptly subdued it without even putting her laundry down.

This print has some lovely touches: the figure of Okane clutching her washing makes a marvellous montage of textile patterns, beautifully caught. Her no-nonsense manner as, hands full, she simply traps the horse's tether with her free foot, conjures up both humour and resolution at the same time. The horse is magnificent too, from the energy with which it bucks and capers to the wonderful way its swirling tail and mane pick up the black and white patterning of the clouds.

CREATED

Japan

MEDIUM

Print

SERIES/PERIOD/MOVEMENT

Edo period, nineteenth century

Utagawa Kuniyoshi *Born* 1797 Tokyo, Japan

Died 1861

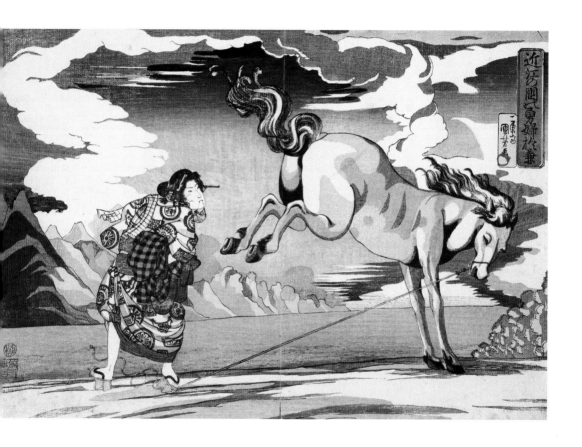

Japan
Boys Playing With Spinning Tops

Utagawa Kuniyoshi was a minor mould breaker: although his *Ukiyo-e* credentials were impeccable, he ventured beyond the customary range of the courtly artist. As popular as his prints of heroic women and famous warriors were, he also made good-humoured studies of scenes from everyday life, like this wonderfully indulgent depiction of three boys playing. As so often in Japanese art, we have the sense of a coiled-spring tension captured in the stillness of a pose, an interplay of perfect balance and riotous energy.

Was it his upbringing as a dyer's son that gave Utagawa Kuniyoshi his interest in and flair for capturing textile colourings and patternings, again displayed to great advantage here? In fact his enthusiasms were as varied as his talent was versatile. He was one of the most celebrated printmakers of his time, yet, popular as he was with the public, he managed never to compromise his creative integrity. He was famous too for the advice and support he offered younger artists, establishing a teaching dynasty that would endure through the twentieth century.

CREATED

Japan

MEDIUM

Woodblock print

SERIES/PERIOD/MOVEMENT

Edo period, nineteenth century

Utagawa Kuniyoshi *Born* 1797 Tokyo, Japan

Died 1861

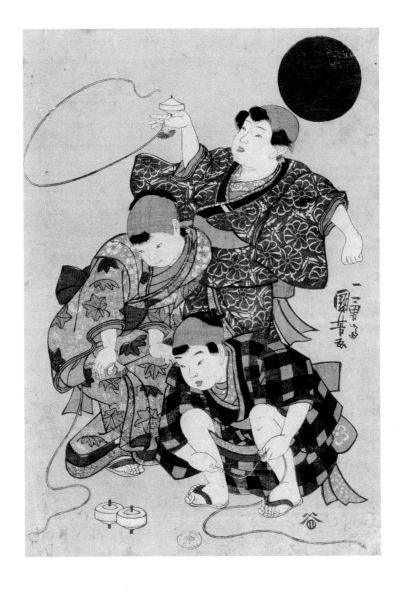

China

A Wedding Procession

A magnificent wedding procession weaves its way across the countryside. Yet the bride, the object of the festivities and ultimate subject of the picture, is nowhere to be seen. The astonishing ornateness of her palanquin (an Oriental litter) only underlines the irony that its main function is not display but concealment: this peculiar painting holds back what it purports to show.

Modern criticism has frequently found itself at a loss to know what to make of nineteenth-century Chinese painting: the temptation has always existed to see in it evidence of 'decline'. This work is a case in point: the rules of aesthetic engagement unclear, gaudy colours applied selectively (as with so much enamelling) against a pallid background left largely empty apart from a distant and washed-out-looking wall. Once we set aside stereotypical expectations of classic austerity on the one hand or imperial opulence on the other, we see a scene with a life and an integrity all its own. But it's undoubtedly a problematic painting; one that asks far more questions than it answers and is a quizzical, even an oddly troubling, work.

CREATED

China

MEDIUM

Painting

SERIES/PERIOD/MOVEMENT

Qing dynasty, nineteenth century

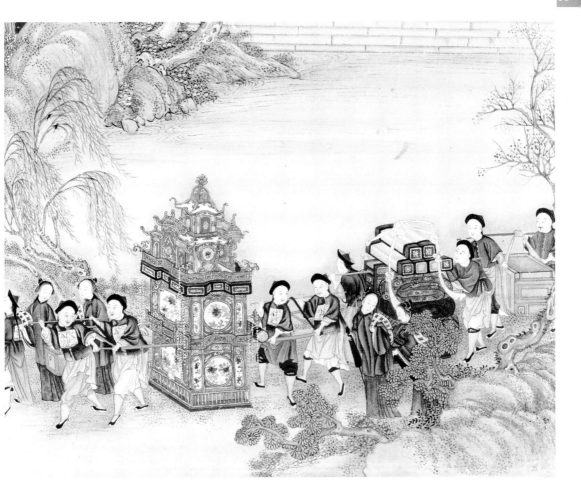

Indonesia
God of the Week

Java is celebrated for its shadow puppets, used to represent scenes from the Hindu *Maharabhata*, frequently given their own reinterpretation through generations of Indonesian tradition. But the same divinities and demons recur in other artistic genres: this stunning print is a page from a nineteenth-century almanac of divination. A week-by-week guide to the unfolding year with the magic and mystical associations of every given date, this would have been consulted in conjunction with other data, such as dreams, by the fortune-teller.

The Javanese artistic tradition offers an extraordinary illustration of just how powerful a hold a set of artistic imagery can take on the imagination, since the island's people haven't been Hindus for half a millennium. Pushing inland from the coast, the Muslim Mataram Sultanate extended its rule over the island as early as the sixteenth century, but made no serious attempt to stamp out popular traditions and tastes that clearly ran very deep. Today the overwhelming majority of Javans are Muslim in their religious beliefs, but there's a corner of their imagination that is Hindu.

CREATED

Java, Indonesia

MEDIUM

Print

SERIES/PERIOD/MOVEMENT

Nineteenth century

Thailand

Apsaras Bearing Offerings to the Buddha

© The Art Archive/Musée Guimet, Paris/Dagli Orti

Apsaras, divine dancing girls, are a particular feature of Southeast Asian tradition, with those created at Angkor Wat, Cambodia, in the twelfth century are the most famous. The Angkor examples are so celebrated largely because they are so frankly erotic in their appeal, although that was not the primary function of the apsara in Buddhist tradition. Painted some six centuries later in Siam (now Thailand), those depicted here seem more genuinely celestial, symbolizing heavenly happiness rather than hinting at earthly sex.

To the left of this scene rises a *stupa*, a stylized mound whose top points to heaven like the church spire of Christendom, and which is the characteristic monument of Buddhism. There is more to its symbolism than that, however, for it also represents Meru, the mountain of the universe, with spirituality at its peak and earthly degradation at its base. The single spike is balanced here by the twin-pointed poles on either side of the Buddha and the triangular *mandorla* that frames his face.

CREATED

Thailand

MEDIUM

Painting

SERIES/PERIOD/MOVEMENT

Nineteenth century

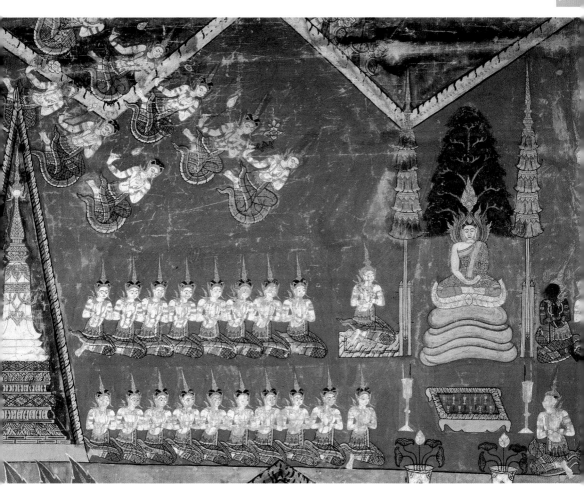

Japan
The Emergence of Amaterasu

The modern representation of an ancient myth, this splendid print by Utagawa Kunisada (1786–1864), shows the Shinto sun-goddess Amaterasu coming out of the cave into which she had retreated some years before. Offended by the neglect of her brother, the storm god Susanowo, she finally reappeared after the other gods created a collective din to call her forth. The picture was perhaps prophetic: Amaterasu was patroness of the Japanese imperial house, whose rule was to be restored a few years later after seven centuries of the Shogunate.

The most striking features of this picture are not just the stylized beams of light but also the real sense of surging energy and dynamism that seem to radiate from the figure of the goddess at the centre. We feel repressed tension turning to movement as the rocks are parted and the gods in the foreground come tumbling towards us; the instant captured for eternity by the vision and brilliance of an artist.

CREATED

Japan

SERIES/PERIOD/MOVEMENT

Late Edo period, nineteenth century

Utagawa Kunisada *Born* 1786 Tokyo, Japan

Died 1864

Burma (Myanmar)
Land of the Elephants

A fabulous land of elephants, as depicted by an unknown artist in a book of Buddhist cosmology printed in Burma (Myanmar) in the late nineteenth century. Elephants abound in the art of Southeast Asia: it was considered an auspicious beast in the astrological tradition. The white elephant was particularly prestigious, largely on account of sheer rarity: basically an albino, the white elephant would always by definition have been exceptional. But in the Buddhist scheme, as in so many other cultures throughout world history, white has been the colour of unsullied purity and so the dazzling white elephant was seen as symbolizing the soul of the Buddha himself.

Hence, in this multicoloured collection, the pride of place that this family group of white elephants takes in the top right-hand corner, to which the reader's eye is inexorably drawn by a cunning juxtaposition of light and shade. In the foreground lion-like mythological creatures chase each other and water spirits cavort.

CREATED

Burma (Myanmar)

MEDIUM

Print

SERIES/PERIOD/MOVEMENT

Late nineteenth century

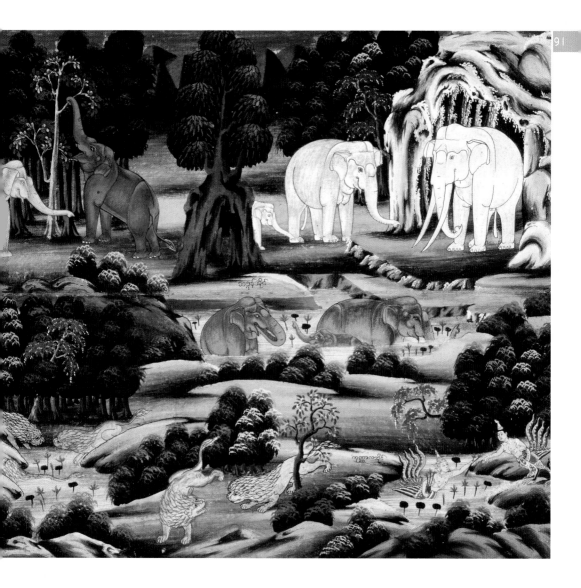

Korea

Taoist Immortal

The work of Korea's Chi Wun-Yung (1852–1935), this hanging scroll of silk, painted in ink, depicts an episode from one of Taoist tradition's most famous myths. There were eight immortals in all, virtuous men and women who had achieved everlasting life through their good deeds. One day they found themselves having to cross the sea. Each worked their own different miracle, according to their character and special powers: the story has come to stand for each person's ability to accomplish things in their own way.

Tao (or Dao), 'The Way', is at once a philosophy and a religion, its emphasis on the need to become one with the universe. This might involve retreat from the world and its immediate concerns in favour of a higher rhythm or contemplation in the face of nature. Alternatively it could simply mean an effort to lead the life one has been given as well and simply as one can. Hence the significance of the immortals: each used the talents the universe had invested in them to attain the purpose for which they had been put on earth.

CREATED

Korea

MEDIUM

Ink and colour on silk scroll

SERIES/PERIOD/MOVEMENT

Choson dynasty, nineteenth century

Chi Wun-Yung *Born* 1852 Korea

Died 1935

Tibet

Vajrakila Mandala

The word *mandala* means 'circle' in Sanskrit, although within its circular form it typically takes the form of a square building or enclosure with four gateways. It is a symbolic representation of the universe, or of the pure, enlightened mind, which amounts to the same thing. A guide to meditation, it is widely used by Hindus, although this one was made around 1800 by Buddhists in Tibet. It is dedicated to the dagger-wielding deity Dorje Phurba or Vajrakila, who occupies the centre with his consort: the person praying would make an identification with him in order to assume some of his powers.

Dorje Phurba's phallic dagger is symbolic of masculinity and of spiritual aspiration, like the point of the *stupa*. It also recollects the pegs with which Tibetan nomads fixed their tents. As such it was associated with the idea of 'binding' the universe, of pinning down the earth and all its demons. Every image in the Tibetan Buddhist iconographic scheme carries generations of accumulated meaning, making a *mandala* such as this one a picture-text of enormous significance and astonishing compression.

CREATED

Tibet

SERIES/PERIOD/MOVEMENT

*c.*1800

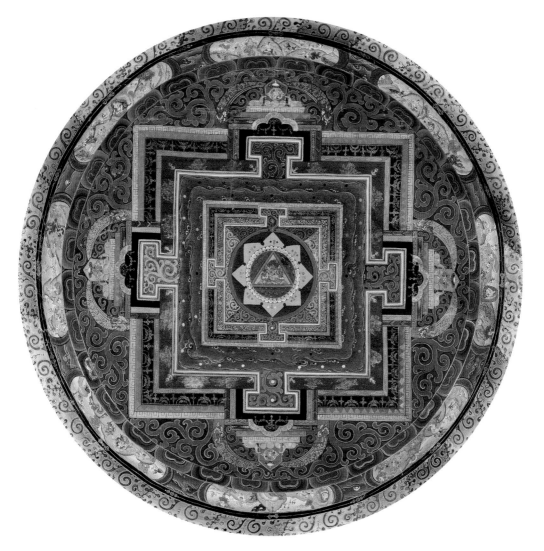

China

Spring Landscape in Rain

The skeletal trees, the misty spaces, the overwhelming atmosphere of peace and calm in nature: any Chinese painter of the last millennium would sense that a kindred spirit was at work here. Yet so too would any modern western artist from the age of Impressionism to the present day. This ravishing work by the Beijing-born Bai Xueshi (b. 1915) takes ancient forms and triumphantly renews them. Pictures such as this have brought Chinese art to a new and eager audience worldwide.

The idea of the individual artist 'communing with nature' and finding inspiration in a setting of this sort, empty of people, is actually a comparatively recent one in the western tradition. Prior to the late eighteenth century uncultivated country was widely viewed as wasteland, literally a waste of land. The simplicities of rural life, the pastoral existence, might have been envied by city-dwelling artists since Classical times, but not till Wordsworth and the romantic poets was wild nature celebrated for its own sake. In China, however, it has been part of Tao tradition since the early first millennium BC if not before.

CREATED

China

MEDIUM

Ink and colour on paper

SERIES/PERIOD/MOVEMENT

Twentieth century

Bai Xueshi *Born 1915 China*

China

Magpie on an Autumn Maple Branch

The spare simplicities of classic Chinese tradition inform every brushstroke of this beautiful hanging scroll, which was painted by Xie Zhiliu (1910–97) in 1976. But the painting also has a distinctly modern freedom and is open to outside influences, especially those of twentieth-century western art.

The Shanghai artist Xie Zhiliu belonged to a generation of Chinese artists who witnessed political tumult and confusion on an overwhelming scale. From civil war and Japanese invasion through to that national nightmare the 'Cultural Revolution' (1966–68), China's modern history has been broadbrush stuff, heroic and hellish. Twenty million or more died in the famines that accompanied the Great Leap Forward from 1958 and creative artists have been among those bearing the brunt of political repression. Yet at the same time, through all the tumult, the place of the painter in Chinese society has endured as have the age-old principles of Chinese art. Perhaps even more important has been the artist's relationship with nature, a haven of peace and continuity in a time of often violent change.

CREATED

China

MEDIUM

Ink and colour on silk scroll

SERIES/PERIOD/MOVEMENT

Twentieth century

Xie Zhiliu *Born* 1910 China

Died 1997

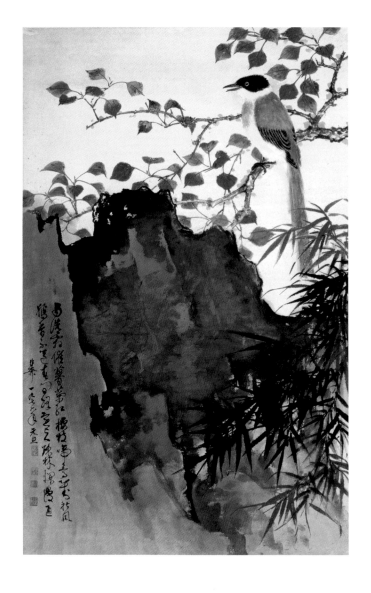

China

Red Lotus

Never have lovely lotus flowers seemed more menacing than in this dramatic 1992 work by Yuan Yunfu, who was born in Nantong, China, in 1933. Two blooms, beautifully rendered, stand out against a dark and disturbing background; the right-hand flower has been ravaged by who knows what violence. Most famous as a public artist, Yuan Yunfu has created huge murals on some of Beijing's most important buildings, yet he has also created more private works of quite extraordinary power and poetry.

That duality is hinted at here in the unexpected intimacy of the portrayal of the flowers in the foreground: the right-hand one in particular, at least what is left of it. With its yellow stamens hanging down, captured in perfect but unfussy detail, it draws and then holds the eye in fascination. Damaged though it may be, it seems the still centre in a raging storm: this picture encapsulates the spirit of a paradoxical painter.

CREATED

China

SERIES/PERIOD/MOVEMENT

Twentieth century

Yuan Yunfu *Born 1933 Nantong, China*

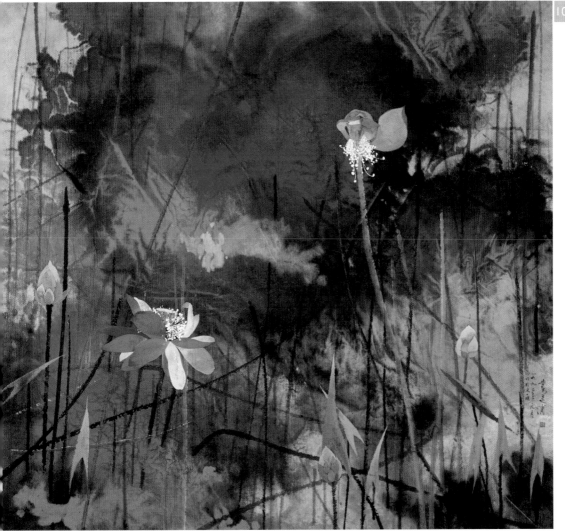

China

The Mist of Huang Mountain

This almost eerie landscape was painted by Zhang Daqian (1899–1983). Born in Sechuan, he drew inspiration from the mountains of his native north, yet he also travelled widely in Europe and North America and studied the great masterpieces of modern western art. The distinctive 'splashed' style he developed was strongly influenced by these examples and allowed him to develop an interest in plane surfaces, which Chinese art had not shown before.

Previous painters over many centuries had played with line, misty washes and other devices to indicate depth and distance, but most of all they had achieved their effects by the recessional placing of objects in open space. Empty 'gaps' often appear in Chinese pictures, one of their most alien features in western eyes. Their main function is to provide that sense of recessive distance. As in a western work, no area of this picture has been left untouched. The result is at once a wild landscape and a symphony in paint. Zhang Daqian's is an artistic idiom that, while authentically Chinese, speaks with great directness to the viewer in the West.

CREATED

China

SERIES/PERIOD/MOVEMENT

Twentieth century

Zhang Daqian *Born* 1899 China

Died 1983

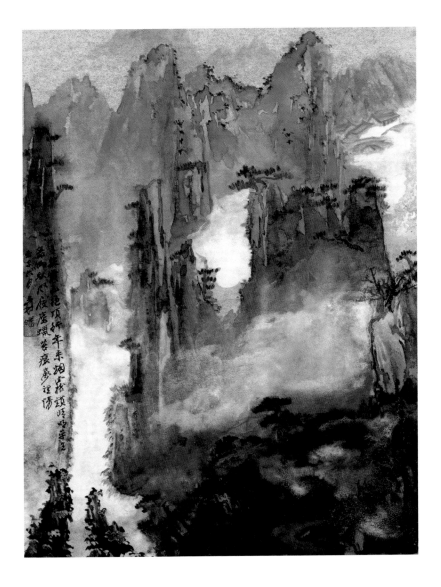

Vietnam

Lovers in the Garden

© Estate of Vu Cao Dam/Christie's Images Ltd

Most westerners, when they think of Vietnam, think of the country's war with America and there is no doubt that this left a lasting mark. Of much greater cultural significance, however, is the century the country spent as part of the French colony of Indochine. The great painter Vu Cao Dam (1908–2000) always freely acknowledged the influence of traditional Chinese and Khmer (Cambodian) art. Yet his first love and his first models were European, from the French Fauves and Italian Primitives to Gauguin, Van Gogh, Matisse and Modigliani.

Vu Cao Dam took to painting in oils at much the same time as he discovered the work of Marc Chagall, his neighbour in southern France from 1952. Chagall's influence is clear in this work, but it is only one of many. "Today," said Vu Cao Dam before he died, "there's a search for a multiracial, multicultural expression and I think I'm the first to have tried to reconcile... my Asian roots with my idea of what I understand of the Western masters".

CREATED

Vietnam

MEDIUM

Oil on canvas, laid down on board

SERIES/PERIOD/MOVEMENT

Twentieth century

Vu Cao Dam *Born* 1908 Vietnam

Died 2000

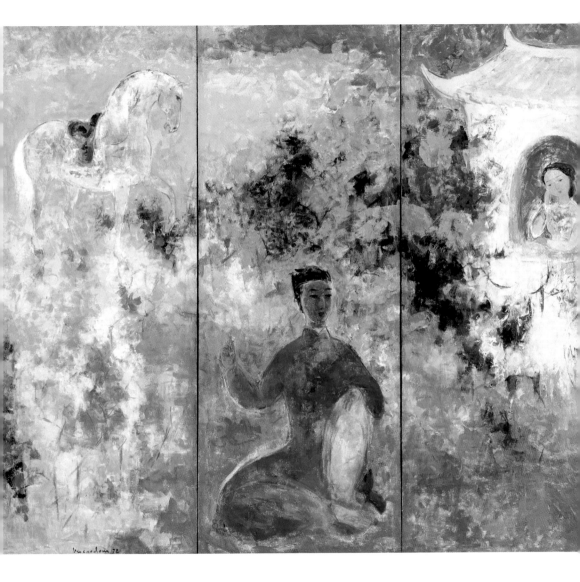

China

Lotus Scroll

Another work by Zhang Daqian (see *The Mist of Huang Mountain* on page 102), this painting sets the delicate blossom of a lotus flower against a background of grey foliage. The broad veins of the big, fleshy leaves behind obviously echo those of the pink petals but will they set the flower off to advantage or overpower it? There's a comparable counterpointing of lines and dots, the sweeping curves of the leaves and petals set against the pinpoints on the flower's stamen and stalk, and here too, there is a striking contrast of dull black and a delightful pink.

Whilst doing homage to traditional techniques, Zhang Daqian's 'splashed ink' method makes experimental play, not just with colour, but also with the use of space and with plane surfaces. The natural theme has been a timeless given in Chinese art. There could be no more ancient eastern symbol than the lotus flower, here, however, both have been renewed. As so often before we see an Oriental artist's strong sense of his ancient inheritance not curbing but setting free his sense of adventure.

CREATED

China

MEDIUM

Ink

SERIES/PERIOD/MOVEMENT

Twentieth century

Zhang Daqian *Born* 1899 China

Died 1983

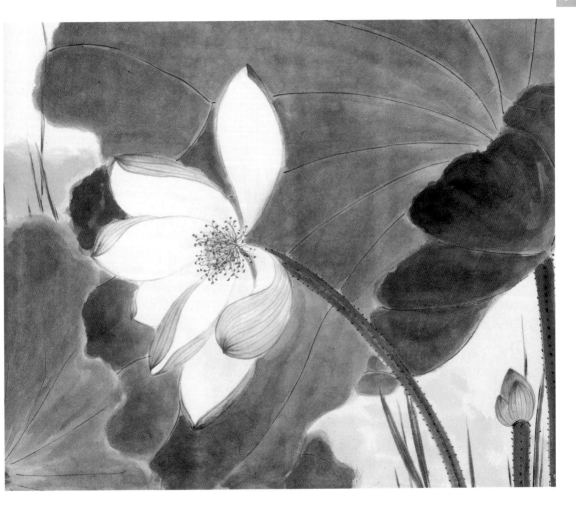

Asian Art

Ceramics

China

Longquan celadon jar and cover

In 1127, Song dynasty China was invaded, its northern territories lost to nomadic invaders from the steppe, causing the imperial court to leave Kaifeng and flee south. Setting up home in Hangzhou, they established a new capital there: the 'southern Song dynasty' would last until 1279. It was a time of change in art, the tastes and traditions of the south coming abruptly to the fore. From the kilns at Longquan on the Ou River came splendid ceramics, heavy and strong, whose thick glazes, green and sheeny, resemble jade.

Southern Song potters, recorded by a Chinese writer just a generation or two later, were celebrated for their celadon. 'Its pure body of exceptional fineness and delicacy, its clear and lustrous gaze, have been prized ever since.' He was not exaggerating: examples have been found in which the porcelain was indeed so 'fine' that the glaze turned out to be thicker: modern collectors have prized it just as much. This pot was probably made for export: the ornamental figures, a telltale sign, would have doubled as attachments for loops to keep the lid on.

CREATED

Southern China

MEDIUM

Celadon-ware

SERIES/PERIOD/MOVEMENT

Southern Song dynasty, 1127–1279

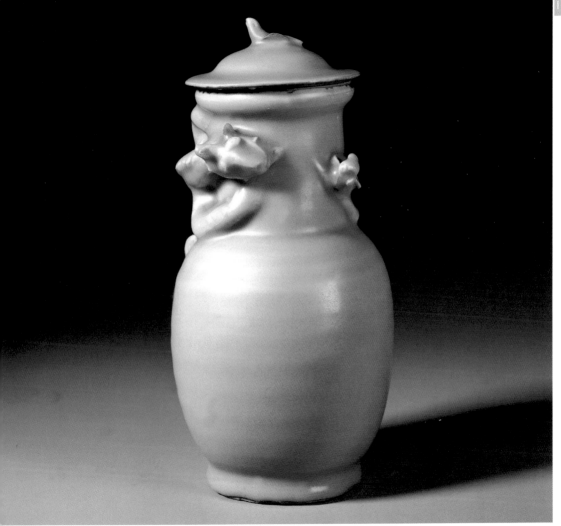

China

Junyao deep bowl

This splendidly lustrous bowl was made in China in the twelfth century, during the reign of the Jin dynasty. Its Turkic rulers had displaced the Song from the northern areas of their empire but, much as the Mongols would do a hundred years later, had maintained many of their cultural traditions.

'Celadon', the name now given to this blue-green glaze, is a modern European coinage, believed to come from 'Céladon', the name of the green-clad shepherd character in a famous seventeenth-century French play. Despite those picturesque associations, this distinctive ceramic type could be used to produce some rather more striking effects. The splash of copper painted into the glaze had been a signature of northern Song ceramics, although southern potters were now producing very different ware. The craftsmen of the time seem to have enjoyed the little random grace note it gave to an otherwise perfectly regulated form. In its sheer outrageousness, it strikes a chord with the modern viewer accustomed to the abstract art of the twentieth century.

CREATED

Northern China

MEDIUM

Celadon-ware

SERIES/PERIOD/MOVEMENT

Jin dynasty, twelfth century

Korea
Inlaid celadon ewer

In ancient times, as in the twenty-first century, Korea was a divided pensinsula: three kingdoms jostled for supremacy over centuries. In the second half of the first millennium, Silla, in the south, was the dominant power politically and culturally, lording it over Paekche, and the kingdom of Koguryo in the north.

Towards the end of the tenth century, Koguryo's Koryo dynasty came to power and conquered their southerly neighbours to create a unified Korea. For all their military strength, it was an unaccustomed situation; the dynasty was widely resented outside its home kingdom and its hold on the country was never quite secure. Yet despite ceaseless politicking and popular unrest at home, relations with the outside world were harmonious and there was a brisk exchange, both commercial and cultural, with Song China. Chinese ceramic techniques were widely adopted, with enthusiasm and with such success that by the twelfth century, when this elegantly inlaid ewer with cranes and clouds was made, they were exciting admiration in China itself.

CREATED

Korea

MEDIUM

Celadon-ware

SERIES/PERIOD/MOVEMENT

Koryo dynasty, twelfth century

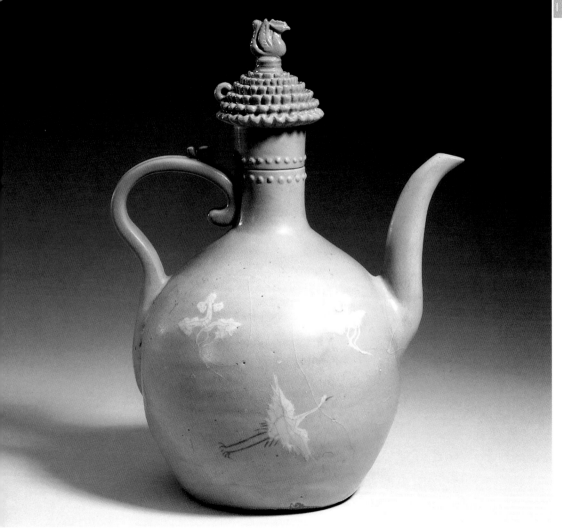

Korea
Egg cup

This charming little egg cup in the form of a lotus flower is another example of celadon ware from twelfth-century Korea. From its delicate flower fluting to its geometrical incisions and inlaid forms, its maker lavished love and attention on it. The lotus is a popular symbol in Korean Buddhism as in other eastern religions: its roots in the mud, it strains upwards towards enlightenment. It opens up its petals as the human heart does to divine grace and, of course, it's a thing of wondrous beauty in its own right.

Buddhism had come comparatively late to Korea: the Koryo dynasty was frank in its admiration for all things Chinese and religion was a part of the cultural package. It is hard to resist the feeling that the air of innocent joyousness about this lovely piece testifies to the freshness the new faith still had in the country at the time.

CREATED

Korea

MEDIUM

Celadon-ware

SERIES/PERIOD/MOVEMENT

Koryo dynasty, twelfth century

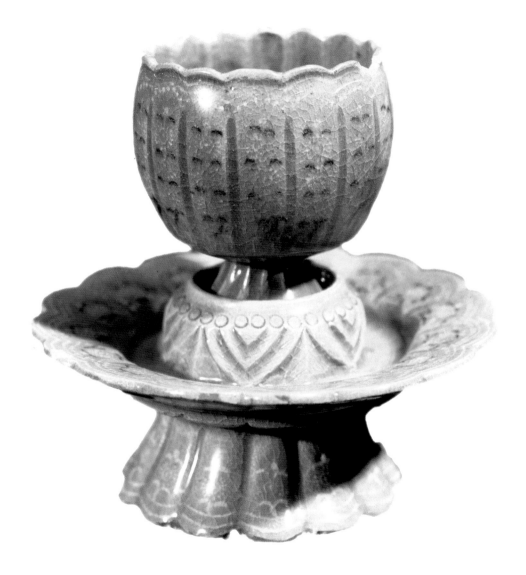

China

Stoneware vase

Creamy white in colour, painted with dark patterning and then finished with a transparent glaze, this sort of stoneware was produced at the Song dynasty's imperial kiln at Tzu-Chou, near the mouth of the Huang He (Yellow) River in northern China. Ceramics manufactured here tended to be a good deal more exuberant than the austere pottery that is normally associated with the northern Song.

This vase is characteristic: the flower and foliage are at once stylized in their symmetry and full of energetic life as is the butterfly, whose antennae chime with the decorative flicks around the shoulder of the vessel. For all the artistry of its ornamentation, though, this piece retains the simple, unfussy look that has ensured Tzu-Chou ware's irresistibility to collectors in modern times. North China stonewares set the ceramic tone throughout the century and a half of the northern Song dynasty from AD 960. After 1127, the creative centre shifted southwards and work from Hangzhou and Longquan led the way.

CREATED

Tzu-Chou, northern China

MEDIUM

Stoneware

SERIES/PERIOD/MOVEMENT

Northern Song dynasty, AD 960–1127

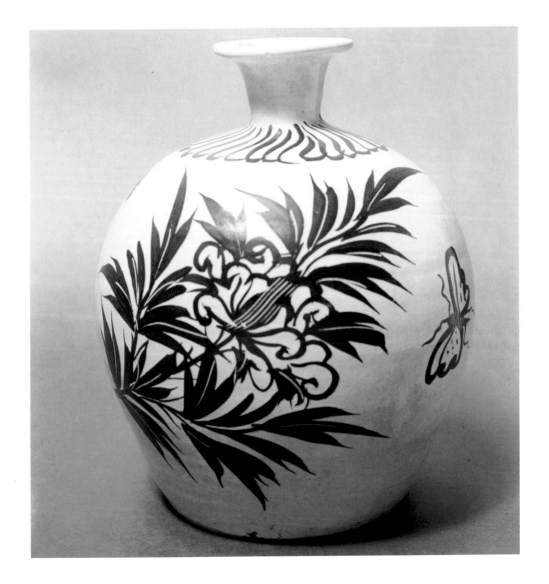

China

Pear-shaped vase

The basic blue and white opposition has been central to ceramic design through much of modern history, coming to Europe through the China-inspired potteries of modern Delft. Key to its creation is the use of underglaze painting (in copper-based pigments) on porcelain, which was first done by Chinese craftsmen under the Yuan dynasty of the fourteenth century. This lovely vase is an early example, yet still wonderfully accomplished and well judged, strikingly chaste, for all the rich, elaborate decoration. A tinted glaze gives the 'white' background just a hint of blue.

The *yuhuchunping* pear-shaped style of vase was particularly popular during this period, no doubt because it gave so much scope for the decorative craftsman's art. Often, as here, the ornamentation was divided up into three distinct (though clearly complementary) zones, with tight friezes round the neck and base and a more expansive design around the sloping shoulders. In this case the topmost design is starkly geometric; the central pattern foliate, more obviously natural looking; while the one round the base is a clever combination of the two.

CREATED

China

MEDIUM

Glazed ceramic

SERIES/PERIOD/MOVEMENT

Yuan/early Ming dynasty, late fourteenth century

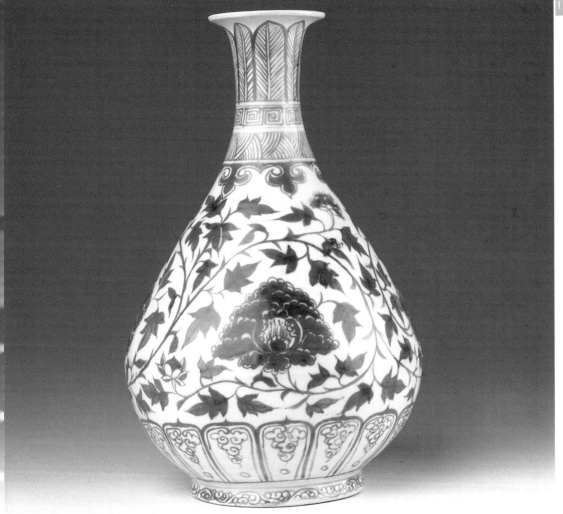

China

Four Accomplishments stem cup

Named after K'ung Fu-Tzu (or Confucius) (551–479 BC), Confucianism has often been misunderstood in the West: it was not so much a religion as a code for living. The highest duty of the young man, for Confucius, was to be of service to his society, a support to its government and a help to its other members; it was incumbent on him to equip himself for that role in any way he could.

'Four accomplishments' were required to form the young scholar's mind according to Confucian tradition: calligraphy, music, painting and the game of *Go*. Two of the four are evident in this charming cup. *Go*, a complex board game that was thought to foster farsightedness and strategic thinking, can be seen being played by the group on this charming cup. 'Painting' in the form represented here is actually five-colour enamelling, one of many artistic accomplishments of the Ming dynasty, it reached its height during the reign of Jiajing (1522–67) when this attractive item was made.

CREATED

China

MEDIUM

Enamelled ceramic

SERIES/PERIOD/MOVEMENT

Ming dynasty, sixteenth century

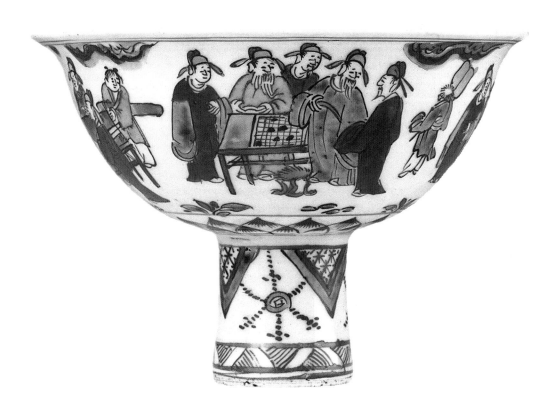

Vietnam

Kneeling Attendant ewer

A play in porcelain: the kneeling attendant proffers a pitcher that is itself the outlet of the larger ewer that the entire exquisite piece comprises. The signs of Chinese influence are clearly to be seen in the lovely cobalt colouring and the dexterous design, but this item was actually made in Champa in the central highlands of Vietnam, around the end of the fifteenth century.

A prosperous kingdom had existed here since the second century AD, but by now it was overshadowed by the more northerly Dai Viêt state. Champa has generally been famous for its extravagant Hindu statuary in stone and wood, but these great works belong to an earlier time. That great Hindu kingdom was pretty much in the process of collapse at the time when this artefact was made. Yet the rise of Dai Viêt was academic in a sense, since the whole of the country we now know of as Vietnam was at this time coming under Chinese domination, from a mercantile point of view, if not from a military one.

CREATED

Champa, Vietnam

MEDIUM

Porcelain

SERIES/PERIOD/MOVEMENT

Late fifteenth century

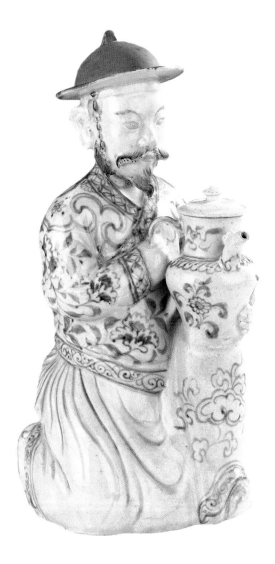

China

Cloisonné basin

© Christie's Images Ltd

The use of *cloisons*, medallions of opaque glaze demarcated by soldered metallic wires was reported in China as early as the fourteenth century, although no examples of this vintage have been found. The technique went on being refined until the eighteenth century, but by that time all the aesthetic life had been squeezed out of it by exhibitionistic virtuosity. Made in the sixteenth century this stunning basin shows the art of *cloisonné* enamelling at its height: the ceramic art aspiring to the condition of jewellery.

This item clearly shows how the accomplished and imaginative craftsman could make strengths of the medium's obvious limitations: the use of lozenges of molten glaze and metal wires militated against anything too soft or subtle in either colour or design. Artistic fortune favoured the bold in other words: hard-edged mosaic patternings and clearly outlined shapes like the procession of brightly garbed officials and generals in the bottom section of this beautiful basin, and the perfect little flower forms around its rim, each one a tiny enamel masterpiece.

CREATED

China

MEDIUM

Porcelain with *cloisonné* enamelling

SERIES/PERIOD/MOVEMENT

Ming dynasty, sixteenth century

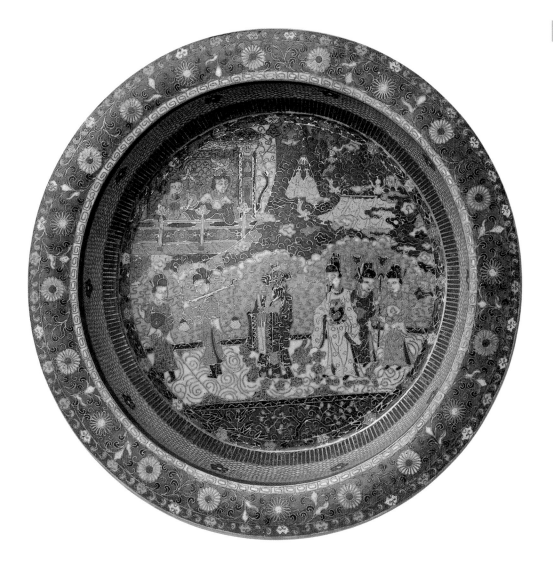

China

Garden seats

The idea that furniture might be made in ceramics strikes the westerner as odd, yet for outdoor use in particular the practice had much to offer. Seats of porcelain were weatherproof and although admittedly brittle, they offered more rigidity than wood or bamboo. Just so long as they were carried carefully and could be kept safe from running children and other hazards there was no reason why they should not last for ever.

Best of all they could be sumptuously decorated, like these barrel-shaped seats made in Ming dynasty China, enamelled in the famous *Fa-hua* style. In a development of the *cloisonné* technique, the craftsmen of Hebei, the region around Beijing, did wonderful work in splendid turquoises, blues and yellows. The lacquer-like gloss and the boldness of the colours here should not cause us to overlook the beauty of the figurative design in which stately egrets are set amongst extravagantly oversized flowers.

CREATED

China

MEDIUM

Enamelled porcelain

SERIES/PERIOD/MOVEMENT

Ming dynasty, 1368–1644, *Fa-hua* style

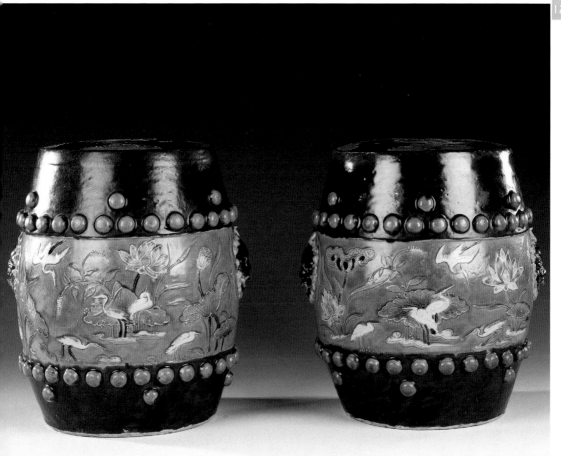

China

Kinrande ewer

A fine brocade of gold on a rich red background is the mark of the rare *kinrande* porcelain, the co-product of Chinese supply and Japanese demand. The style came into being in the sixteenth century under the Ming dynasty, but the Chinese cultural context is to a degree irrelevant given that this stunning ware was made overwhelmingly for export to the courts of the Shoguns. This shapely ewer is characteristic: it feels luxurious simply looking at it and *kinrande* was among the most prestigious pottery ever made.

This piece is not just a status symbol, but a beautifully conceived, even witty, work of design, stupendously well executed: the not-quite-symmetrical arrangement of handle and spout seems almost to tease the viewer. The pear-shape of the body is lent extra emphasis by the large and lustrous inverted-heart lozenge of red, outlined in blue, and once again complementary designs run around the neck and base.

CREATED

China

MEDIUM

Porcelain with gold brocade

SERIES/PERIOD/MOVEMENT

Ming dynasty, sixteenth century, *kinrande* style

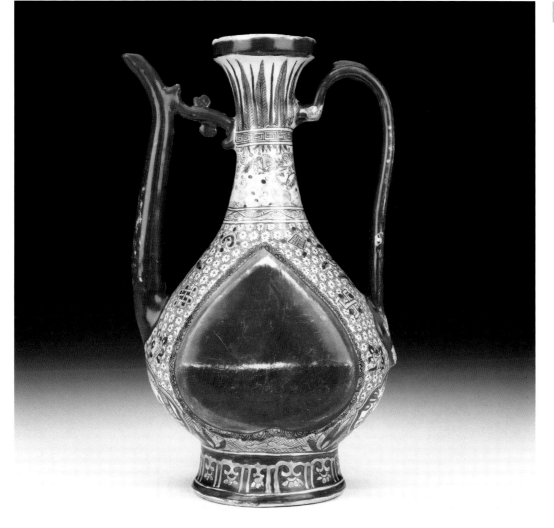

China
Turquoise jar

A vessel fit for an emperor, this turquoise jar with gold-bound rim was made in the sixteenth century for use in the imperial palace in Beijing. Ming ceramics have been justly celebrated, mostly because European tastes were so seduced by the delicately decorated porcelains produced at this time, but there was rather more to the era artistically than exquisite 'china'. This beautifully shaped jar is just about as opulent as a work in clay could be, its surface a burnished blue of thrilling intensity.

The Ming period was a crucial time for the Chinese imperial court as an institution. After the fall of the Yuan dynasty in 1368 it had briefly been moved back southward to Hangzhou. In 1403, however, Yong Le made the Mongol city of Beijing the capital again, and work began on the construction of the Forbidden City. In hindsight this can clearly be seen as a conscious attempt to reinvest the emperor with mystique and to reinforce the imperial cult in China. The more splendid his surroundings, the more godlike his status: the emperor was only as impressive as his possessions.

CREATED

China

MEDIUM

Porcelain with gold-bound rim

SERIES/PERIOD/MOVEMENT

Ming dynasty, sixteenth century

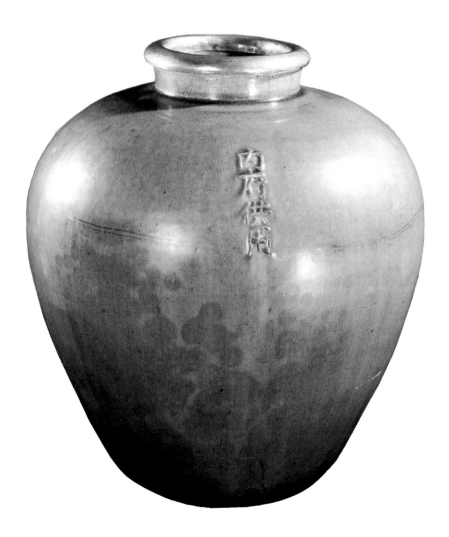

Korea

Dragon jar

Having brought the manufacture of celadon ware to something like perfection over several centuries, the Koreans were ready for a change. They fell in love with the first white porcelain shipped north from China in the early days of the Choson dynasty (late fourteenth century). So much so, indeed, that for a long time their preference was for plain white pieces: the sheer purity of the porcelain enraptured the ruling caste and the common 'herd' were even prohibited from owning them by law.

The sense that white porcelain was a thing apart would never quite disappear. In the early nineteenth century the distinguished scholar Yi Kyu-gyong commented that, 'The greatest merit of white porcelain lies in its absolute purity. Any effort to embellish it would only undermine its beauty'. For the most part, however, such absolutism was set aside and over time the Koreans acquired a taste for more elaborately decorated vessels. This fine jar dates from the early seventeenth century.

CREATED

Korea

MEDIUM

Porcelain with iron decoration

SERIES/PERIOD/MOVEMENT

Choson dynasty, early seventeenth century

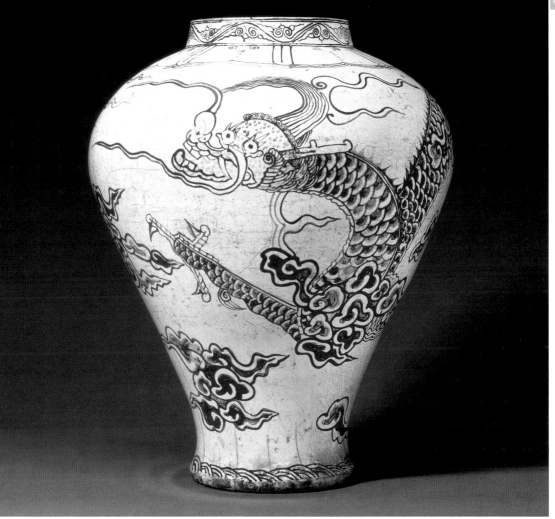

Japan
Ewer and basin

In recent times Japanese design has been associated with 'Zen' minimalism, yet this has been a historical exception, not the rule. Ceramics certainly do not come much more luxurious than this ornate ewer and basin in black and gold, made by an unknown craftsman at some point in the seventeenth century.

It is very much in the over-the-top spirit of the *Ukiyo-e* tradition, the ceramic equivalent of all those gorgeous geisha and actress prints. The stunningly executed mythic landscape to be seen within the richly stylized vegetal border of the basin (and repeated on the body of the jug) may not immediately resemble those palace pleasure gardens we are used to seeing in *Ukiyo-e* pictures, but the sense of opulence, even decadence, is the same. The accent, as in the works of artists such as Iwasa Matabei or Kitagawa Utamaro, is on extravagant elegance, style for the sake of it and conspicuous consumption.

CREATED

Japan

MEDIUM

Black and gold glazed ceramic

SERIES/PERIOD/MOVEMENT

Edo period, seventeenth century

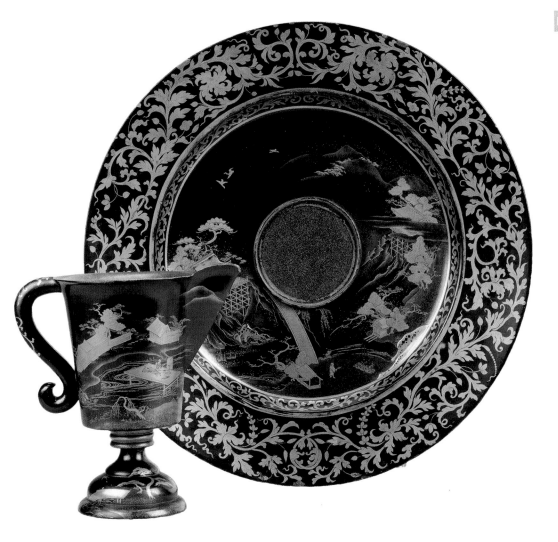

China
Guanyin

Originally a Buddhist *bodhisattva*, Guanyin came to be worshipped in China and Southeast Asia as a goddess of compassion: 'she who hears the sorrows of the world'. She is thus beloved in much the same way as the Virgin Mary, *Mater Misericordiae* ('Mother of Mercy'), in the western Catholic tradition, as innumerable statues throughout the region testify. This one is out of the ordinary, though, made in the superlative porcelain of the Dehua kilns, it is believed to date from 1679.

Dehua lies in Fujian province, not far from the coastline looking eastward to Taiwan. The ceramics made here were marvellous even by Chinese standards. Known as *Blanc de Chine* in Europe, where they were highly sought-after, they were prized for their lovely ivory sheen and for the delicacy and expressiveness with which they were worked. Guanyin figures like this one were a speciality: the fine features, the serene expression, the flowing robes gave ample scope for the virtuosity of the Dehua craftsmen.

CREATED

Dehua, southern China

MEDIUM

Dehua porcelain

SERIES/PERIOD/MOVEMENT

Ming dynasty, 1679

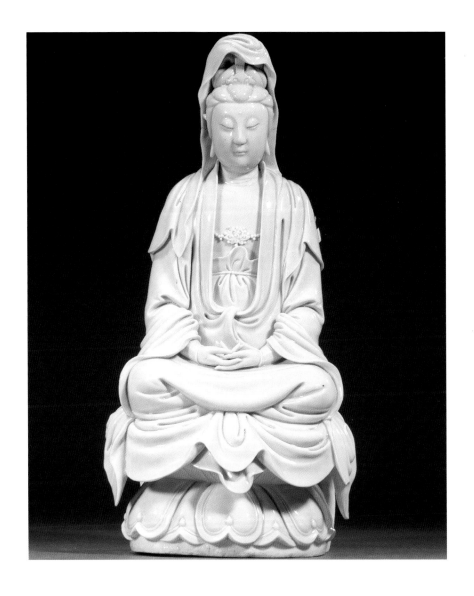

Japan
Imari vase

Ceramic goods of many kinds passed through the Japanese port of Imari, handy as it was for the manufacturers at Arita. In the West, however, the name 'Imari' has been given to a distinctive type of porcelain that was exported to Europe in considerable quantity in the seventeenth century. In considerable quality too: this captivating vase is typical, its dazzling white set off by gleaming gold, warm reds and lustrous blue. This last was an underglaze; the other colours were applied afterwards and the overall effect is ravishing.

After the overwhelming first impressions, it's a piece to be enjoyed at leisure, the striking elegance of the court scene on the side being only the start. Around that are relatively naturalistic flowers in a more stylized foliate design; above mythic forms in blue and red stand out against a white background. The neck is circled by a gorgeous collar of warm reds and golds with just a little blue, and the base is decorated by further flowers and geometric forms.

CREATED

Japan

MEDIUM

Imari porcelain

SERIES/PERIOD/MOVEMENT

Edo period, seventeenth century, Imari style

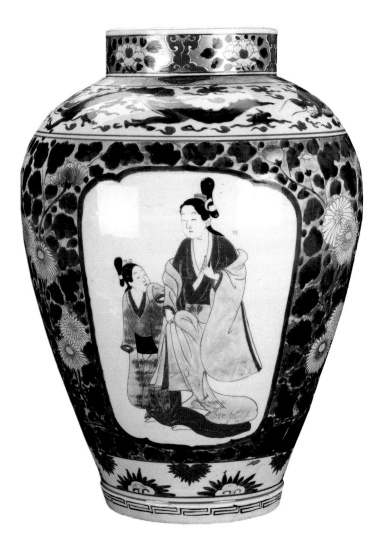

Japan
Ko-Kutani dish

While the Europeans were buying up Imari as fast it was made, pottery of a much more modest style was being made for the domestic market in the mountain village of Kutani. Under the patronage of the local warlord, Maeda Toshiharu, an industrial venture began here in the mid-seventeenth century after the discovery of reserves of good-quality clay.

So it was that ceramics began being made in imitation of the *wucai* ('five colours') enamelled style of sixteenth-century china. In truth the Kutani craftsmen were not equipped to match these models: their ware was relatively crude, its surfaces uneven, their glazes thick and coarse. Yet, naive as it was next to Imari, Ko-Kutani ('Old Kutani) is prized by the Japanese themselves more highly than any other antique ware. What it lacks in sophistication and refinement, it makes up in vibrant freshness and in the deep intensity of its distinctive golds and greens.

CREATED

Japan

MEDIUM

Glazed Ko-Kutani

SERIES/PERIOD/MOVEMENT

Edo period, seventeenth century, Imari style

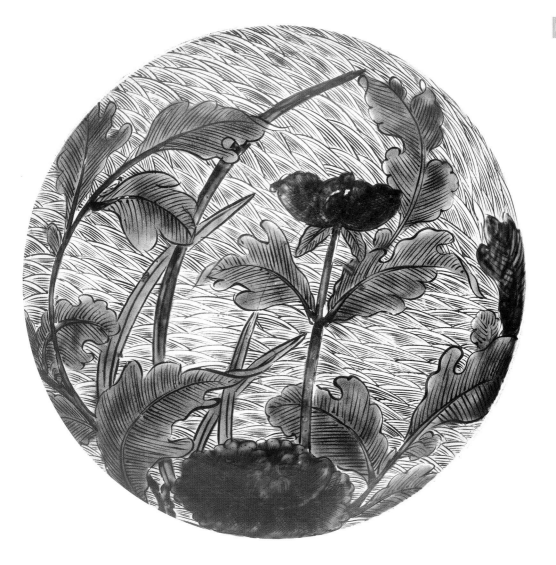

China

Red lacquer bottle

Made from the resinous sap of a tree, *Rhus vernicifera*, lacquer was first used in China under the Zhou dynasty around 1000 BC. It raised wooden items, such as furniture and trays, to jewelled splendour. The tradition of carving in lacquer reached its height in the seventeenth century when this exquisite bottle was made. Since sixty to a hundred layers of lacquer had to be applied to a form and allowed to dry for a day or more before enough thickness for carving was achieved, this medium tested not only ingenuity but also perseverance.

Red lacquer, and red in general, was especially fashionable during the Ming period because the word for the colour, *zhu*, punned with the name of the dynasty, Zhu Yuanzhang. Peonies such as those carved with such wondrous artistry on this bottle were perennially popular in Chinese culture. All-round auspicious symbols, they were associated with everything from spring, love and beauty to material prosperity and good luck.

CREATED

China

MEDIUM

Lacquer

SERIES/PERIOD/MOVEMENT

Late Ming dynasty, seventeenth century

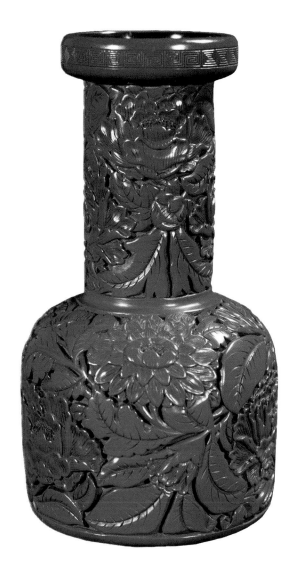

Japan
Imari tureen

The greater the surface area, the more room for decoration, making this bulbous tureen with its cover the perfect vehicle for the painter's skills. Increasingly as the seventeenth century wore on and the original Shoki-Imari gave way to what is now known as Ko-Imari ('Old Imari'), this famous ware was designed with western tastes explicitly in mind. The accent was on opulence as these were always going to be bought as luxury items, yet stylistic integrity was still miraculously maintained.

There is just a suggestion of the Buddhist wheel, the symbol of death, rebirth and eternity, about the main design, which would not be entirely out of keeping with its Japanese background. However, the emphasis is very clearly on exuberance and floral fun. While all the flowers are obviously stylized, there's a clear gradation from the boldly geometrical to the almost natural, and the almost natural seems to recede, giving an uncanny sense of three-dimensional depth.

CREATED

Japan

MEDIUM

Enamelled Imari

SERIES/PERIOD/MOVEMENT

Edo period, seventeenth century, Imari style

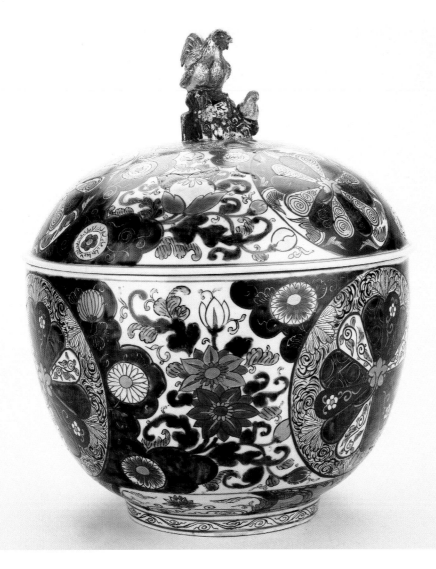

China

Bowl with blossoms

'Peach bloom' is the name for the lovely pink glaze used here, perhaps made with a mixture of copper and lime, so it is appropriate enough that this bowl should be so beautifully patterned with blossoms. It was made in Guangzhou (Canton) during the reign of Kangxi (1662–1722), the second emperor of the Qing or Manchu dynasty. By this time the seaport city was coming to be China's main gateway to the outside world, and the fashion for chinoiserie was sweeping sophisticated Europe.

Kangxi had been more welcoming to western influences than any previous emperor, Kublai Khan apart, and he sponsored a series of surveys of his realms by Jesuit cartographers. The maps they made were partly a way of showing China to the West, but they also offered China a new way of seeing itself. Yet awestruck as he may have been by his visitors' know-how, Kangxi must still have taken comfort from the thought that a creation like this bowl would have been far beyond the expertise of European culture.

CREATED

Guangzhou (Canton), China

MEDIUM

Porcelain with peach-bloom glaze

SERIES/PERIOD/MOVEMENT

Qing dynasty, 1662–1722

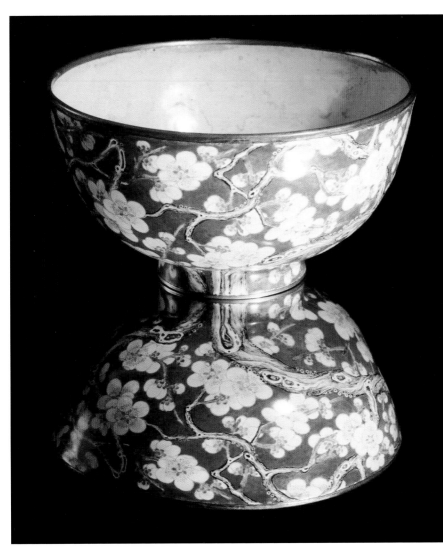

China

'Soldier' vases

Standing upwards of 130 cm (50 in) tall, you could almost fit a soldier inside them, but that is not how these 'soldier' vases' got their name. The vogue for massive porcelain pieces of this sort is said to have begun when Frederick William I of Prussia acquired some for his collection of fine china. Poland's Frederick Augustus I (or 'Augustus the Strong'), a fellow connoisseur and indeed a competitor, was so desperate to get them that he gave his rival 600 of his dragoons for 150 of these giant vases, hence the name.

It really is hard to overemphasize the extent of the craze for all things Oriental in eighteenth-century Europe. German *chinsercy* was every bit as strong as chinoiserie in France. Frederick II ('Frederick the Great') was practically to bankrupt himself in his attempt to grow silkworms on a commercial scale, and from 1710 European porcelain was being produced at Meissen. The history of Chinese ceramics in the eighteenth century is as much about western as Oriental tastes, so responsive had potters become to the demands of their export market.

CREATED

China

MEDIUM

Blue and white glazed porcelain

SERIES/PERIOD/MOVEMENT

Qing dynasty, 1662–1722

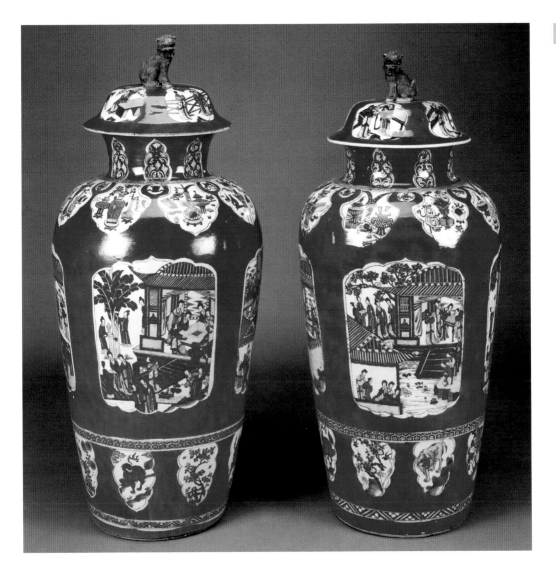

Japan

Imari *bijin*

© Christie's Images Ltd

The Japanese *bijin*, a 'beautiful woman', often a courtesan, was familiar in Europe from the *Ukiyo-e* printmaking tradition, and now you could have a bit of the 'floating world' in your European drawing room. Porcelain figures like these were exported in large numbers from the end of the seventeenth century. Eventually the figures were supplanted in respectable homes by the more innocent Meissen shepherdess (herself made of Oriental-style porcelain, of course). Yet the *bijin* still found favour with self-consciously sophisticated collectors after something a little more exotic and risqué.

Not that figures of this sort were without admirers in Japan itself, although here *fushimo-ningyo* and other clay dolls were to prove more popular. These were porcelain figures that could be dressed in specially made clothes of fabric, like modern dolls; they were popular both with children and adults. Little children, of course, had dolls they could dress and undress in play and grown-ups favoured ornamental figures. Some had large collections and there were themed series, from ancient gods and legendary heroes to cute little boys and girls.

CREATED

Japan

MEDIUM

Imari porcelain

SERIES/PERIOD/MOVEMENT

*c.*1700, Imara style

China
Plate with theatrical scene

© The Art Archive/Musée Guimet, Paris/Dagli Orti

It is ironically the case that the European craze for chinoiserie had a strongly westernizing effect on Chinese art, or at least on those areas of artistic output that were most closely tied up with the export trade to the West, of which ceramics was probably the most important. One result was a much freer pictorial style that, whilst recognizably Chinese in origin, was quite alien to the traditions of ceramic art. This depiction of actors in performance typifies the new approach, dating from the reign of Kangxi (1662–1722).

China's theatrical tradition has been strong, though it has made less impact in the West than has Japan's *Noh* drama, which attracted a great deal of attention from European poets and playwrights like W. B. Yeats in the early part of the twentieth century. One problem has been the trajectory travelled from the informal, freely acted, relatively realistic adventure and comic plays of medieval times to the rigid formality of the Peking Opera. Although it is not quite the opposite of what has happened in western drama over the same period, it comes close.

CREATED

China

MEDIUM

Glazed ceramic

SERIES/PERIOD/MOVEMENT

Qing dynasty, 1662–1722

Japan
Kakiemon four-lobed dish

Sakaida Kakiemon was reputedly born towards the end of the eighteenth century: he was to be the founder of a (so-far) thirteen-generation ceramic dynasty. One of the first Japanese potters to succeed in making white porcelain, which was a difficult art only recently introduced from China, he established a kiln at Arita in Kyushu. He also succeeded in finding a way of applying enamel overglazing in the Chinese way, and this gave his wares a real head start over the competition.

Kakiemon porcelain was one of the leading 'brands', both domestically and overseas: Kakiemon is said to have been the first manufacturer to sell his ceramics in Europe. Although Imari would become the famous 'name', Kakiemon ware continued to sell well and often what was sold as Imari was actually Kakiemon in any case. The two are indeed similar, yet there are important differences. Kakiemon ceramics tend to look quieter and less crowded in their design. Also, Imari blue enamel was painted on to the pot before it was glazed and the other colours added after; all Kakiemon colours were overglazes – this was their 'feature'.

CREATED

Japan

MEDIUM

Enamel overglazed porcelain

SERIES/PERIOD/MOVEMENT

c.1700, Kakiemon style

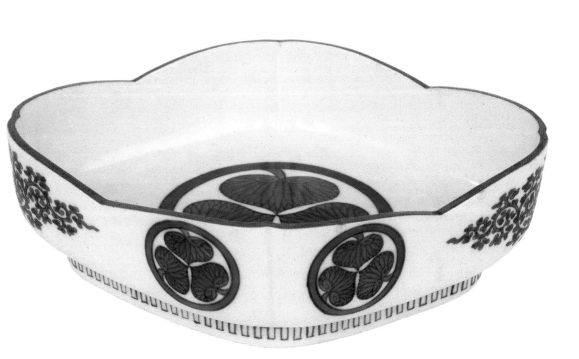

China
Blue and yellow moonflask

This near-spherical vase with its two tiny handles is of the kind known as the 'moonflask': it was made during the reign of the Qing or Manchu emperor Yongzheng (1723–36). The desire to cater to a European idea of Oriental taste that centred on extravagance and exoticism would eventually send the potters of this era plunging into self-parody. This vase teeters on the brink: almost too much in its Rococo exuberance, it is redeemed by the purity of its colours.

A certain sense of eccentricity seems to dog our perceptions of Kangxi's fourth son, Yongzheng, especially when he is seen in several of his portraits decked out in fashionable, even foppish, European dress. Yet such images may easily mislead, as modern scholar Amin Jaffer has pointed out: the emperor did this in a spirit not of slavish imitation but of masterful appropriation. It was, he suggests, his claim as Chinese emperor to 'universal sovereignty', an authority over both East and West.

CREATED

China

MEDIUM

Enamelled ceramic

SERIES/PERIOD/MOVEMENT

Qing dynasty, 1723–36

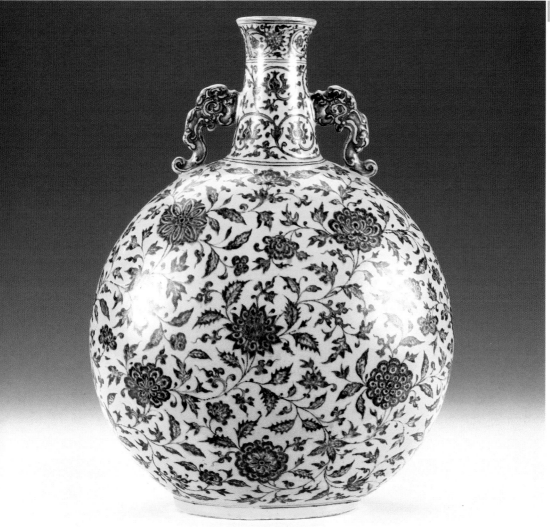

China

Lobed vase

This massive eighteenth-century vase has been treated with *ge*-type glaze to achieve the 'craquelure' effect so characteristic of vessels made during the days of the Song dynasty. Qing craftsmen in the reign of Yongzheng produced large numbers of items of this sort, their intention apparently more to show off their skills than to deceive potential purchasers. In fact, the 'distressed' antique-look crackleware created had been contrived from almost the very start: to begin with this may have been an accidental effect. By the time of the Song dynasty, however, the processes were sufficiently sophisticated for potters to avoid it if they really wanted: these glazes had actually been designed to 'crackle' quickly.

It is worth reflecting on the extraordinary alchemy involved in the creation of any porcelain. The 'clay' actually has to be pounded down from solid rock and then its impurities removed. Igneous in its formation, the mineral 'clay' then has to be fired a second time, as though being re-created in the heart of the earth.

CREATED

China

MEDIUM

Glazed porcelain

SERIES/PERIOD/MOVEMENT

Qing dynasty, 1723–36

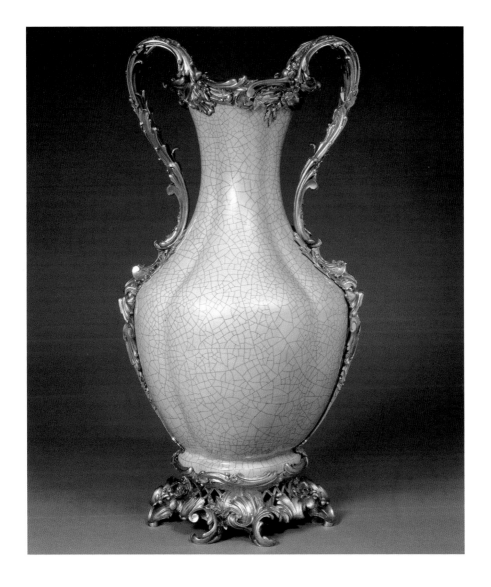

China

Glazed dish

The pure black background of this stunning dish lends a fathomless depth to its jade-green design: it dates from the time of the Qing (Manchu) emperor Qianlong (1736—95). Like the preceding reign, that of Yongzheng, this was a time of outrageous extravagance in Chinese ceramic design, a time when flamboyant virtuosity could at times court bathos. At their best, however, such pieces are saved by their boldness and, as here, by the thrilling intensity of the colours used.

This period of China's history was an exciting but in many ways confusing one, in which China was attempting to find an understanding of, and a relationship with, the outside world, specifically the western world. The export trade was important economically, but was also, the Chinese recognized, the conduit for an image of China and its people in the West. With European craftsmen working at the Qing court and adding to the cultural complexity by bringing in their outsiders' sense of China's exoticism, this was a time of what the scholar Mary Tregear has called 'chinoiserie in reverse'.

CREATED

China

MEDIUM

Ceramic with ground green glaze

SERIES/PERIOD/MOVEMENT

Qing dynasty, 1736—96

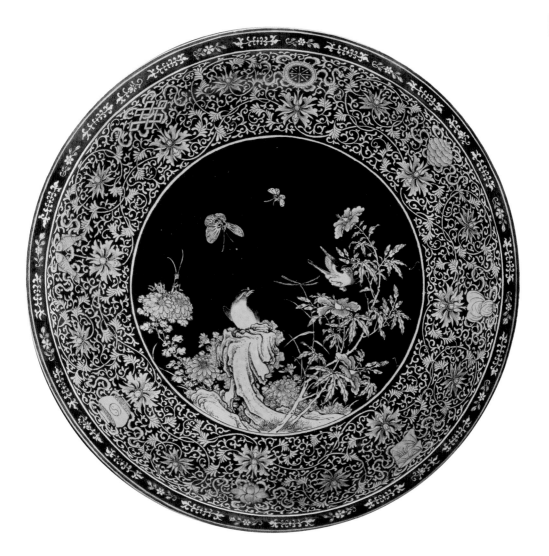

China

Double-gourd vases

The shimmering splendour of these extraordinary pieces shows the consummate skills at the disposal of the Qianlong-era craftsmen. The gold effects are astonishing, but just as striking to the western collector of the time would have been the more subtle and yet still-prominent use of pink enamel. This colour was still a relative newcomer to Chinese ceramic design, but during the eighteenth century there would be a boom in *famille rose* ('pink family') pottery produced for the export trade. Here, in fact, pink and gold are more closely related chemically than they may immediately appear, the roseate colour deriving from the infinitesimal traces of gold distributed 'colloidally' (dispersed in ultramicroscopic particles) through the enamel.

It was not just the presence of pink or gold that made the porcelains of this period so attractive to the European market: such touches just underlined their sense that these were ceramics of a very special kind. Along with showier innovations, general production methods had been slowly and steadily improving and these were technically some of the finest porcelains ever seen.

CREATED

China

MEDIUM

Enamelled ceramic with inlaid gilt bronze

SERIES/PERIOD/MOVEMENT

Qing dynasty, 1736–96

Korea
Five-clawed dragon jar

The coiling, snarling dragon surges with energy; the piece as a whole is symmetrical, still and its classic colouring suggests order and repose. That counterpoint is characteristic of Korean porcelain at its best: quiet, chaste and yet never for a moment dull. This fine jar was made in the eighteenth century, a time of comparative peace and prosperity, and, with the 400-year-old Choson dynasty still in power, of continuity.

Talk of 'nationalism' would be too strong, but Korean artists and thinkers of this time were certainly reassessing the influence of China over their political and artistic culture. It was far too deeply ingrained ever to be rejected completely, of course, yet in small ways Koreans wanted to assert their independence. Something of this may perhaps be seen in the design of the dragon here: its tendency towards abstraction is characteristic of the time. In hindsight, of course, we know that Korea would eventually be under the domination of Japan, but at this point that was still a hundred years away.

CREATED

Korea

MEDIUM

Blue and white glazed porcelain

SERIES/PERIOD/MOVEMENT

Choson dynasty, eighteenth century

China

A pair of pagoda lamps

These hexagonal lamps, shaped like traditional Chinese tower-temples were made during the Qing dynasty, in the eighteenth century. Their bases and elaborately two-tiered 'roofs' are richly ornamented in *cloisonné* enamelling, the knob at the top both a decorative flourish and a functional carrying handle. The connection between light and religious insight is common to many cultural traditions, but it has a special place in the Chinese scheme of things. Since ancient times a 'Lantern Festival' has been celebrated annually to mark the first full moon of the new year, with houses, temples and streets festooned with lanterns.

The pagoda temple is one of the most instantly recognizable Chinese forms there is, although ironically its ultimate origins lie in India. It can be seen as China's local variation on the theme of the Buddhist stupa, itself a representation of Mount Meru, the mountain of the universe. Yet a symbol may stand for many things: perhaps we should be considering not whether a lantern looks like a temple but whether the temple should be seen as a sort of stylized lantern.

CREATED

China

MEDIUM

Enamelled ceramic

SERIES/PERIOD/MOVEMENT

Qing dynasty, eighteenth century

China

Flambé-glazed bottle vase

The Qianlong seal mark impressed in this pear-shaped bottle vase dates it to the period 1736–96, but to the western eye it has a remarkably modern look. Flambé glazing was an eighteenth-century innovation: iron, copper or other metal-rich glazes were splashed on to vessels or poured over them from the top and allowed to dribble down. Hence the random uneven colouring overall and of the appearance, as here, of duller streaks where metallic particles have suffused the surface of the glaze in patches.

Artistic judgements will always and necessarily depend much on social fashion and subjective taste, but in purely technical terms Qianlong ceramics are unsurpassed. Crucial to that, it seems, was the figure of one man: T'ang Ying, the director of the imperial kilns in Qianlong's reign. Very much a 'hands-on' manager, he seems to have lived among his craftsmen and eaten, breathed, slept and generally lived their work. He experimented personally with all manner of new designs and firing techniques and with refinements to glazes, enamels and inlays, satisfied with nothing but the very best.

CREATED

China

MEDIUM

Flambé-glazed ceramic

SERIES/PERIOD/MOVEMENT

Qing dynasty, 1736–96

China

Buddhist-style lion dogs

This engaging pair was made with *cloisonné* enamel in the eighteenth century, but do lions have any business being so cute? Like other peoples, the Chinese from antiquity associated the king of beasts with bravery and strength and regarded it as a protector against all evil. In Buddhist lore, the lion, as the beast on which the *bodhisattva* of wisdom rode, acquired another layer of significance. Over time, the lion emblem was elided with that of the Pekinese dog to produce a good-luck symbol combining heroic strength with the charm of a favourite pet.

This easy and unselfconscious slide between high philosophy, deep spirituality and 'mere' superstition is one of the strangest aspects of the eastern mind from the western point of view, yet it makes sense given the complex history of the region. The chronological overlaying of one religious culture upon another has led, as much in Japan and Southeast Asia as in China, to a situation in which religion is at once pervasive and undogmatic. Syncretism, the combination of elements from a number of different faiths, has not been the exception but the rule.

CREATED

China

MEDIUM

Porcelain with *cloisonné* enamelling

SERIES/PERIOD/MOVEMENT

Qing dynasty, eighteenth century

China
Carved pear-shaped vase

The scene and surrounding decoration were incised into the damp porcelain of this vase before glazing and firing: the result is at once extravagant and understated. Crucial to the overall effect is the 'oxblood' glaze, a copper-oxide derivative much favoured by the potters of the Qing dynasty. Arguably it was 'over-favoured' as with so rich and warm a colouring, a little goes a long way, and cumulatively this style can become wearying. Seen individually, as here, however, the stupendous workmanship can be appreciated and such ceramics can be recognized for the masterpieces they are.

Again, perhaps, we see the influence of Qianlong's director of ceramics, T'ang Ying: certainly this vase could not have been made without craftsmanship and technical expertise of the highest order. Yet there is an artistic vision here too, the natural landscape with grazing deer is a virtuoso performance undoubtedly, but is also a lovely scene, rooted in centuries of Chinese artistic tradition. The deer theme is picked up more whimsically in the handles on the neck of the jar, which would also have allowed a lid to be looped down.

CREATED

China

MEDIUM

Lacquered porcelain

SERIES/PERIOD/MOVEMENT

Qing dynasty, eighteenth century

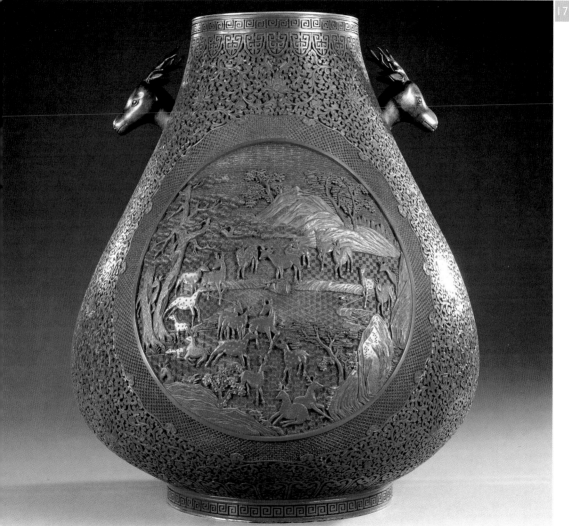

China

'Nine-dragon' bottle vase

In the famous Chinese myth the dragon had nine sons, each with his own special characteristics, from nobility and courage to the love of music. All, however, differed from the fearsome monsters of western fairy-tale tradition in being overwhelmingly positive forces, associated not with destructive fire but with life-giving water.

The Chinese dragon is wingless; his snake-like coils resemble the meanders of a stream and there is more than a suggestion of the phallus about his form. It was an unthreatening sort of masculinity that it symbolized; one rooted in fertility and the provision of plenty. Again, this dragon is not the abductor and rapist of western myth. To move from the legendary to the mundane level, it was also a form easily moulded in clay and then added as a relief to a porcelain surface, as with this appealing nineteenth-century vase made by the craftsmen of Qing China at some time in the nineteenth century.

CREATED

China

MEDIUM

Porcelain with relief moulding

SERIES/PERIOD/MOVEMENT

Qing dynasty, nineteenth century

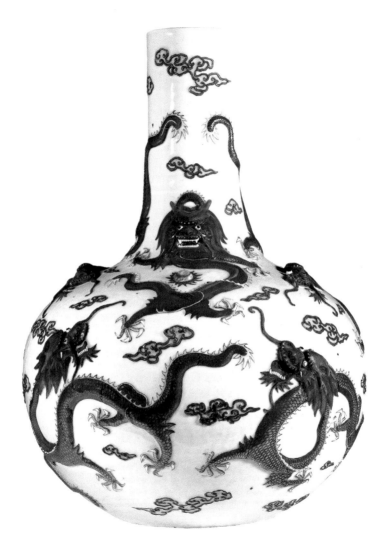

Japan
Meiping vase

© Christie's Images Ltd

Given the breathtaking accomplishment of so much Oriental decorative work, both colours and patterning, it is easy to forget the significance of shape and the less easily pondered importance of function. The type of vase known as the *meiping*, or 'plum blossom', was designed to display a single spray of plum blossom: hence its narrow neck, its shapely shoulders and elegantly tapered body. These vases were understated as a rule, and this Japanese example by Namikawa Sosuke (1847–1910) has *cloisonné* enamelling but in pastel shades.

Its lovely design makes reference to the vase's function: an entrancing scene of a plum tree and its blossoms, wreathed eerily in mists in the tradition of classic painting. In their wonderful whiteness and delicacy, plum flowers suggested purity and femininity, but that was not all. Like many fruit trees, plums come into flower before the foliage has appeared, but plum blossom stands out to particularly striking effect against the bare boughs of winter. Thus they took on for Chinese art a hint of something more heroic, an indomitable stoicism and strength in adversity.

CREATED

Japan

MEDIUM

Porcelain with *cloisonné* enamelling

SERIES/PERIOD/MOVEMENT

Nineteenth century

Namikawa Sosuke *Born* 1847 Tokyo, Japan

Died 1910

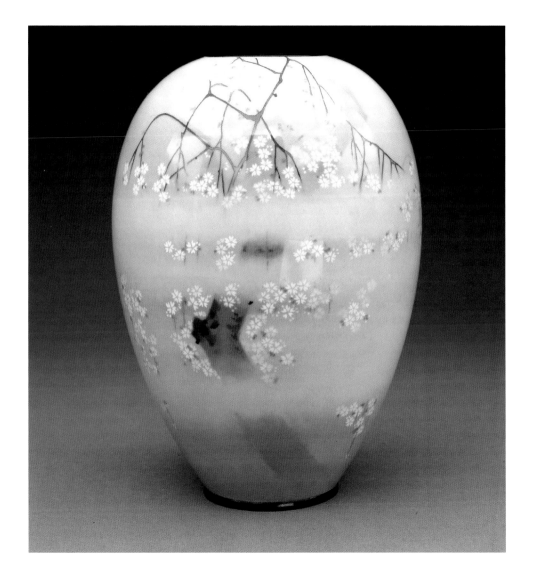

Korea
Blue and white bottle

Few countries can have been quite so put-upon as Korea, in a history said to have seen no fewer than 900 invasions and still by no means de-militarized after the great Cold War conflict of 1950–53, the Korean War. That was a 'proxy' war, fought between external superpowers and Korea has suffered a great deal of this sort of arm's-length meddling. So perhaps it's surprising that for 500 years under the Choson dynasty, Korea should have earned itself the nickname of 'the hermit state'. It did indeed remain autonomous for all that time, living in apparent peace and self-sufficiency, except for the fact that it was a tributary of China.

Being a tributary of China was quite an exception, though, and what cultural consequences flowed from it. Choson art was wonderfully creative, but the Chinese influence is always clear. It can be seen in this blue and white vase and its ornamentation: the burgeoning blooms below, the slender stalk tapering above, the cunning design playing off the bottle shape so beautifully.

CREATED

Korea

MEDIUM

Blue and white glazed ceramic

SERIES/PERIOD/MOVEMENT

Choson dynasty, nineteenth century

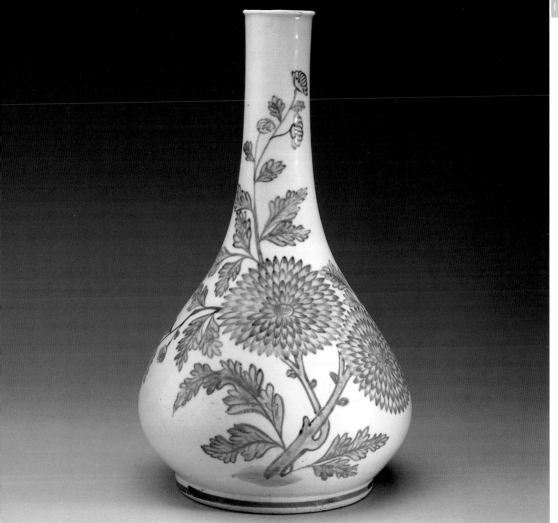

Japan
Imari dish

The bitter war for supremacy between the Taira and Minamoto clans convulsed Japanese society in the late twelfth century, but took on a semi-mythic quality in retrospect. Japan would always treasure its warrior tradition, but in the Meiji period from 1869 onwards it re-embraced this past with a renewed fervour. This was odd on the face of it. Firstly because the restoration of the imperial monarchy was intended to sweep away the ascendancy of the warlords once and for all. Secondly because the country was consciously moving forward at the same time, eagerly industrializing and reforming institutions.

Yet this modernizing mood only underlined the importance of Japan's warlike history, and the need for a romantic 'frame' through which the new expansionism could be seen. The Battle of Dannoura (1185) was especially celebrated and especially apposite for a nation now taking the first steps to becoming a naval power. An attack on an island fortress in the inland sea, between Honsho, Shikoku and Kyosho, the battle had been fought over land and water as all Japan's wars of the coming decades were to be.

CREATED

Japan

MEDIUM

Enamelled Imari

SERIES/PERIOD/MOVEMENT

Meiji period, 1868–1912

China

Rose and yellow tripod censers

The sight of smoke wafting heavenwards, the fragrance filling the air like a divine presence, the association between incense and religious rite are as ancient as they are obvious. For centuries censers were made of bronze. The tripod construction was as much about physical stability as Buddhist symbolism and early porcelain versions aped this earlier form. The first examples, made under the Song dynasty, were striking in their simplicity: these two betray their late manufacture (the reign of Jiaqing, 1796–1821) by their ebullient complexity.

This return to ancient religious roots is intriguing, coming as it did at a time of crisis in the Chinese porcelain industry, the export trade having all but failed completely. Industrial concerns in Europe had not only mastered the main techniques of porcelain manufacture to a very respectable level but had found a way of using transfers to produce 'authentic' Oriental images and ornamentation. Individual Chinese artefacts would never lose their prestige as antiques, but mass-produced ware never regained its former position in the market.

CREATED

China

MEDIUM

Enamelled Imari

SERIES/PERIOD/MOVEMENT

Qing dynasty, 1796–1821

Japan
Shibayama vase

Fragments of ivory, coral and mother-of-pearl are inlaid along with amber and other semiprecious stones, the pieces surrounded with lacquer to produce a smooth, continuous surface of stunning visual effect. This Japanese technique is known as Shibayama after the artist who invented it in the nineteenth century and whose family continued to be among the finest workers in the medium. The beautiful example shown here was created by an unknown craftsman some time after the restoration of the Meiji emperors in 1868.

From the modern western point of view, it must be acknowledged that this work is problematic: seldom can such skill and artistry have been directed to producing a work that comes so excruciatingly close to kitsch. There may be much that is foreign to us about Oriental art but, paradoxically, it never seems quite so alien as when it bids directly for a charm rooted in what ought to be a universal 'human interest'. But then the serious student of art history tends to be an austere judge in these matters: popular art has always had its sentimental side, in both the East and the West.

CREATED

Japan

MEDIUM

Shibayama porcelain

SERIES/PERIOD/MOVEMENT

Meiji period, 1869–1912

Japan
Fukagawa dish

The Fukagawa family firm, Koransha ('Company of the Scented Orchid'), began producing porcelain in Arita in 1875 specifically for export. Several exciting young designers were on the payroll. Which one created this dish is unknown, but it has all the dash and colour that one would expect from a house that encapsulated the commercial drive and cultural buoyancy of the Meiji period.

Irregularly shaped, with a suggestion of the scallop shell, the dish is a flurry of contrasting colours and patterns, yet the respect for line is rooted in classic Japanese design. The stooping central figure seems to dissolve into an exhilarating explosion of swirls and angled forms, and it is hard to feel sure just where the representational image ends and the abstract design begins. There are suggestions of scenery too: is that a lakeside or seashore with hills behind in the middle distance, or just more billowing folds in the figure's gown, or simple patterning? This really is a mesmerizing piece of work.

CREATED

Japan

MEDIUM

Koransha porcelain

SERIES/PERIOD/MOVEMENT

Meiji period, 1875–1912

Japan
Oviform vases

Known as *shippo* in Japan, the Chinese style of *cloisonné* enamelling underwent a revival at the Meiji court in the late nineteenth century, thanks largely to the efforts of two men, Namikawa Yasuyuki (1845–1927) and Namikawa Sosuke (1847–1910). Although unrelated, they shared a name and an interest in extending the possibilities of *cloisonné* by applying enamels without wire partitions. The maker of these vases is unknown, but the benefits of the Namikawas' innovative techniques are clear: a far greater fluidity and expressiveness than had been attainable before.

The phoenix in Oriental art took on certain attributes of the real-life bird of paradise, as is evident in the swirling tail feathers of these magnificent creatures, but its symbolic significance was both varied and profound. It was widely seen as a female counterpart to the male dragon, bringer of rain, its endless lives making it an emblem of human fertility and religious rebirth. In Japan it was specifically associated with the person of the empress, in whom the eternal principles of femininity were pre-eminently invested.

CREATED

Japan

MEDIUM

Shippo-enamelled porcelain

SERIES/PERIOD/MOVEMENT

Meiji period, 1869–1912

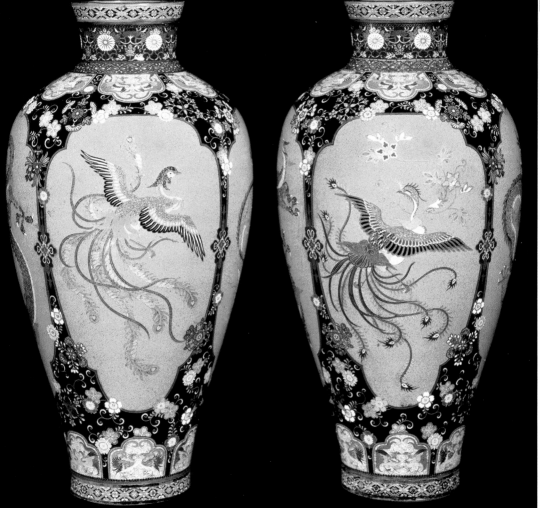

Asian Art

Statues & Figures

Cambodia
Head of Vishnu

Geographically speaking Cambodia may fall into what we nowadays think of as Southeast Asia, but the key influence on its emerging civilizations came from India, through trade. So it was that Buddhism first took hold here and that Hinduism came to lie at the heart of the culture of the Khmer empire, which emerged from the ninth century AD, a civilization remarkable for the range and skill of its statuary.

Vishnu was one of the three great gods of the Hindu pantheon: the 'preserver of the universe'. He had a number of different 'avatars' or earthly forms, including such animals as the turtle and the fish. He also famously rode about on the Garuda, half-man, half-eagle, one of the most familiar figures of Southeast-Asian art. Here, however, he appears not just as a human, but seems extraordinarily warm and affable. This fine head was sculpted from solid sandstone in the tenth century. Its only real ceremonial touch is the *stupa*-shaped headdress.

CREATED

Cambodia

MEDIUM

Sandstone

SERIES/PERIOD/MOVEMENT

Angkor period, tenth century

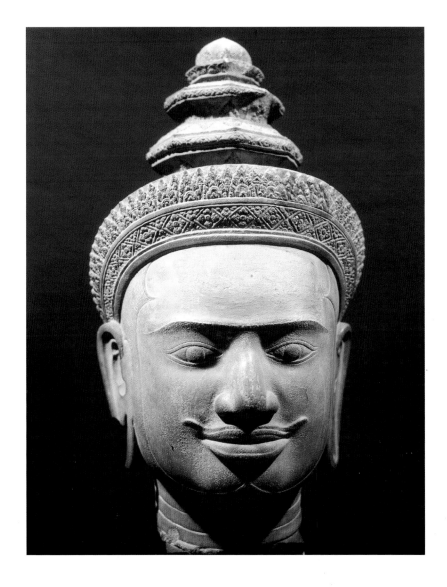

Cambodia

The kneeling goddess Tara

© The Art Archive/Musée Guimet, Paris/Dagli Orti

This figure of the goddess Tara was placed in the great temple at Prean Khan, built by the Khmer emperor, Jayavarman VII, in the late twelfth century. It has been suggested that this statue was modelled on the god-king's late queen Jayarajadevi, whose known portraits it resembles. That would seem appropriate enough as, her legendary beauty apart, Jayarajadevi was famed for her beneficence. Tara, in Buddhist tradition, was one of the greatest female *bodhisattvas*, divine patroness of mercy and compassion.

Jayavarman VII ascended the Khmer throne in 1181, restoring order to an empire that had been spinning out of control since 1150. At that point, having brought the civilization to a glorious height with the building of a magnificent temple complex at Angkor Wat, Suryavarman II had died. He left a power vacuum into which the neighbouring kingdom of Champa was only too happy to step, its forces invading and actually occupying Angkor Wat in 1177 before Jayavarman drove them out again four years later. He had a completely new capital constructed at Angkor Thom: a fresh start for a revitalized Khmer empire.

CREATED

Prean Khan, Cambodia

MEDIUM

Stone

SERIES/PERIOD/MOVEMENT

Angkor period, late twelfth century

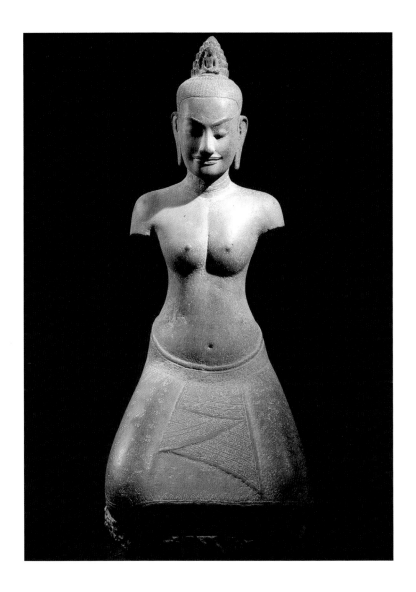

Japan
Amida Buddha

Buddhism came to Japan around the sixth century AD; by the ninth century it had become the official religion. As it took root in the country, however, new schools of devotion emerged, most famously, perhaps, the cult of Amida Buddha. This figure was associated with entry into the 'Western Paradise of the Pure Land', which could be gained by the ceaseless chanting of a simple prayer.

Namu amida butsu literally means 'I take refuge in Amida Buddha', but its content was not really the point: it was in the monotony of endless repetition that the devotee found a way of leaving the meaning behind and ascending to a transcendent state of consciousness. The process may be seen as analogous to the trance in which the central Asian shaman was brought by his ritual chant or dance, though Buddhists interpreted it in a very different way.

Amida Buddha was an object of particular devotion in Japan in the late twelfth century, the period when this statue was made.

CREATED

Japan

MEDIUM

Cypress wood

SERIES/PERIOD/MOVEMENT

Late Heian period, twelfth century

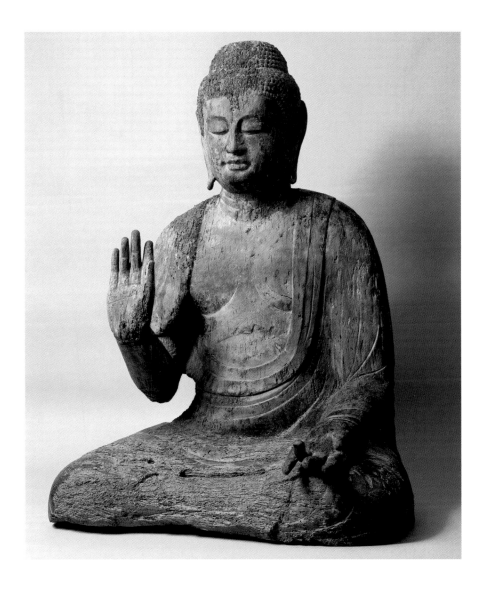

Cambodia

Five-headed Naga

'Indochina', as it used to be called, combines both Indian and Chinese cultural traditions: the former can be seen in figures like Vishnu and the goddess Tara. The latter may be discerned in the ubiquity of stories about, and statues of, the Naga, a sort of water serpent clearly related to the life-giving Chinese dragon. It was the Naga king who, in ancient myth, drank up the sea so that Kambuja or Cambodia could emerge as dry land in the first place.

This five-headed feminine figure was carved at Preah Thkol in the late twelfth century. The square sandstone shrine stands on a small island in the extensive *baray* (sacred pool), which lies across the main approach to Jayavarman VII's temple complex at Preah Khan. At around five kilometers square in area, it is the largest sacred construction in Cambodia. This figure was carved to form part of a balustrade: the Naga is dramatically framed by a mandorla.

CREATED

Prean Khan, Cambodia

MEDIUM

Sandstone

SERIES/PERIOD/MOVEMENT

Angkor period, late twelfth century

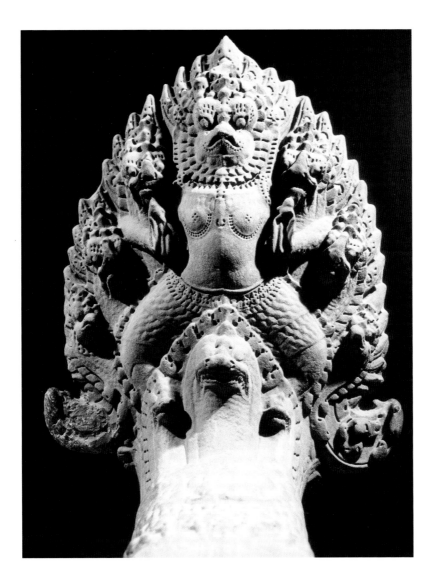

China

Bronze Buddha

This beautiful bronze Buddha was made in the kingdom of Dali, which occupied what is now the Chinese province of Yunnan between the tenth century and the Mongol invasion of the 1250s. Yunnan is a place apart in Chinese terms: the most south-westerly part of China, it borders on Vietnam, Thailand, Laos and Myanmar, and in some ways may be seen as belonging culturally and historically to Southeast Asia. Yet this statue recognizably follows the scriptural traditions of Chinese Buddhism, in everything from facial expression and clothing to hair and posture.

The Buddha is shown seated in his usual *padmasana* (lotus position), his hands clasped left over right in prayer, but in many ways he is an unusual figure. Dalian figures of Avalokitesvara abound: the all-seeing, all-hearing lord of all compassion has been described as 'The Luck of Yunnan', but very few bronze Buddhas of this type are known to have survived.

CREATED

Yunnan, China

MEDIUM

Bronze

SERIES/PERIOD/MOVEMENT

Dali period, tenth–thirteenth century

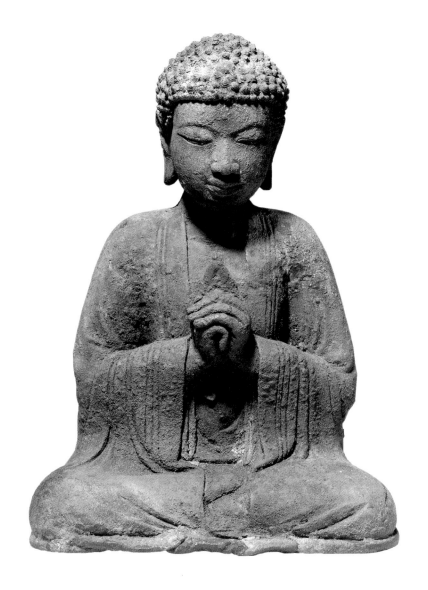

Cambodia

Dancing Hevajra

One of the most remarkable Indian deities honoured at Angkor was Hevajra, with his eight heads and eight pairs of hands. He danced as a sign of escape from worldly constraints. In this he can be seen as harking back to the tradition of the shaman's ecstatic trance, or to the later tradition of the whirling dervish of the Islamic world. For both, ecstatic abandon was a way of leaving behind everyday concerns: a crucial step on the way to spiritual enlightenment for Buddhists and Hindus too.

This one wears a *sampot*, a short loincloth tied at the front of the sort that is seen on many of the statues made at Angkor, and his has a fishtail-shaped sash hanging down in front. Characteristically his major face looks cheerful and benign; the others stare out more blankly. In his hands he brandishes tiny figures of gods and animals, all lovingly reproduced in miraculous detail.

CREATED

Cambodia

MEDIUM

Bronze

SERIES/PERIOD/MOVEMENT

Angkor period, late twelfth/early thirteenth century

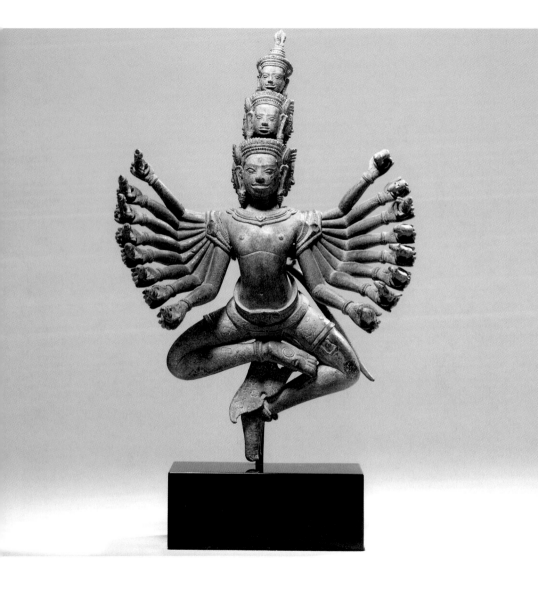

Cambodia

Archers

Spears raised and bows at the ready, a Khmer army advances to put an enemy to flight. This relief is at the great temple of Bayon, in the capital built by Suryavarman II at Angkor Wat in the twelfth century. At this time the Khmer empire was under more or less constant threat from its northerly neighbour, the kingdom of Champa in what is now Vietnam. Such scenes seem to have been carved at least partly in a spirit of wish fulfilment: a city so well guarded need have no fear.

And so it was to turn out: although Khmer's fortunes would dip after Suryavarman's death, they would revive dramatically under Jayavarman VII. Having expelled the invaders from Angkor Wat in 1181, he pressed his advantage in a continuing series of campaigns. In 1203 he led his forces to victory over the forces of the Cham kingdom, and Champa became a province of the Khmer empire.

CREATED

Angkor Wat, Cambodia

MEDIUM

Stone

SERIES/PERIOD/MOVEMENT

Angkor period, twelfth/thirteenth century

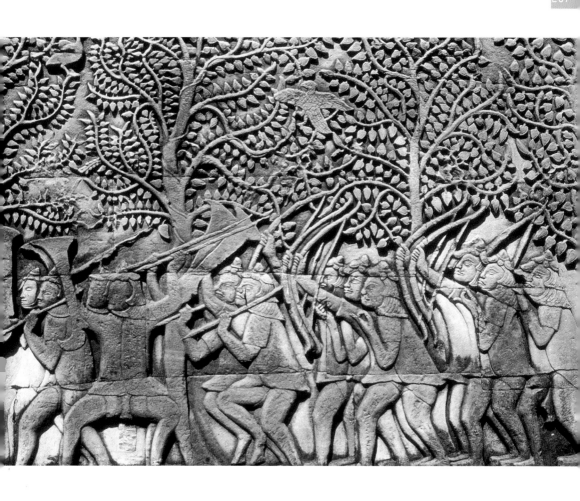

Indonesia

Ganesha

The Hindu god Ganesha is instantly recognizable by his elephant head. He is revered as lord of beginnings and remover of obstacles. He was the divinity that the pious turned to before embarking on any major journey or undertaking. Anyone approaching this Indonesian sculpture in volcanic stone would surely feel reassured: this Ganesha radiates good humour and easy-going charm. A cheerful glint in his eye, he reaches across his potbelly to a box of sweets.

He is beautifully accoutred, with a fine ornamental chain about his neck and his splendid headdress has a jewelled fringe. Foliate amulets with flower centrepieces can clearly be seen round his 'arms' and ankles; he wears a patterned loincloth or *dhoti*, with decorative sashes hanging down. The third of his four arms is visible behind: in it he holds the axe with which he is empowered to cut earthly ties. Across his chest loops the sinuous form of a cobra, symbol of fertility. This wonderful figure was created some time in the thirteenth or fourteenth century.

CREATED

Java, Indonesia

MEDIUM

Volcanic stone

SERIES/PERIOD/MOVEMENT

Thirteenth/fourteenth century

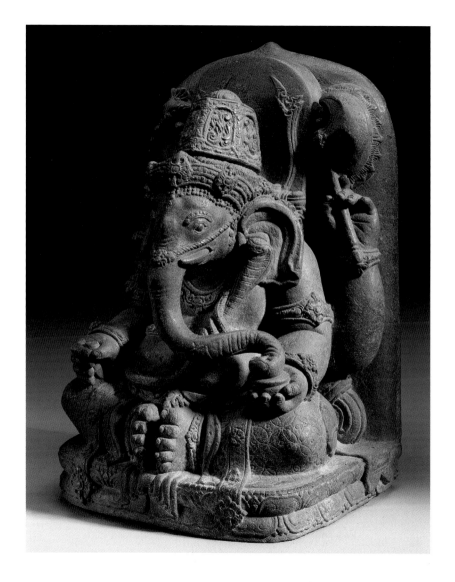

Tibet

Milarepa

This stunning bronze statue was cast in the fourteenth century. It represents one of Tibetan Buddhism's most famous figures, Milarepa, who lived from 1040 to 1123, although his life story has been blurred by legend down the centuries. A dabbler in black magic in his youth, he repented and embraced Buddhism: he is said to have attained the sacred status of true Buddha in single lifetime. As he was a young man of extraordinary piety and commitment, this is hardly surprising. At one point it is said he took himself off to a solitary cave and sat meditating for a full year, a butter lamp balanced on his head to keep his back straight.

He was also a poet and singer and many of Tibet's most popular folk songs are attributed to him. The hand cupped to his right ear is a characteristic pose, believed to indicate that he is listening to the 'echoes of nature'. The pot he holds in his left hand is a *kalasa*, a common symbol for fecundity and abundance, rather like the Classical western cornucopia or 'horn of plenty'.

CREATED

Tibet

MEDIUM

Bronze

SERIES/PERIOD/MOVEMENT

Fourteenth century

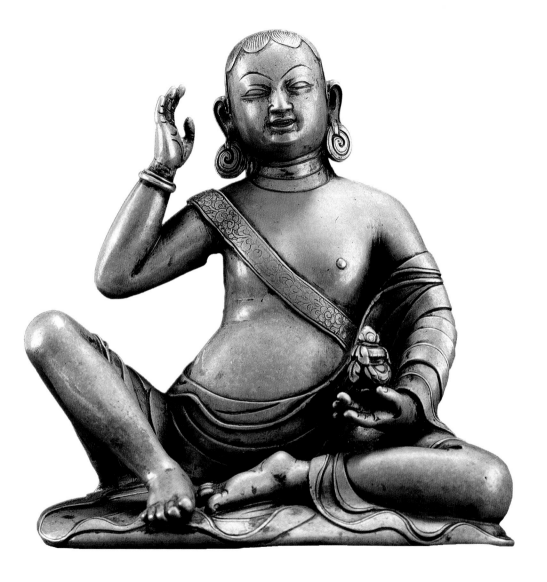

Thailand

Bronze head of the Buddha

The head in the shape of an egg; the hair tightly knotted like scorpions' stings; the nose like the beak of a parrot; the eyes like lotus leaves; the eyebrows like drawn bows; the chin the same shape as a mango stone – the ideal features of the Buddha, as laid down in the sacred scripture, the *Silpasastra*. All have been magnificently realized in this bronze head, serenity personified, by a fourteenth-century sculptor in the kingdom of Sukhothai, in what is now Thailand.

This state emerged in the mid-twelfth century to usher in something of a golden age of Buddhist art in Thailand, its sculpture especially remarkable for its emotional and spiritual resonance. The faces of its figures in particular show a dreamy ethereality that we find a hint of here, although this head was made not long before the civilization's decline towards the end of the fourteenth century. Ultimately Sukhothai would be eclipsed by the growing might of Ayutthaya, its southern neighbour, and the first kingdom to rule over what amounted to a unified Thailand.

CREATED

Sukhothai, Thailand

MEDIUM

Bronze

SERIES/PERIOD/MOVEMENT

Late fourteenth century, Kamphaeng Phet style

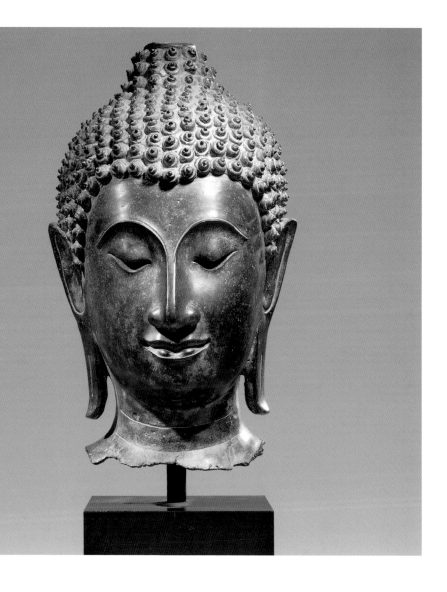

Japan

Attendant of Fudo Myo-O

As Buddhism gained ground in Japan from the ninth century onward, it incorporated many of the gods or *kami* of the native Shinto tradition. One of the most popular of these was Fudo Myo-O, bringer of light and fighter against evil. As reinvented by Buddhism, however, he had aspects of the ancient Hindu deity Shiva. Oriental religion is nothing if not complicated and paradoxical. Fudo was a benign deity and yet a fearsome one, generally depicted surrounded by raging flames. He was a dealer of death and destruction, but not on that account to be feared or resisted, since his very violence made him a bringer of rebirth.

This bald attendant looks formidable enough himself: like many of Japan's finest religious sculptures he was carved in wood and then painted, although his colours have now largely faded. He stands at Kyoto's Jorurichi temple, and is believed to have been made in the fifteenth century.

CREATED

Japan

MEDIUM

Painted wood

SERIES/PERIOD/MOVEMENT

Fifteenth century

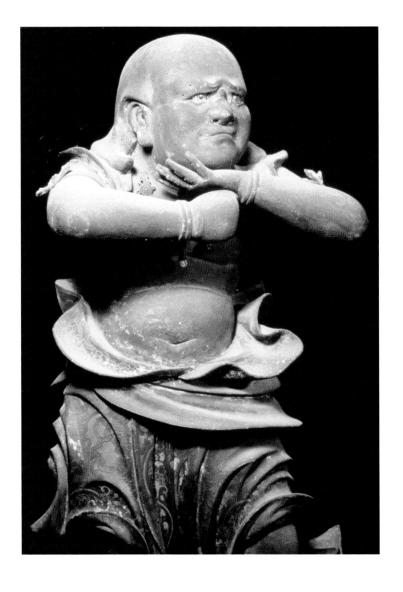

Tibet

Tsundu Tsangpo

Also known as Thang-stong rGyal-po, or the 'Builder of Iron Bridges', Tsundu Tsangpo occupies a unique place in Tibetan tradition. He is said to have built all the country's historic bridges, including a cantilever construction across the Yarlung Tsangpo (Brahmaputra River) in 1420. Built of non-corroding iron, it was well over 100 m (330 feet) across. Not only that, but Tsundu Tsangpo is said to have inaugurated his country's religious drama as well and founded an important orchestra of monks.

Like Milarepa, a true-life figure, he lived from 1385 to 1464, but his life story has been subsumed into legend. Quite how quickly that came about is clear from this stunning bronze inlaid with silver copper, which, although made in the decades immediately following his death, presents him in a state of godlike splendour. An inscription on the rear of this bronze reads, 'Praise to the Guru! Just by your glance, you subdue all sentient beings. By mere threat, you enslave the eight demonic forces. Just by mere thought, like falling rain, your desires are abundantly fulfilled. We bow to the great saint, Tsundu Tsangpo'.

CREATED

Tibet

MEDIUM

Bronze

SERIES/PERIOD/MOVEMENT

Fifteenth century

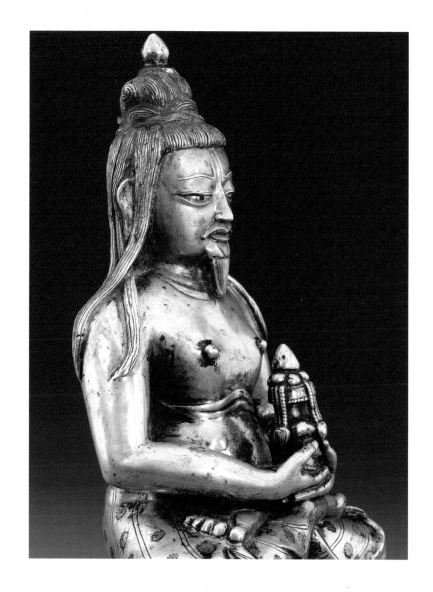

Japan
Buddha

This fierce-looking Buddha was carved in wood before being painted some time during Japan's Ashikaga or Muromachi period (1392–1568). Japan has a wonderful tradition of religious sculpture, but very little was done in stone: bronze and especially wood were much more favoured.

Many must have been lost in the series of devastating fires that swept the then-capital Kyoto in the course of the eighteenth century. One in 1705 destroyed 75 Buddhist temples, not to mention Shinto shrines, whilst another in 1788 destroyed over 200. Much of Japan's cultural heritage has gone up in flames in a series of conflicts from the feuds of the medieval clans to the Tokyo Firestorm of the Second World War. In peacetime too there have been accidents, especially during the country's frequent earthquakes, where braziers have been upset or, more recently, electrical fires caused. The damage is the greater because of the expensive use of wood and even paper, not just in sculpture, but also in the construction of public buildings, shrines and homes.

CREATED

Japan

MEDIUM

Painted wood

SERIES/PERIOD/MOVEMENT

Muromachi period, 1392–1568

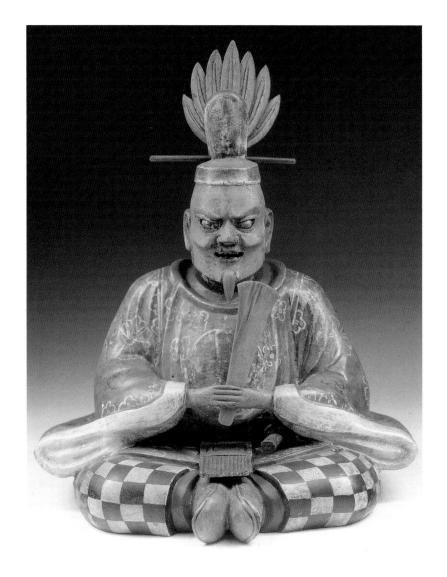

Thailand
Buddha Shakyamuni

Siddhartha Gautama, or the Buddha, had been born into the elite Nepali warrior clan, the Shakya, hence his later title, Shakyamuni or 'Sage of the Shakyas'. He was born to pride and privilege and carefully protected from all the ills and hazards of existence, before he made his 'Great Departure' and took himself off to wander through the world.

In showing him as the Buddha Shakyamuni, therefore, this striking sandstone figure created in the Sukhothai kingdom of Thailand in the fifteenth century honours the historical as opposed to the purely spiritual Buddha. His human beauty and nobility are emphasized: this statue does not suggest a simply spiritual presence but the physical form of a noble and beautiful young man. It looks back to the prince's life he left behind, as well as the purely spiritual existence he embraced.

Sukhothai sculptors did not normally work in stone: this piece was made in sections that were then attached together with lacquer. A coat of lacquer gave the whole a seamless finish.

CREATED

Sukhothai, Thailand

MEDIUM

Sandstone

SERIES/PERIOD/MOVEMENT

Fifteenth century

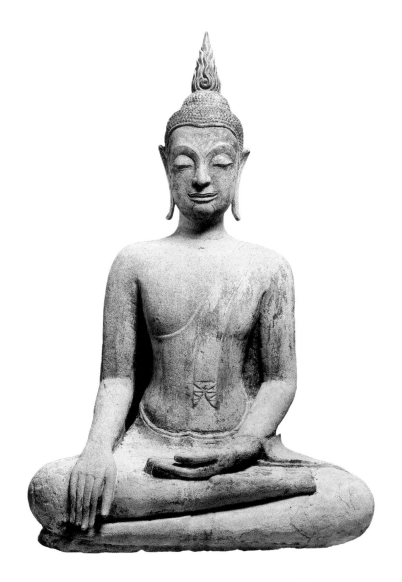

Japan

Buddha

This splendid figure, richly accoutred with extra hands as well as headdress, halo, rod and costume and other finery, was made during the Muromachi period, at a time when Japanese Buddhism was coming under attack. After two centuries of government by shogunate, the emperor being only a feeble figurehead whilst real command was excercised by a military dictator or shogun, there was little sign of the new system bringing greater stability to Japan. In 1392 the Ashikaga clan had deposed the existing emperor and imposed their own candidate, but faced a long struggle to enforce their rule as shoguns in the face of a rising class of local warlords or *daimyo*.

It was a time of assertive nationalist rhetoric and as the established religion of the centralized state, Buddhism was regarded with suspicion. The impact on religious thinking and its artistic expression was clear. Where previously the Shinto *kami* had been seen as manifestations of the Buddha and his *bodhisattvas*, the pressure mounted for that role to be reversed, with consequences both for ritual and iconography.

CREATED

Japan

MEDIUM

Painted wood

SERIES/PERIOD/MOVEMENT

Muromachi period, fourteenth–sixteenth century

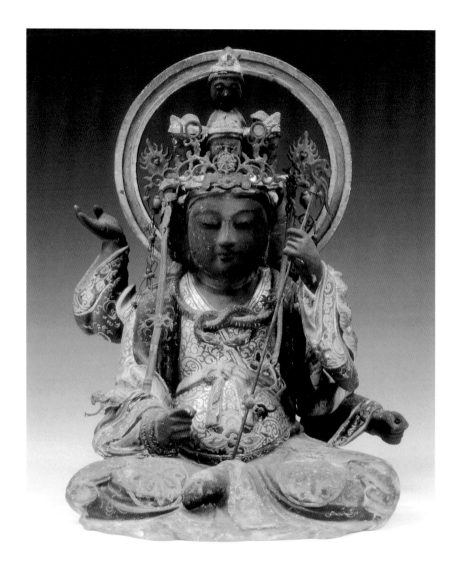

China
Guan Di

Guan Yu was a general under the last Han emperor of China: he died in AD 220 as that dynasty approached its end. With two other heroes, Zhang Fei and Liu Bei, he formed the famous 'Brotherhood of the Peach Orchard', whose high deeds in defence of the emperor went down in Chinese legendary history. He was famous for his *sang froid*: one story tells how, while surgeons operated on a wound received in battle, he calmly continued playing a game of *Go*.

So celebrated was Guan Yu for his nobility and courage that after he died he was deified as Guan Di ('Lord Guan'), god of righteousness and wealth as well as war. His cult was encouraged under the early Ming dynasty, in the fourteenth or fifteenth century, when this large figure was made, and in 1594 he was declared guardian deity of the Chinese state. This fine figure shows him armoured for combat, his expression severe and yet not unkind: Guan Yu was always regarded as a benevolent figure. He loved learning as well and was regarded as a god of literature. This statue shows him with a scholar's long beard.

CREATED

China

MEDIUM

Bronze

SERIES/PERIOD/MOVEMENT

Early Ming, fourteenth/fifteenth century

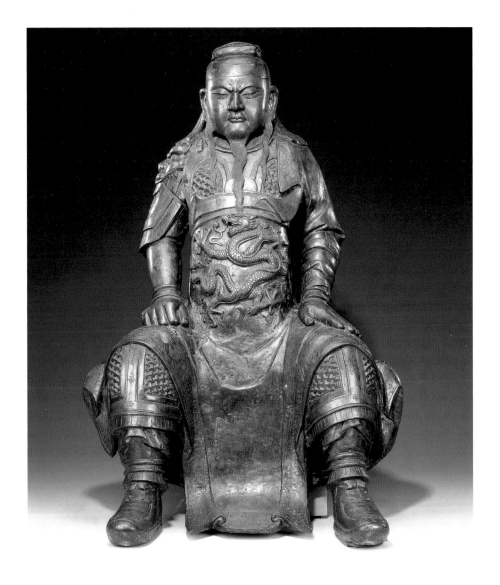

Tibet

Virupaksa

One of the four *lokapala*, gods of the directions, held in reverence by Buddhists, Virupaksa was the Guardian of the West. Fierce warriors, traditionally armoured, the *lokapala* were figures of great antiquity, taken from the Indian traditions of pre-Hindu times. Under Hinduism they had guarded the four slopes of Mount Meru, sacred mountain of the universe, and for Buddhists they were the custodians of heaven.

This late fourteenth or early fifteenth-century Tibetan Virupaksa is particularly splendid, cast in bronze then gilded and adorned with semi-precious stones. His ornate suit of armour is richly decorated in relief, its breastplate inlaid with turquoise, coral and lapis lazuli. His pointed headdress is surmounted with a figure of a Garuda, the eagle-man on whom the Hindu god Vishnu was accustomed to ride. The snake he holds in his left hand is a symbol of fertility whilst, with his right, he makes the open-handed gesture that is known as *varada mudra*. In the elaborate gestural code of Buddhist iconography, this has its own appointed meaning as a mark of welcome, blessing and reassurance.

CREATED

Tibet

MEDIUM

Gilt bronze

SERIES/PERIOD/MOVEMENT

Late fourteenth/early fifteenth century

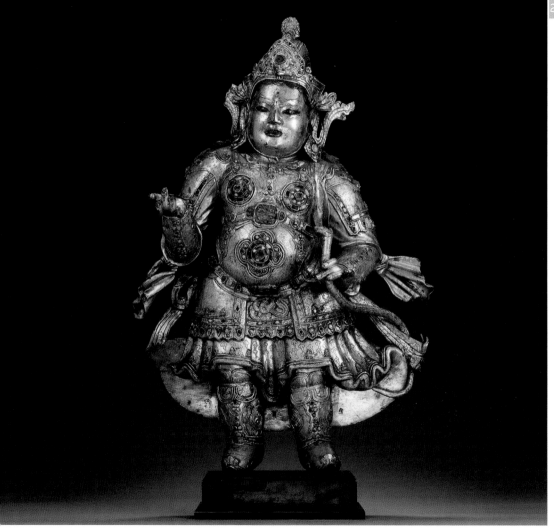

China
Buddhist trinity

This trio of *bodhisattvas* in painted stucco cut a distinctly cheerful figure, clad as they are in brightly coloured clothing. They also have a relaxed air that suggests some considerable skill and sophistication in the craftsman who made them. See the easy way they raise their hands in blessing, the comparatively 'natural' fall of the loose gowns. Even so it is hard to say with any great precision when they were created, beyond the fact that it was in China some time during the Ming dynasty (1368–1644).

Despite the quasi-divinity of their subjects, these figures have a decidedly human quality that is not so often seen in Chinese statuary. This is not because Chinese sculptors have lacked skill, or because a sense of everyday humanity has been missing from Chinese art in general, for it is to be found widely in paintings, ceramics and other media. However, the tendency has certainly been for Chinese sculpture to be monumental in mood and often in scale. The sense of easy intimacy we feel here is unusual.

CREATED

China

MEDIUM

Painted stucco

SERIES/PERIOD/MOVEMENT

Ming dynasty, 1368–1644

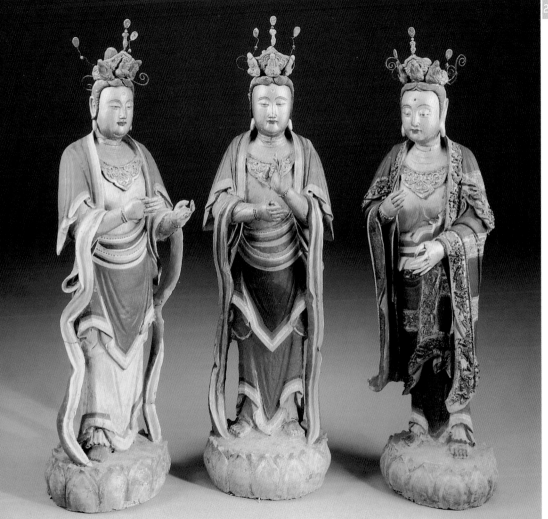

China

Lokapala

The Buddhist tradition of the *lokapala*, or Guardians of the Directions, found ready-enough acceptance in China, where Taoism already taught the existence of Four Heavenly Kings who performed similar functions. Gilt bronze figures such as these, from the fifteenth or sixteenth century, were placed in the entrances of tombs to ward off any evil spirits who might be tempted to steal inside.

The sword wielded by the left-hand figure shows that he is the Guardian of the South; the right-hand figure looks very much as though he may once have played a stringed instrument, which would make him the Guardian of the East. Each wears splendid armour, highly individuated, its detail meticulously done with a real fluidity about the fall of textile folds, bowed ribbons and long sashes. Each also wears a warlike expression, although there is an element of grotesquerie here. These figures clearly take their duties as guardians very seriously.

CREATED

China

MEDIUM

Gilt bronze

SERIES/PERIOD/MOVEMENT

Ming, fifteenth/sixteenth century

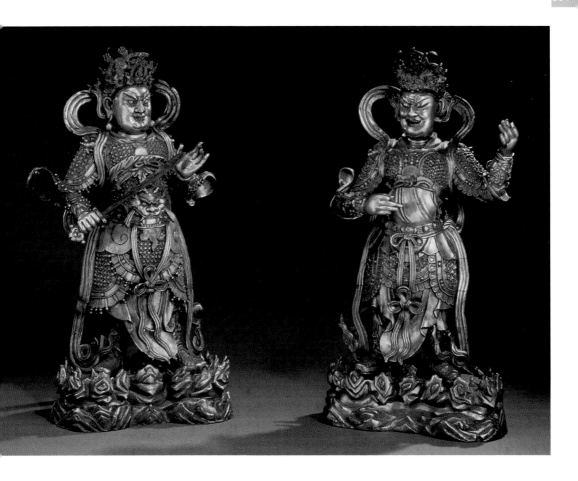

Korea

Seated Buddha

The advent of the Choson dynasty in the fourteenth century was in many ways a boon to Korea, inaugurating as it did a period of prosperity and order. The introduction of Chinese Confucianism helped to inculcate the sense of social responsibility and loyalty to the state that would promote this: in that regard its influence was overwhelmingly positive.

At the same time, however, it had a negative impact as the obedience it fostered could be stifling. The instinct to uphold order and conformity at all costs quelled the intellectual restlessness that encourages creative enterprise. The net result was social and religious intolerance and in the area of the arts a degree of Philistinism. Buddhism can in hindsight be seen to have been not just a religious but also a cultural saving grace. It was marginalized, at times even persecuted, but its endurance helped keep alive not only religious freedom but the artistic spirit that produced this gilt-lacquer Buddha in the fifteenth/sixteenth century.

CREATED

Korea

MEDIUM

Gilt lacquer

SERIES/PERIOD/MOVEMENT

Choson dynasty, fifteenth/sixteenth century

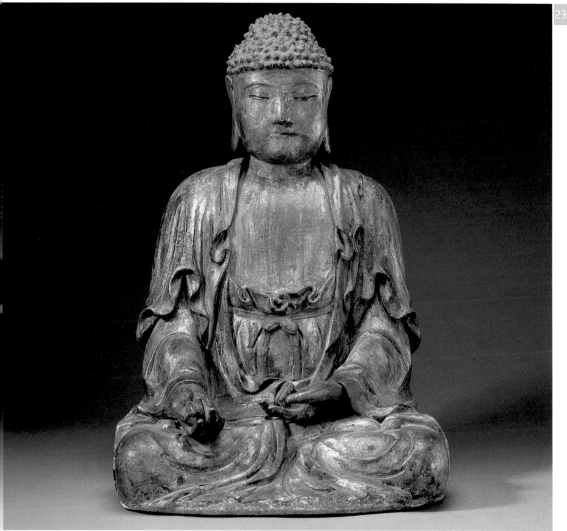

China

Yuanshi Tianzun

Yuanshi Tianzun was, to give him his full title, the 'Heavenly Venerate of the Original Inception', revered by all followers of the Taoist way. He was venerated, rather than worshipped, since he was not quite a creator, but an emanation of the same spontaneous coming-into-being of the universe that produced the Taoist scriptures, the 'Celestial Writings'. Taoism has been part of the Chinese spiritual scene since the ninth century BC, coexisting and interacting with other creeds.

This majestic seated statue dates from around the end of the fifteenth century. Strictly speaking it is a ceramic figure, but its massive size means that it demands consideration as a work of sculpture. The *sancai* system used to colour it seems to have been invented in the seventh century, under the Tang dynasty: the word literally means 'three glazes'. These were lead-based glazes with oxides of iron (yellow/brown), copper (green) and cobalt (blue), the three often blended for effects both striking and subtle.

CREATED

China

MEDIUM

Sancai porcelain

SERIES/PERIOD/MOVEMENT

Ming dynasty, late fifteenth/early sixteenth century

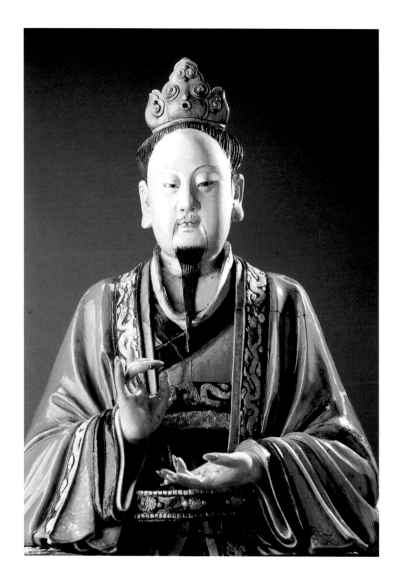

Tibet

Yaksha

Vaishravana (or Kubera), Guardian of the North, was attended in Tibetan tradition by eight spirits or *yakshi*. This one, carved in stone and then painted, is a particularly fine fifteenth/sixteenth-century example. Its forms are stylized almost to the point of cartoon or caricature and yet there is an undeniable sense of reality there. His face is simply done, but still expressive. He gazes into the distance with a distinctly noble air and there is a sense of contained energy in the way he holds his sword. His armour is richly decorated in red and gold and there is a fluid ease about the way his long sashes billow back over his shoulders. His shield is of tiger skin, with a snarling face at its centre. Clearly to be seen in his left hand is Vaishravana's mongoose, which was said to vomit forth jewels. Framing the figure behind is the form of the flaming mandorla, which symbolized sacred inspiration in the Buddhist world.

CREATED

Tibet

MEDIUM

Painted stone

SERIES/PERIOD/MOVEMENT

Fifteenth/sixteenth century

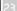

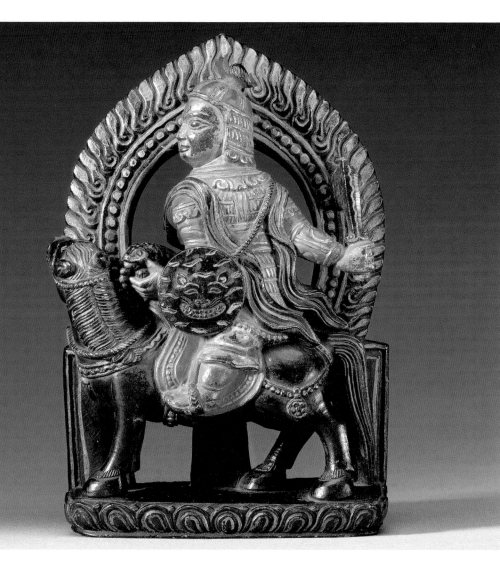

China

Buddha throned in turquoise matrix

The mineral agglomerate of 'matrix' from which turquoise is obtained naturally has a knobbly, 'cauliflowered' appearance that has been imaginatively exploited in this charming Chinese sculpture. Perhaps one should say 'sculptures', for the ivory Buddha here was carved in the sixteenth century, in one of the middle reigns of the Ming dynasty.

It is a beautiful work in its own right and has aged very gracefully, the natural discoloration of time only adding character to a figure in whose creation simplicity has been balanced with skill to great effect. The Buddha's expression is only just this side of blank and yet it suggests a deep spirituality and gentleness. There is nothing exhibitionistic about the way in which the folds of his garments have been executed, yet the result suggests both naturalness and order. The framing throne appears to have been added some time later. It was undoubtedly an inspired touch however: the blue-grey matrix beautifully setting off the creamy brown of the figure and the two elements complementing one another perfectly.

CREATED

China

MEDIUM

Ivory figure with turquoise matrix surround

SERIES/PERIOD/MOVEMENT

Ming dynasty, sixteenth century

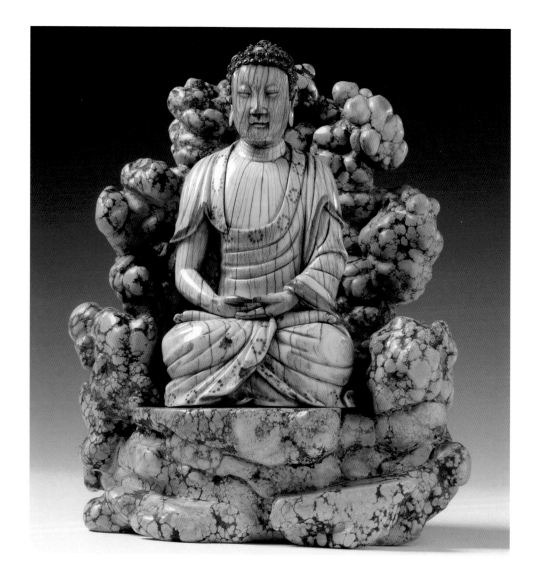

Japan

Bodhisattva

In Buddhist teaching, it might take a number of lifetimes to attain the spiritual status of the *bodhisattva*, even for the most virtuous and devout. Such a being was deemed to have succeeded in leaving behind all earthly concerns, achieving infinite wisdom and compassion. Being a *bodhisattva* thus involved majesty and modesty, a paradox that many artists appear to have enjoyed. Here, a Japanese sculptor from the Edo period (1603–1868) has used gold and silver, the stuff of earthly wealth, to produce an unforgettable image of transcendence.

Contradiction goes to the core of a creation that can be seen as a study in oppositions reconciled, in contraries resolved. The figure seems to hover weightlessly over the lotus flower springing from its massy base. The moon-halo behind it is startling in its simplicity compared with the complexity of the ornamented pedestal, and the gilt in turn contrasts with the white and silver of the lotus and the statue. In its detail, rococo and exuberant, and in its overall effect, simple and symmetrical, this piece is as haunting as it is magnificent.

CREATED

Japan

MEDIUM

Painted wood

SERIES/PERIOD/MOVEMENT

Edo period, 1603–1868

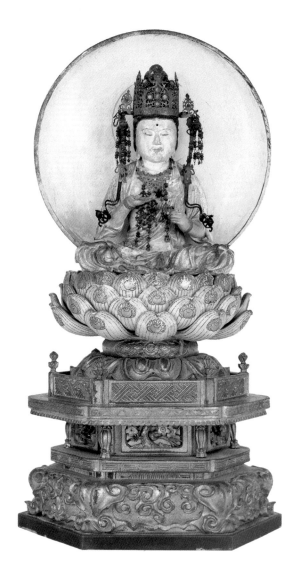

China

Recumbent horse

It is not difficult to comprehend the long-standing love of Chinese craftsmen for green jade: its understated luminosity, its living warmth – especially when it is carved with the sort of skills exhibited here. Every detail of this beautiful horse has been lovingly captured, from its flicking tail to its mane and flaring nostrils. Some 35 cm (14 in) in length, it is believed to have been made for display in one of the imperial palaces of Beijing.

Jade, chemically speaking, is a silicate of sodium and aluminium, but that description can give no sense of its unique beauty. The Chinese word for it, *Yu*, was used generically for any treasure: jade represented the gold standard, as it were, for wealth. Many traditions surrounded jade: it had been born in a storm, it was said, hence the insertion of a small piece in the foundations of the home to ward off lightning. It was also held to be crystallized moonlight, analogous to (if rather more magnificent than!) the western tradition that the moon was made of 'green' cheese.

CREATED

China

MEDIUM

Jade

SERIES/PERIOD/MOVEMENT

Ming dynasty, seventeenth century

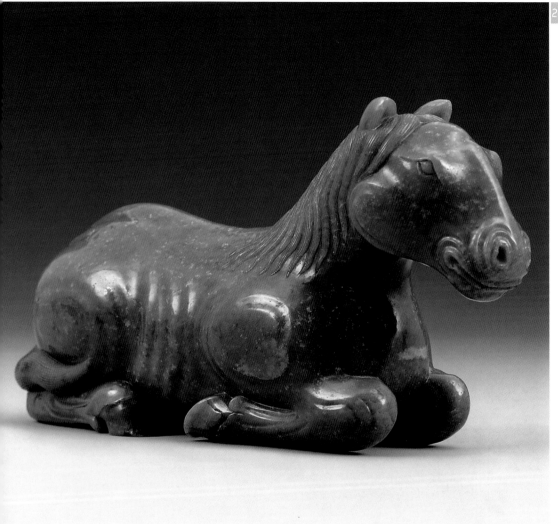

Japan
Bronze Ashura

With three faces and eight arms, Ashura was revered in Japan as one of the supernatural guardians of Shakyamuni. The role that he or she played was, however, reinterpreted over time: in the Nara period (AD 710–94) she had the pretty faces and shapely arms of a young woman. Later sculptors paradoxically harked back to the much earlier Hindu tradition in which Ashura had originated, in which he was a fierce and warlike spirit, sometimes even evil. This grim-looking god monster was created in the Edo period (1603–68).

Yet the Buddhist scheme was nothing if not pluralistic: although the face looking out to the right seems set and severe, that just glimpsed in profile to the left seems more conciliatory. Much that is apparently perverse and freakish in eastern sculpture makes more sense when its role as religious art is remembered: the multiplicity of faces and arms represents a multifaceted god. The hands here, for example, express everything from welcome and blessing through guidance and direction to solemn prayer: no straightforward statue could have encapsulated all these things.

CREATED

Japan

MEDIUM

Bronze

SERIES/PERIOD/MOVEMENT

Edo period, 1603–1868

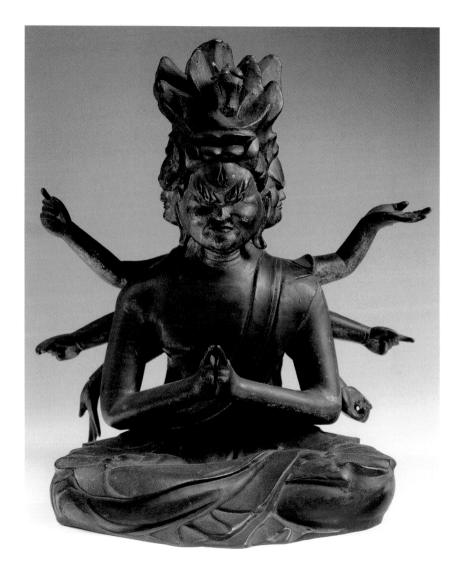

Tibet

Chakrasamvara

One of the most revered gods in the Tibetan Buddhist pantheon, Chakrasamvara was at once a god and an instrument of meditation: his 12 arms brandished an elaborate set of symbols, clearly seen in this stunning sculpture (c.1700). His bell, for example, was a recognized sign of divine wisdom, to which the coiled cord in another hand would bind the believer. His axe head and chopping blade suggested severance from mortality and earthly pride respectively; his trident stood for his war against the devil.

Around the rim of his splendid tiara are ranged a row of grinning skulls, a symbol of death, of course, but at the same time of rebirth. Buddhism shares the originally Hindu sense that we constantly die and are reborn in different human and animal forms in a swirling circle of existence called *samsara*. Only those who attain a *bodhisattva's* purity can escape this endless cycle. Death, accordingly, is to be welcomed since it offers a fresh start, new opportunities for living a good life and gaining enlightenment.

CREATED

Tibet

MEDIUM

Gilt bronze

SERIES/PERIOD/MOVEMENT

c.1700

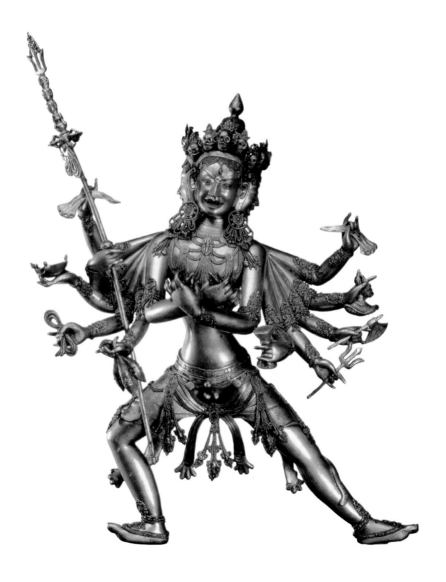

Tibet/China

Elephant

This magnificent little gilt-bronze elephant, just over 17 cm (6.5 in) tall, was made by a Tibeto-Chinese craftsman of the eighteenth century. It is at once a splendid and a wonderfully charming work. From the saddle blanket incised with lotus scrolls to the flaming headdress inset with semi-precious stones, it announces its owner's wealth and prestige, yet there are a host of more engaging touches too. The crinkled knees, the curling trunk and the animal's long-suffering facial expression make this a work as much of humour as of pomp.

There is, of course, a more serious side as tends to be the case with artefacts of Tibetan or Tibeto-Chinese manufacture. The distinction between religious and secular art was unknown and would have been inconceivable in that tradition. The elephant was a recognized Buddhist emblem; the beast's unique combination of massive strength and gentleness made him the perfect symbol for the powers of the Buddha. This one's headdress takes the form of the 'Three Precious Jewels', representing the three 'pillars' of Buddhism: Shakyamuni himself, his *dharma* or doctrine and *sangha* (his monks and nuns).

CREATED

Tibet/northwest China

MEDIUM

Gilt bronze

SERIES/PERIOD/MOVEMENT

Eighteenth century

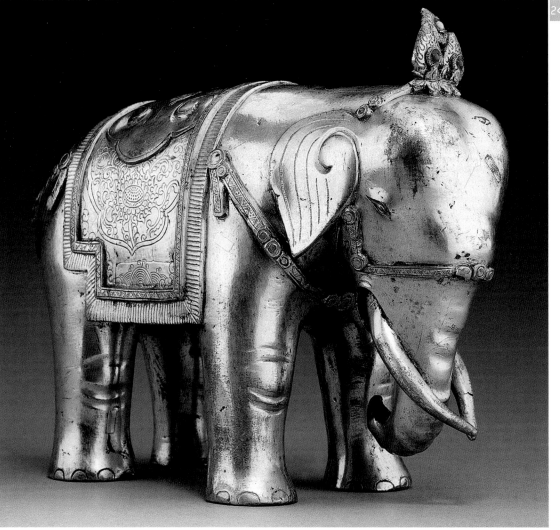

China

Seated Budai

There were many famous *bodhisattvas* in the Buddhist world, each of them exemplifying a different set of virtues. None, however, was held in greater affection than Budai, the 'laughing monk'. This jocund figure, as generous in his girth as in his charity, might have been the invention of a Chinese Chaucer. He had been a real, historical personage, though, a wandering holy man of the tenth century who had become famous for his easy-going contentment and jollity.

As such he became associated with the ancient Chinese divinity Hotei, the god of good fortune and happiness. He is often shown surrounded by a crowd of small children or friendly animals. Out of sight here, because traditionally he carried it slung behind his back, was the cloth bag he took with him everywhere he went. This impressively potbellied figure was made during one of the middle reigns of the Qing (Manchu) dynasty, in the late eighteenth or early nineteenth century.

CREATED

China

MEDIUM

Gilt bronze

SERIES/PERIOD/MOVEMENT

Qing dynasty, late eighteenth/early nineteenth century

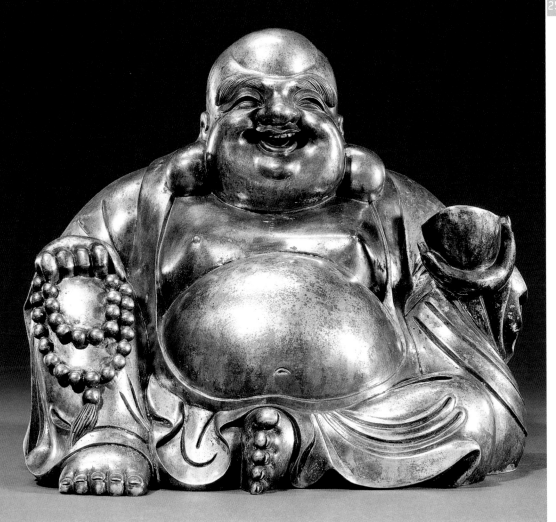

Tibet

Dorje Yu Gronma and Miyo Lobzangma

The 12 Tenma goddesses of Tibetan tradition were ancient deities of the mountaintops, conquered by the perfect *bodhisattva* Padmasambhava and conscripted to the Buddhist cause. Their leader, Dorje Yu Gronma, was a commanding figure who rode about on a mule; Miyo Lobzangma went mounted upon a tiger. These two exquisite figures capture some of the old, elemental wildness of these deities; their flowing robes and billowing sashes suggest ungovernable force. They were carved in wood then lacquered in gold by a Tibeto-Chinese craftsman at some time during the eighteenth century.

Much Tibetan legend surrounds the subjugation of the old deities by Padmasambhava, or, as he is also known in Tibet, Guru Rimpoche. This makes mythic sense, and not just because it reassured people that one of the wildest landscapes in the world had somehow been brought into subjection or that the country's pre-Buddhist *Bön* traditions had been tamed: it was important at the individual, spiritual level too, since it could be taken to symbolize the subjection of earthly desires and ambitions to higher things.

CREATED

Tibet

MEDIUM

Lacquered wood

SERIES/PERIOD/MOVEMENT

Eighteenth century

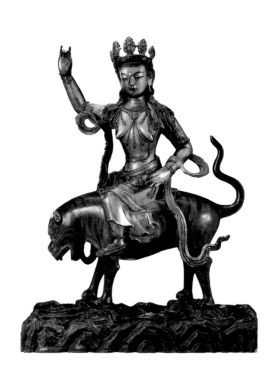
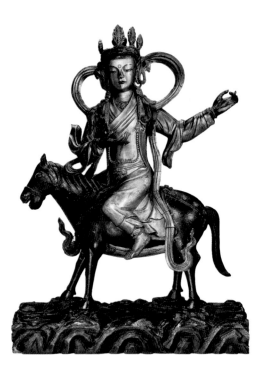

Java

Shiva Mahakala

Mahakala 'the Terrible' was also known as Bhairava, a monstrous manifestation of the great god Shiva. Although Hindu in his origins, he figured in Buddhist tradition too: clear evidence that there is more to that endlessly complex creed than gentleness and peace. He was widely associated with the phallic *lingam* symbol.

Appropriately enough, perhaps, he was the main object of religious devotion for the warlike state of Singasari, which came to the fore in Java, Indonesia, during the thirteenth century. Originally a Hindu kingdom, Singasari absorbed many Buddhist influences at this time, King Kretanagra building a combined shrine to Shiva–Buddha: a classic Hindu temple topped by a Buddhist *stupa*. Over the ensuing period, the kingdom collapsed and the island as a whole was progressively Islamized. As elsewhere in Java, however, Hinduism endured as an iconographic undercurrent in art. It was certainly evident in the eighteenth century, as this intimidating statue plainly shows.

CREATED

Singasari, Java

MEDIUM

Basalt

SERIES/PERIOD/MOVEMENT

Eighteenth century

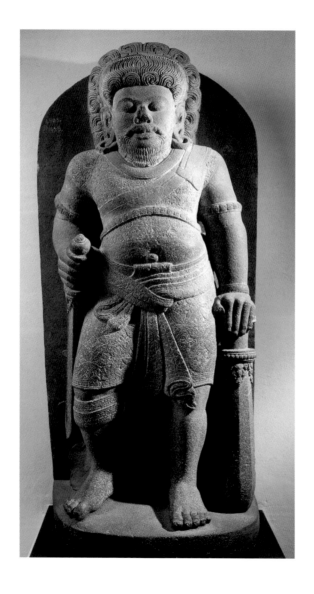

Burma (Myanmar)
Reclining Buddha

Despite the ravages of time, indeed because of them, this statue seems as beautiful today as the day when it was made in Burma (Myanmar) three centuries ago. Carved in wood and then gilded, it has lost much of its ornamentation, although we see just a hint of it in the hem across the chest and in the tight curls of the figure's hair.

Yet for all its silence, it speaks as eloquently as ever. The reclining figure, as all believers knew, represented the moment when the Buddha lay down to die, thus at last shaking off his material body and earthly cares. This moment was of profound significance for all Buddhists, for whom the leaving of life was the paradoxical point of existence: only in turning one's back on the world, its wants and its values, could one find spiritual fulfilment. Hence the persistent fascination with Shakyamuni's own experiences at the threshold between life and death, and the beauty of its evocations in so much Buddhist art.

CREATED

Burma (Myanmar)

MEDIUM

Gilded wood

SERIES/PERIOD/MOVEMENT

Early eighteenth century

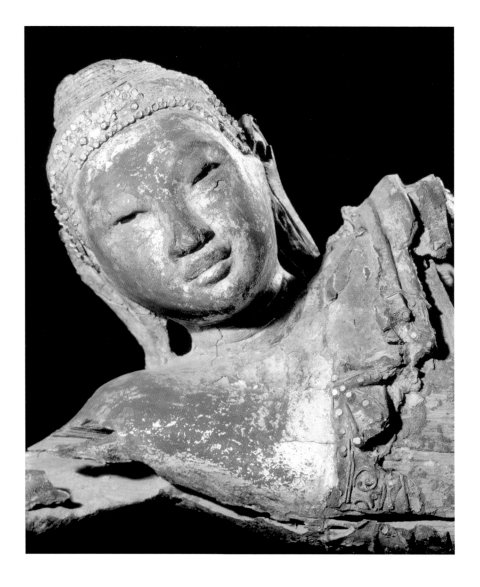

Japan
Monkey *okimono*

Okimono (literally 'display things') were little ornaments designed to be placed in the *tokonoma*, a special alcove in the Japanese living room, or increasingly as the nineteenth century went on to be sold abroad. As might be imagined, they did rather tend towards the whimsical and winsome, but it would be wrong to assume that they were nothing more than kitsch. Many were made by serious craftsmen and often they are works of real ingenuity and humour, like this macaque monkey made around the beginning of the nineteenth century.

Monkeys make frequent appearances in Japanese legend, literature and art, although there is ambivalence about the way in which they are regarded. Sometimes they are seen as cunning tricksters, their intelligence setting them apart from other animals; in other cases they are compared with a humanity whose slow-witted obstinacy they can be seen to exemplify. But *okimono* were made in all sorts of other animal forms as well, such as birds, snakes, dragons, crayfish and many more.

CREATED

Japan

MEDIUM

Gilt lacquered

SERIES/PERIOD/MOVEMENT

Edo period, late eighteenth/early nineteenth century

Japan
Fisherman figure

Ivory *okimono* depicting traditional trades, and almost invariably including children, were made in large numbers in the late nineteenth and early twentieth centuries. They were popular both on the domestic and export markets. This fisherman with a small boy, by Mitsutoshi, is typical of the genre. Easy as it may be to sneer at the sentimentality, it is hard not to admire the execution of this piece only 37.5 cm (15 in) tall: the sense of movement as the boy reaches for the shell, the sheer detail of the net bag, or the texture of the wet sand beneath the old man's feet.

Often, as we have seen, *okimono* were made by serious craftsmen, including swordsmiths and metalsmiths, but increasingly in the late nineteenth century a breed of specialized professionals arose. Many had learned their precision skills working on the tiny but exquisitely worked toggles or *netsuke* used to work the drawstrings on the traditional *inro*. After a lengthy vogue, *inro* were just beginning to go out of fashion in the Meiji period and *okimono* provided an obvious output for these craftsmen's skills.

CREATED

Japan

MEDIUM

Ivory

SERIES/PERIOD/MOVEMENT

Meiji period, 1868–1912

Mitsutoshi *Born* Japan, date unknown

Died Date unknown

China

Seated *Lohan*

The word *lohan* is said to have originated *a-lo-han*, the way Chinese speakers pronounced the Indian Sanskrit word *arhan*. This name, which simply meant 'ascetic', was given to the very first 16 companions of the Buddha and eventually came to be confined to these, his closest disciples. This particular sage is almost a metre tall: he is believed to have been made under the late Qing dynasty, but carries the mark of the Emperor Xuande (1426–35).

The historical homage is revealing. This was a time when China was in something of a ferment, both political and religious: two and a half centuries after their arrival from Manchuria, the Manchu or Qing were still resented as foreigners and other outsiders were coming in, bringing their religion and ideas with them. Christianity was catching on widely, but so too was the backlash: Buddhism, Tao and Confucianism all enjoyed a revival at this time and all took on a certain aggressive nationalistic edge. In 1900 China would explode with the rebellion of the Society of the Righteous and Harmonious Fist, better known to western historians as the 'Boxers'.

CREATED

China

MEDIUM

Bronze

SERIES/PERIOD/MOVEMENT

Qing dynasty, late nineteenth century

China

Buddhistic lions

These flamboyant lions seated resplendently on their intricately ornate rectangular bases were cast in bronze during the final decades of the Qing dynasty. In China, as in the West, the lion had originally stood for strength and courage, and it was for this reason that it was associated with good fortune. Over the centuries, however, that significance was steadily watered down: the lion eventually became an all-purpose talisman along the lines of the western rabbit's foot – and about as threatening.

Yet in the sort of uncertainty increasingly to be endured in China as the nineteenth century drew towards its conclusion, it is not hard to understand that a superstitious people would cling closer than ever to such traditions. The fixed conservatism of imperial China may often have been exaggerated, the scale of real change under-appreciated, but there is no doubt that modernity, and capitalism, were coming as a shock. As China's markets filled up with western consumer goods, the country's culture was assaulted by new ideas: it was a disturbing time for every section of society.

CREATED

China

MEDIUM

Bronze

SERIES/PERIOD/MOVEMENT

Qing period, late nineteenth century

Asian Art

Objets d'Art

China

Trinket box

Designed for keeping jewellery or trinkets, this box seems literally to have been stacked up in several different tiers. Although roughly circular in form, it is lobed for extra tactile interest and to allow the intricate gold designs to catch the light more intriguingly. Set against a deep blue background, the decorative work has been done to an exhilarating standard; foliate patterning and geometric forms alternating with scenes from nature, birds and flowers, and country life.

The inlay here is mother-of-pearl, the translucent lining taken from the inside of seashells. Having first been cut precisely to shape, the pieces would have been carefully set in the lacquer surface to create the design while it was still wet. Then a further layer of lacquer was applied on top to ensure a smooth surface. This delightful box was made in China during the Yuan dynasty (1260–1368).

CREATED

China

MEDIUM

Lacquer with mother-of-pearl inlay

PERIOD/SERIES/MOVEMENT

Yuan dynasty, 1260–1368

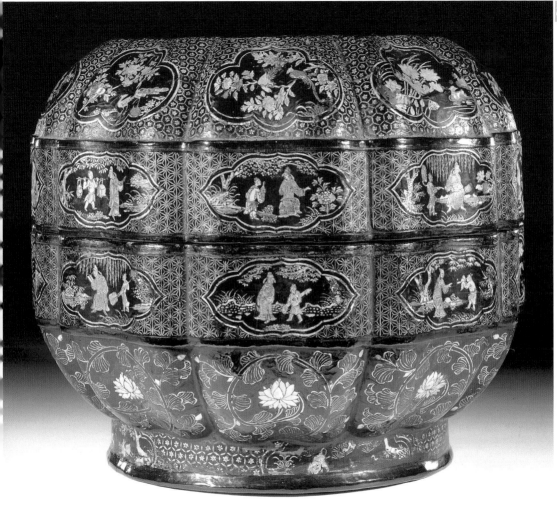

Cambodia

Vajra

Shaped like a double-tipped sceptre, with multiple points often curving inward at each end, the *vajra* is used in Buddhist prayers and rituals, often in conjunction with the bell. The *vajra* is believed to have originally been a symbolic thunderbolt, overlain with aspects of a stylized trident. Its name means 'hard' and its associations are overwhelmingly phallic and masculine, hence its use alongside the concave, and thus symbolically feminine, bell.

This *vajra* was made by a Khmer craftsman in Cambodia during the fourteenth century, at a time when Buddhist influences were creeping into several previously Hindu Southeast-Asian cultures. This should be seen as an evolution rather than some violent break with the past, as Buddhism was itself an outgrowth of Hindu tradition. Arguably more significance were the political changes taking place in the region, where the Thai kingdom of Ayutthaya was now in the ascendant. By the time the century was out, it would have eclipsed not only its rival in Thailand, Sukhothai, but the once-great Khmer empire itself.

CREATED

Cambodia

MEDIUM

Bronze

PERIOD/SERIES/MOVEMENT

Fourteenth century

Cambodia
Gilt-bronze palanquin terminals

These sublimely ornamented terminals would have fitted over the ends of the wooden poles of the palanquins (Oriental litters) used to carry important personages or divine effigies in ritual processions. Each is splendidly cast in the form of the garuda, the mythical creature, half man, half eagle, on which the great Hindu god Vishnu was said to ride. They were made in the thirteenth century, in the Angkor period of the Khmer empire and represent a *tour de force* of the metalworker's art.

There is a danger of the overwhelming magnificence of these astonishing objects crowding out our perceptions of their individual details, yet these repay the closest of attention. Note, for example, the precision with which the garudas' bulging eyes and outstretched arms have been executed, artistic extravagance never for a moment being allowed to outrun meticulous workmanship. The largest holds the tips of conquered serpents in his hands; and there are *kirttimukha*, sacred lion masks, front and rear above the socket for the pole.

CREATED

Cambodia

MEDIUM

Gilt bronze

PERIOD/SERIES/MOVEMENT

Khmer, Bayon style, thirteenth century

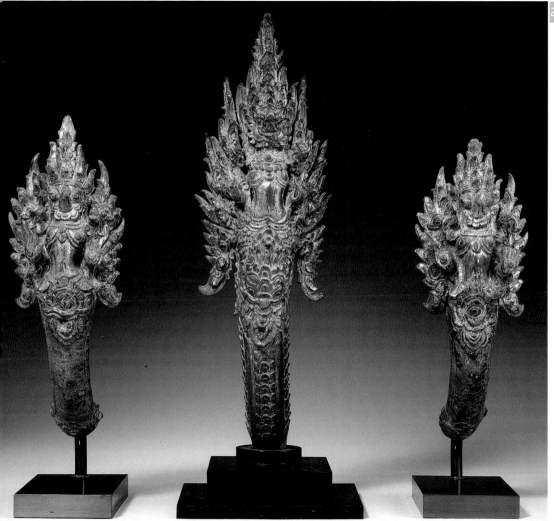

China
'Double Bird' vessel

Bodies pressed tightly together, their necks entwined and gaping beaks a single aperture, these birds have been beautifully fashioned out of bronze. Their form is taut, with a sense of living energy constrained, which makes it hard to see this wonderful sculpture in terms of mere ornament. Not that it is not attractive, of course: the birds' bodies have been inlaid with silver and gold to produce a striking feathered effect. This fine piece was made at some time during the Song (AD 960–1279) or Yuan (1260–1368) dynasties.

Strictly speaking, in the western tradition the phoenix was unique: only one existed at a time, and when its life ended, it burned itself in a pyre and emerged renewed from its own ashes. The term is used more loosely for Oriental art. The male bird does occur and is associated with happiness, but the female is far more often seen, a symbol of the empress and of feminine beauty and fertility. Seen together, however, two talismanic figures mean double the luck and, more specifically, the hope of a happy marriage.

CREATED

China

MEDIUM

Bronze inlaid with gold and silver

PERIOD/SERIES/MOVEMENT

Song (AD 960–1279) or Yuan (1260–1368) dynasties

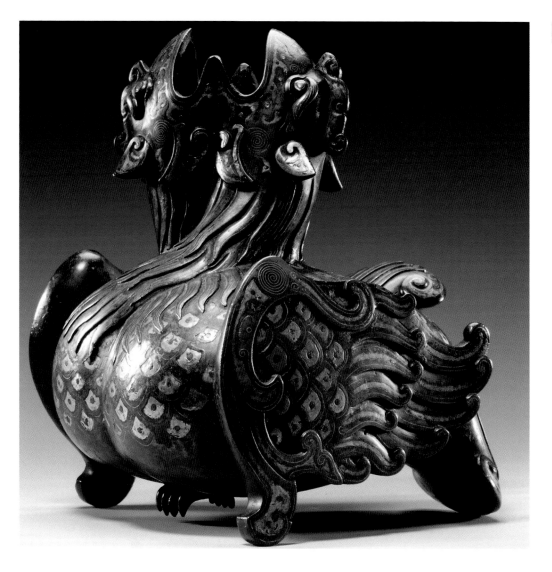

Cambodia

Bronze conch shell

The conch was used as a musical instrument in many ancient cultures: in Hindu tradition its trumpet blast was a sound of war. However, it was also held to represent the original echoing 'om' sound made by the universe in its moment of creation, as the world took shape in the churning of a primordial 'ocean of milk'. Gods and demons alike had been in attendance and either could have claimed the prize, but then the conch emerged from the waves and offered itself to Vishnu. When the god sounded it, the demons were frightened away and the fundamental benignity of the universe assured.

This fine conch of cast bronze features a dancing figure of Hevajra with female attendants on both sides and all framed by an arched mandorla of scrolling dragons. It was made by Angkor craftsmen in Khmer, Cambodia, towards the end of the twelfth century or at the beginning of the thirteenth.

CREATED

Cambodia

MEDIUM

Bronze

PERIOD/SERIES/MOVEMENT

Khmer, Bayon style, late twelfth/early thirteenth century

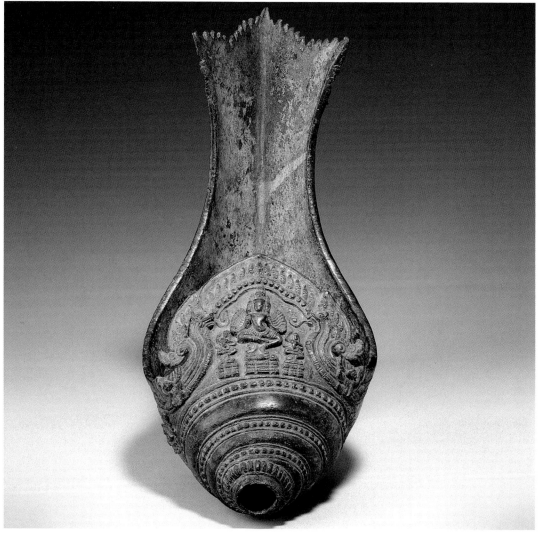

China
Raft cup

The Japanese *cha-no-yu* or 'tea ceremony' is famous: formalized with a hundred rules in the sixteenth century, it has become an act of meditation up to three hours long. Yet the original inspiration for such ritual came, just as the drink itself had done, from China, where tea was also traditionally taken very seriously.

Although often said to date back to some vague 'dawn of time', tea drinking is first recorded in southwest China in the time of the Han dynasty, around 200 BC, and it spread slowly northward through the first millennium AD. By the time of the Tang dynasty (AD 618–907), it had been adopted throughout China, and the steps of its preparation had been turned into a ritual. Buddhist monks took it to Japan and the rest is ritual history. The importance the Chinese invested in their tea and its associated ceremony is, however, attested to by this extraordinary *chabei* or teacup fashioned in the form of a floating vessel: it was made by an unknown craftsman during the Ming dynasty (1368–1644).

CREATED

China

MEDIUM

Rhinoceros horn

PERIOD/SERIES/MOVEMENT

Ming dynasty (1368–1644)

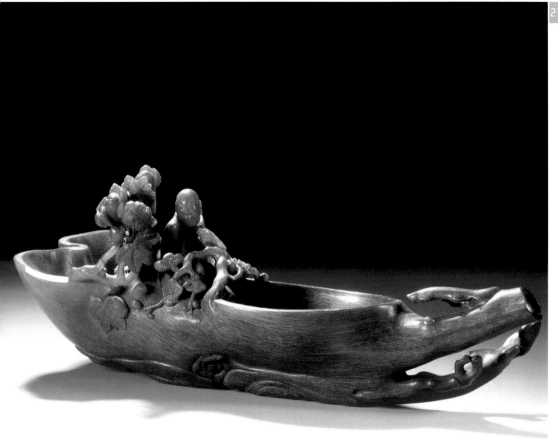

Tibet/China
Gilt-bronze mirror

The Guardians of the Directions stand sentry on the back of this stunningly decorated Tibeto-Chinese mirror of gilted bronze, made some time in the fourteenth or fifteenth century. Over 40 cm (16 in) in diameter, its lobed shape represents the eight-petalled lotus flower in stylized form, and the flower also figures prominently in the ornamentation.

The mirror was a ceremonial object in Buddhist culture, its reflections symbolizing spiritual insight and deemed to reveal a purified vision of reality: demons, it was held, would flee at the sight of their own reflections. At the centre of this one is a double *vajra* – or *dorje*, as it was called in the Tibetan tradition – in which this universal Buddhist symbol had a special significance. Unlike most other Buddhist peoples, the Tibetans were not farmers but nomadic pastoralists. They saw a resemblance in the *dorje* with the tent peg (as also described on page 94), and saw it as emblematic of the pinning down of the earth, the quelling of its demons and the taming of its landscape.

CREATED

Tibet/northwest China

MEDIUM

Gilt bronze

PERIOD/SERIES/MOVEMENT

Fourteenth/fifteenth century

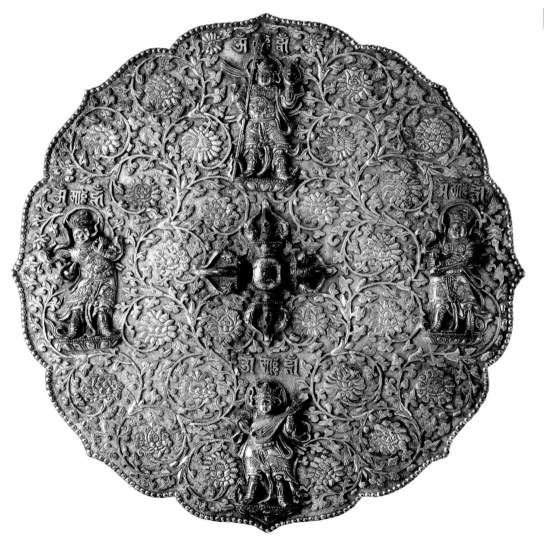

Thailand

Linga and *yoni*

The *linga* in Indian tradition represented masculine fertility, in the divine as well as the human and the agricultural spheres. It predated Hinduism, but was taken up by it, becoming closely associated with the figure of Shiva. He was regarded as the god of generation in conjunction with Shakti, the goddess of creative energy. Her symbol was the *yoni*, a symbolic representation of the female organ: the coupling of the two embodied all that was productive.

It was held in special veneration by India's farmers, who had an obvious interest in fertility, even giving the name *linga* to the digging sticks with which they broke the soil. Those Southeast-Asian kingdoms that subsequently adopted Hinduism were also founded on agriculture, of course: the *linga* and *yoni* were all but ubiquitous in the art and architecture of the region from the time of the Funan civilization (second century AD) on. Crafted in quartz, this fifteenth-century *linga* from Thailand is a prestige item, with a cylindrical cover; it is set in a gilt-bronze *yoni*, the symbolic representation of the female organ.

CREATED

Thailand

MEDIUM

Quartz *linga* and gilt bronze *yoni*

PERIOD/SERIES/MOVEMENT

Fifteenth century

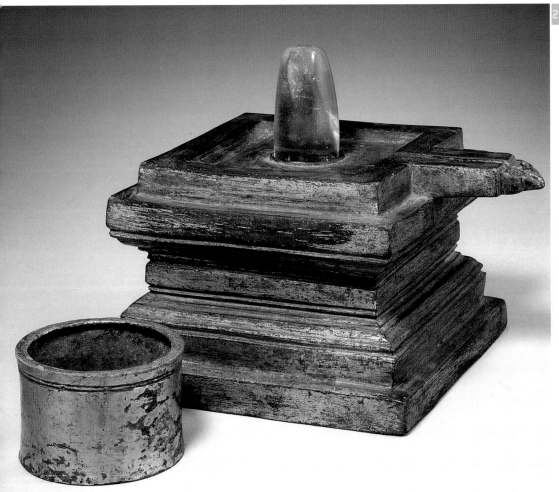

Tibet

Mandoria

This extravagant work in gilt copper was probably made to frame a standing statue or, possibly, a living personage, conferring the sort of glow of spiritual glory associated in western tradition with the halo. Made around the sixteenth century, it is a miracle of the *repoussé* metalwork for which the Tibetan craftsmen of this time were justly famed.

In five sections, it has at its centre a winged garuda (eagle man). Around its edges may be seen the auspicious emblems and at the bottom, with lions above and elephants below, the figures of Jampa (Maitreya) and Chenrezik (Avalokiteshvara). The first of these two *bodhisattvas* was widely revered in Tibet as the 'Future Buddha' and his rebirth on age would bring a heavenly age of purity and bliss. The second, probably the most-reproduced image in Tibetan art, was beloved for his compassion: the name Chenrezik means 'He who gazes upon the sufferings of the world with tears in his eyes'.

CREATED

Tibet

MEDIUM

Gilt copper

PERIOD/SERIES/MOVEMENT

c. Sixteenth century

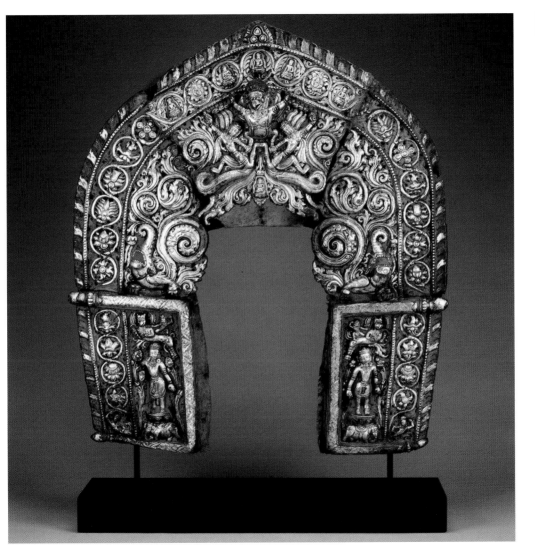

Burma (Myanmar)
Bronze drum

Music played a vital part in Buddhist ritual and the drum was especially important: its loud beating symbolized the commanding sound of the Buddha's voice. The association was thus strong between the drum and the *dharma* or divine doctrine, so the instrument appeared widely not only in ceremony but also in art.

This beautiful bronze drum, wide-topped, but cylindrical in shape, was the work of a craftsman in Burma (Myanmar) It was made some time in the fifteenth century or thereabouts. The concentric circles on the drumhead are decorative but symbolic too, suggesting the endless cycle of existence, of death and rebirth, which is known as *samsara*. The spoked wheel at the centre suggests the *dharmachakra*, or sacred wheel: traditionally this has eight spokes in honour of the Buddha's 'Eightfold Noble Path' to enlightenment. Yet Buddhist iconography is never straightforward: such symbols may have up to a thousand spokes, although in this case they are not regarded as 'wheels' but as the sun, the source of light and truth.

CREATED

Burma (Myanmar)

MEDIUM

Bronze

PERIOD/SERIES/MOVEMENT

c. Fifteenth century

Japan
Folding missal stand

This stunning lectern represents a fascinating marriage of East and West: it was made in Japan during the late sixteenth century or at the start of the seventeenth. The Spanish Jesuit missionary, St Francis Xavier, had only introduced Christianity to the country in 1549 when he landed at Kagoshima, at the southern tip of Kyushu and began his Japanese ministry. Within two years he had established a significant community with members in all the main cities of the country, and by 1614 there were some 300,000 converts to the creed.

Christianity appealed in part because it was associated with new technologies and new possibilities from the West. There was more to it than this, however: in an age known to Japanese history as the 'Epoch of a Warring Country', faction fighting between rival warlords was endemic, and the new religion seemed a spiritual haven amid so much violence and uncertainty. There was a strong traditionalist backlash, though: the first martyrs were claimed when 26 people were crucified in 1597, and in the 1630s Christianity was banned.

CREATED

Japan

MEDIUM

Lacquered wood and inlaid mother-of-pearl

PERIOD/SERIES/MOVEMENT

Late sixteenth/early seventeenth century

Korea

Document box

The art of lacquering came to Korea as early as 200 BC, when the country was under the domination of Han China. Nevertheless the technique took hold, and Korean craftsmen developed their own vigorous tradition. It was through their work that the art first captivated Japan. During the sixteenth and seventeenth centuries, at about the time when this wooden box was made, lacquerwork was only allowed under the auspices of the Choson court. This made for a degree of conservatism in design. The repetitive regularity of the patterning here is characteristic of early Choson work, as is the fact that the whole item is covered, leaving no significant space.

This taste is said to have originated in the ceramic arts of much earlier times, in the days when Korean-made porcelain had to be covered over completely with patterning in order to conceal its flawed surface. There was certainly no need for such precautions to be taken by the maker of this box. Beautifully and tastefully lacquered in black and inlaid with mother-of-pearl and other materials, it represents Oriental craftsmanship at its best.

CREATED

Korea

MEDIUM

Lacquered wood

PERIOD/SERIES/MOVEMENT

Early Choson dynasty, sixteenth/seventeenth century

Tibet

Bronze bell

Opposing principles are mystically combined in a single item here: the feminine bell and the phallic *vajra*, or *dorje*, as it was known in Tibetan tradition. Across the Buddhist world, as we have seen, the symbolic lightning-bolt dagger suggested masculinity. The bell's ringing suggested inspiration, the resonant voice of wisdom, but its form was symbolically feminine, given the empty concavity in which the sound was born. This counterpoint is underlined by the rings of two-sided *dorjes*, around the lower rim and shoulder of this bell, whose haft has the head of a crowned wise deity rising from a stylized lotus flower.

The bell was used in Buddhist monasteries to call the community to worship and as an aid to individual meditation. The pure, simple sound it made provided a focus for the mind attempting to slough off more mundane thoughts and preoccupations and thus attain a higher level of consciousness. This fine artefact dates from the sixteenth or seventeenth century.

CREATED

Tibet

MEDIUM

Bronze

PERIOD/SERIES/MOVEMENT

Sixteenth/seventeenth century

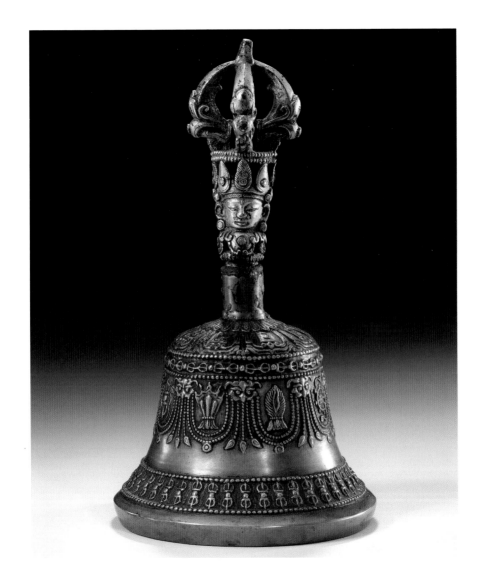

China

Box cover

This exquisitely-wrought box cover, dating from the reign of the Ming emperor Wan Li (1573–1619), offers a wonderfully human glimpse of everyday life in the China of the time. Set in the office of a magistrate, there is the tantalizing hint of a story here: who is the figure being steered away, a convicted criminal, an unsuccessful litigant? And why the scroll and the stylus, apparently flung to the floor?

It is even possible that a satirical point is being made: the magistracy in the Ming period is known to have been in some disarray. The Chinese magistrate was far more than a justice: he was the empire's representative at local level, responsible for everything for policing to maintaining roads. In order to assure their trustworthiness and prevent them from establishing potentially corrupting power bases of their own, magistrates were moved frequently and prohibited from serving in their home areas. This, however, left them ignorant of their jurisdictions, often even of the local language, leaving them wholly at the mercy of an emergent 'scholar-gentry' on whose local assistance they were forced to rely.

CREATED

China

PERIOD/SERIES/MOVEMENT

Ming dynasty, reign of Wan Li, 1573–1613

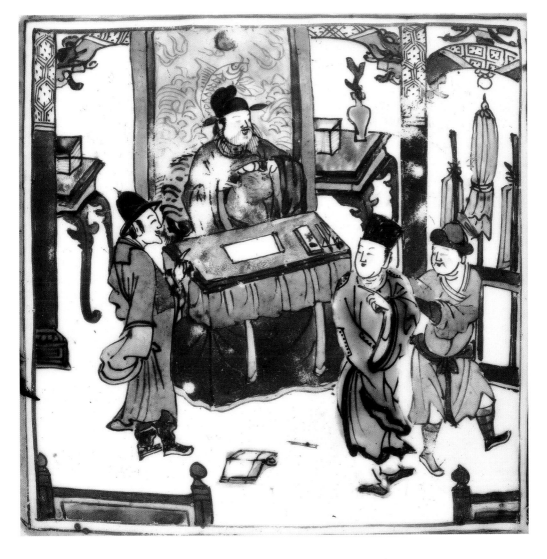

Japan
Barber's bowl

The big 'bite' taken out of one side of this attractive lacquered bowl shows that it was made for a barber when shaving his customers. Is it a mini masterpiece that was artistically 'overqualified' for such a mundane task? Not according to the conventions of the East. If Oriental tradition has had no place for the simply ornamental, neither has any special virtue been seen in mere functionality. Beauty is no add-on but part of the wider purpose of any object: that is what the seventeenth-century Japanese craftsman says so eloquently, if implicitly, here.

Japanese hairstyles, too, married function and form: there was a socially ordered code that was taken very seriously indeed. While the poor, as a badge of their lowliness, had their hair cropped very short all over, samurai shaved the tops of their heads but had the long hair from the back and sides of their head gathered into a queue or braid, which was then drawn forward and tied on top of the crown. Buddhist monks and nuns shaved off all the hair from their heads to symbolize their renunciation of earthly vanity.

CREATED

Japan

MEDIUM

Lacquer

PERIOD/SERIES/MOVEMENT

Seventeenth century

China

Celadon sceptre

Essentially a stylized lotus flower on its stalk, this sort of sceptre has been given as a gift in China for many centuries and is still widely given as a birthday present in the Chinese community worldwide. This type of sceptre was traditionally called a *ruyi*, which means 'may your wish be granted'.

Like many Oriental emblems it is fundamentally ambivalent. Its overall phallic form embodied the force of masculine Yin: emperors of the Qing dynasty (when this one was made) gave these sceptres to victorious generals and officials who had won their special favour by one means or another. Like the sceptre of the western monarch, it suggested temporal authority. However, at the same time, in keeping with accepted principles, the *ruyi* contained not only Yin but also Yang: the flower symbolized all that was feminine. Often it was embellished to suggest the form of a rain-bearing cloud, another recognized symbol of femininity and fertility.

CREATED

China

MEDIUM

Jade

PERIOD/SERIES/MOVEMENT

Qing dynasty, 1644–1911

Tibet
Censer

A minor miracle of metalworking, this Tibetan censer of the seventeenth century marries humble iron with precious gold and silver. The black metal has been damascened (etched in) with brighter inlays to produce lively friezes of lotus petals around the base and shoulder, and florid leaf and dragon forms around the main body and the openwork lid. The gaps in this would have been needed to allow the free escape of sacred smoke from the censer when it was used in the course of Buddhist ritual.

Incense played an important part in the ceremonial life of the Tibetan monastery. Its presence immediately charged the air with a sense of sanctity, banishing any thought of the secular or mundane. Its smoke rose gently heavenwards, like the thoughts of those gathered together in contemplation, and it obscured sensory vision, allowing a higher insight to be attained. Generally, fragrant woods such as juniper were used, with a mixture of musk and clay.

CREATED

Tibet

MEDIUM

Silver and gold damascened iron

PERIOD/SERIES/MOVEMENT

c. Seventeenth century

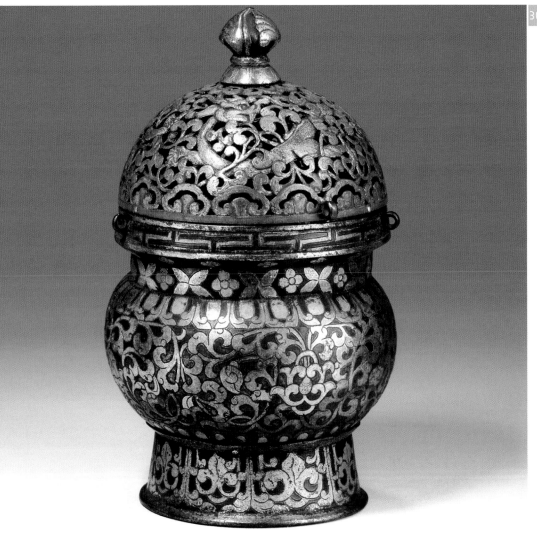

Japan
Bento box

The *bento* was a traditional form of Japanese box, with a compartmentalized interior. Some *bento* had drawers that were designed for taking food and drink out into the open for elegant picnicking. The black and gold look of this one is characteristic of the sort of *namban* lacquerwork that was produced by Japanese craftsmen in the seventeenth century. So is the subject matter: the artefacts of the time can be read as a running commentary on the reaction of a hitherto secluded society to the arrival of the western 'barbarians' in its midst.

The first of these had been the Portuguese traders whose ship had run aground on the coast of Kyushu in 1543, but more had followed, including St Francis Xavier. Shogun Toyotomi Hideyoshi had taken a tough line against Christianity, but other European imports (not least firearms) found more favour. In 1600 a new Shogun, Tokugawa Ieyasu, took in shipwrecked English seafarer Will Adams and kept him at his court for a number of years as an adviser. In 1641 Ieyasu took the decision to exclude all European traders except the Dutch, and they were restricted to Dejima, an artificial island in Nagasaki Harbour.

CREATED

Japan

MEDIUM

Lacquered wood

PERIOD/SERIES/MOVEMENT

Seventeenth century, Namban style

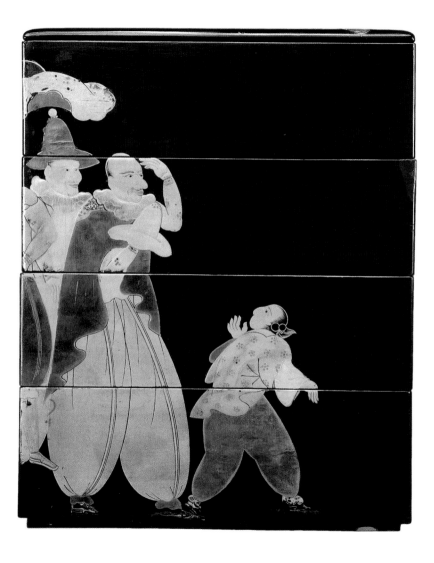

China

Red lacquer brush holder

Red lacquer was very much in vogue among the Chinese craftsmen of the late Ming dynasty (seventeenth century). It was meticulously carved to create designs of staggering intricacy. This little brush holder has a wonderfully intimate scene at court: a couple converses in what appears to be a pavilion in a luxuriant garden, while an attendant can be seen approaching from the left. Every detail is exquisitely captured, from the lush and fleshy foliage hanging overhead to the decoration of the building at the centre.

Thanks to the prints and paintings of the *Ukiyo-e* school we have a clear (if no doubt superficial) sense of what life must have been like in Japan's highest social echelons in the seventeenth century and after, but less is known about life in China's imperial court. The emperor and his circle confined themselves to the Forbidden City, and foreign visitors generally met them only in very formal circumstances. There will, however, certainly have been any amount of elegance and gracious living, with pleasure gardens and pavilions pretty much like the ones shown here.

CREATED

China

MEDIUM

Lacquered wood

PERIOD/SERIES/MOVEMENT

Late Ming dynasty, seventeenth century

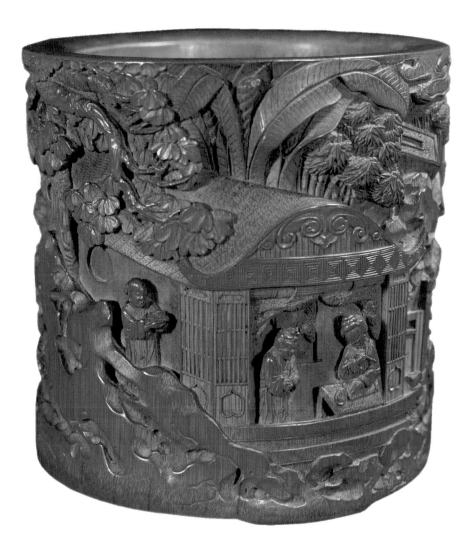

Japan
Sage-jubako picnic sets

Picnic sets of this sort were all the rage in the aristocratic society of eighteenth-century Japan, when the *Ukiyo-e* or 'floating world' tradition was at its height. Nothing better sums up the attitudes of this elegant elite, perhaps, than the care and attention that were lavished on those little touches that were seen as the secret of truly gracious living. Picnics on the lawns of pleasure gardens, or drifting gently down river on a well-appointed barge: these were the moments that courtly life was supposed to be about. No gentleman or lady of any eminence should have to eat or drink from any container on which anything less than the utmost skill and artistry had been lavished.

Like later European aesthetes, gentlemen and ladies at court felt that their daily lives should be works of art, at a time when artists were setting ever more glamorous standards for what that might mean. It could have all seemed absurd, even a bit gross, had not tastes been governed so vigilantly: it is hard to resist the beauty of artefacts such as these.

CREATED

Japan

MEDIUM

Lacquered wood

PERIOD/SERIES/MOVEMENT

Edo period, eighteenth century

China
The Eight Immortals Afloat

The Eight Immortals of Chinese tradition were ordinary men and women who won immortality for their virtue and the way they made the best use of their different talents. The story goes that, their work here done, they at last set sail together for heaven in a boat, their voyage a metaphor for mortal men and women's earthly journey. This is the scene so vividly re-created here by an eighteenth-century artisan, the Immortals crowded round by scholars and attendants.

The boat they plan to make their passage in is not a 'junk', which so fascinated the first western travellers, but the smaller 'sampan', still so widely used today in rivers and harbours through much of the Far East. Steered by a stern oar, its mid-section was often covered with a reed or bamboo canopy for shade and shelter, but this particular vessel must be too overcrowded: instead a forest of parasols protects the voyagers.

CREATED

China

MEDIUM

Bamboo

PERIOD/SERIES/MOVEMENT

Qing dynasty, eighteenth century

Japan

Inro

The Japanese name *inro* literally means 'seal basket' and it is possible that this distinctive type of container was originally used for carrying the wax seals used to close up and authenticate documents, although in truth its origins are obscure. Certainly by the seventeenth century such containers were used for carrying a range of different items, including medicine and tobacco, and the layered construction allowed a number of different things to be carried at the same time. The beauty of the *inro* is its perfect marriage of aesthetic form and functionality, a key principle of Oriental art.

Just as any presentation-conscious person would today, the Japanese gentleman saw items such as this as an expression of his personality and taste. For the craftsman too they offered an opportunity. The peonies on the right-hand *inro* here have been done with especial grace and subtlety. As in China, this flower was associated with prosperity and prestige.

CREATED

Japan

MEDIUM

Lacquered wood

PERIOD/SERIES/MOVEMENT

Edo period, eighteenth century

China
Elephants with clocks

Each of these beasts is 63 cm (25 in) from tusk to tail and only a little less than that in height: made in porcelain they are works of elephantine whimsy. Whose whimsy was it, though? For whilst many such items were made for export, the clocks these figures carry suggest another possibility, as if both had been made by leading London manufacturers. The emperor Qianlong (1736–95) is known to have had a passion for western technology in all its forms: could these elephants have been created for his diversion?

Almost as much ingenuity has gone into the conception and crafting of the elephants and their accoutrements as has gone into the making of their clocks. The yellow-ground blanket they carry sports a horse dancing through breaking waves, above a luxurious pink-tasselled fringe. The clock itself is set in a *cloisonné*-enamel vase adorned with scrolling lotus; the mechanism accessible through a lotus-shaped door. As a last, ingenious touch, the trunk of each elephant ends in the symbolic shape of a good-luck *ruyi* (as described on page 298).

CREATED

China

MEDIUM

Famille rose porcelain

PERIOD/SERIES/MOVEMENT

Qing dynasty, reign of Qianlong, 1736–95

Thailand

Manuscript cabinet

This spectacular cabinet was made in Thailand in the eighteenth century and the intricacy of the ornamentation almost takes the breath away. Across the front, deities and birds may be discerned amid a profusion of foliate and floral scrolling, while the recessed sides feature figures of mythical warriors. Although Thai decorative work had by this time long been influenced by Chinese traditions, some local preferences were nevertheless evident. Typically the gold leaf used here meant a slightly ridged and tactile surface: the Chinese taste was for a smoother sheen.

Thailand was in transition when this superb item was made: the Sukhothai civilization had faded long since but left an enduring artistic mark. Ayutthaya, since the fifteenth century the dominant power in the region, had never been able to surpass its predecessor culturally, and its craftsmen had drawn inspiration from Sukhothai. In 1767, in fact, much Ayutthayan art had been destroyed after the kingdom was invaded by Burma (Myanmar). Despite this the skills survived, as had the ingrained sense of an artistic inheritance, to allow the manufacture of the sort of masterpiece we see here.

CREATED

Thailand

MEDIUM

Lacquered wood with gold leaf

PERIOD/SERIES/MOVEMENT

Eighteenth century

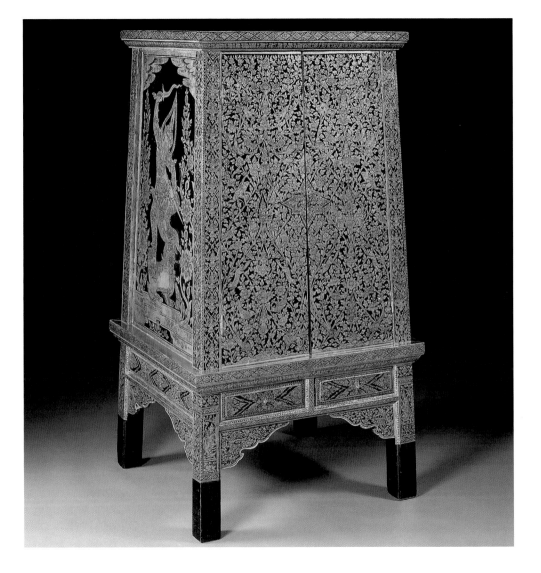

315

China

'Duck and Lotus' box

A duck makes its stately way through a tangle of lotus stalks and the whole scene is captured in carved white nephrite jade. The skill exhibited here is stupendous: the tough stone seems to have taken on the tenderness of the living plant, even though eighteenth-century artisan would not have been seeking what we think of as 'realism'. This piece was intended to charm, as indeed it does, especially when its symbolism is appreciated: the duck stood for joy; the lotus for truth, purity and enlightenment.

The lotus was one of the central symbols of Buddhism: emerging from mud, it strained upwards to the light where it bloomed in grace and beauty. To those raised in a western tradition, the trivial use of sacred symbols in good luck talismans may seem odd, almost irreverent, reducing what should be spiritual to mere superstition. Rather it should be seen as a mark of the pervasiveness of religion and the absence of any demarcation between the realms of the sacred and the secular: religious symbols have a place in every part of life.

CREATED

China

MEDIUM

Nephrite jade

PERIOD/SERIES/MOVEMENT

Eighteenth century

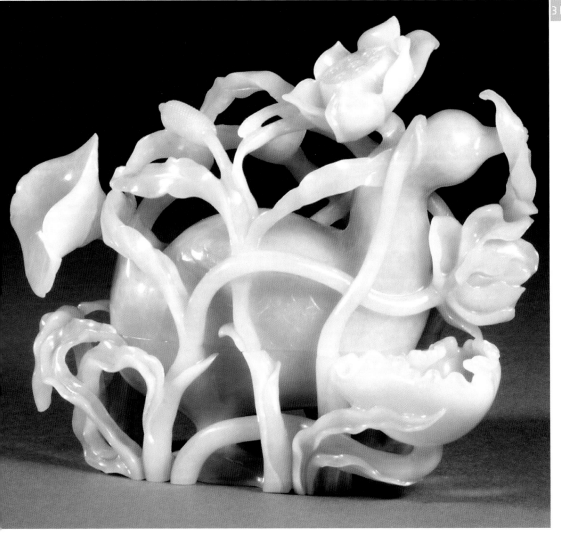

China

Four snuff bottles

Snuff, a powdered tobacco inhaled through the nostrils a pinch at a time, was introduced to China by European visitors in the seventeenth century. It caught on quickly becoming something of a craze, although frowned on by the authorities, and by the eighteenth century the snuff bottle was an essential accessory for every gentleman.

In style these were recognizably descended from the medicine bottles of the Song and Yuan dynasties, but the glamorous status of snuff gave eighteenth-century craftsmen the scope to go to town. Most frequently, bottles were carved in glass and painted with enamel colours; sometimes these were applied with ultra-fine brushes from the inside. Alternatively, different-coloured forms might be fitted one inside the other, with sections cut away so a pattern showed through. But glass apart, a range of more exotic materials was also used for making snuff bottles, including silver, bone, ivory, crystal, coral, lacquer, jade, amber, agate and other semi-precious stones.

CREATED

China

MEDIUM

Amber

PERIOD/SERIES/MOVEMENT

Qing dynasty, eighteenth/nineteenth century

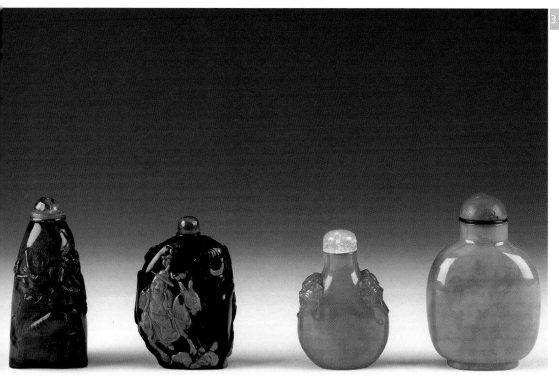

Tibet

Butter lamp

Copper lamps of this sort, which really do burn yak butter, are traditionally set on either side of the altar of the Tibetan Buddhist temple, their flames a living symbol of enlightenment and aspiration. For the most part they are ornamented simply, if at all. This nineteenth-century example, made in eastern Tibet or possibly Mongolia, is outstanding in its decorative richness and in its macabre theme: captured here in gilt-copper *repoussé* and silver are all the gruesome skulls, severed heads and skeletons of a Tibetan *memento mori*.

Yet as we have seen so many times, Oriental art is almost invariably paradoxical and, in the Buddhist scheme of things, death is the doorway to new life. That point is underlined here by the fashioning of the lamp's central section of silver into the form of the 'treasure vase', one of Buddhism's eight 'auspicious symbols'. This vase symbolizes the wealth of understanding to be found in the teachings of the Buddha, and it stands too for long life and prosperity in this existence.

CREATED

Tibet

MEDIUM

Gilt-copper and *repoussé* silver

PERIOD/SERIES/MOVEMENT

Nineteenth century

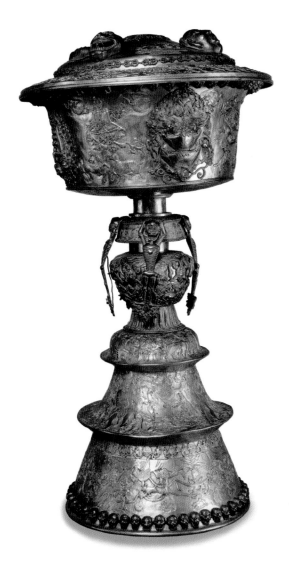

Indonesia

Javanese *gunungan*

The *gunungan* is used to punctuate a performance in the *wayang* puppet theatre of Java, to mark the beginning and the end, a scene change or some other especially dramatic moment. However, it carries more symbolic force than any curtain could in western theatre, its imagery underlining the fact that these plays with their narrative progressions involve transitions of a more significant sort.

Its distinctive pointed form simultaneously represents the Mountain of the Universe, Meru, and the Tree of Life, which grows out of the ground, but strives for heaven, and has many branches. Below, beneath flower symbols, may be seen the stronghold in which the spirit of life is stored. Fierce guardians with huge swords stand guard at the massive doors of this citadel. In this fine example there are cannon too, underlining the relative modernity of a piece that appears to have been made at some point during the nineteenth century.

CREATED

Java, Indonesia

MEDIUM

Wood, painted hide

PERIOD/SERIES/MOVEMENT

Nineteenth century

Japan
Sword fittings

In medieval times, when civil warfare was endemic in Japanese life, swords were tools for killing, no more and no less. The attitude towards them was relatively utilitarian. That said, blades were superbly crafted and since, as we have seen, style and function are never separated in Oriental art, such early weapons were never anything less than handsome.

It was really only later, paradoxically as the samurai tradition became more a matter of social status and a mark of breeding, that care was lavished on the way swords looked. They were still made to the highest functional standards, but in an age in which firearms were making old weaponry redundant, this was more about personal and patriotic pride than anything else. By the nineteenth century, many sword fittings were artistic masterpieces in miniature. Especial care was taken with the *kashira* (centre), a metal design placed upon the pommel, and the *fuchi*, a strip ringing the haft just above the hilt (left and right).

CREATED

Japan

PERIOD/SERIES/MOVEMENT

Late Edo/Meiji period, nineteenth century

Indonesia

Javanese puppets

The *wayang* puppet theatre of Java is famous the world over. Best known, however, is *wayang kulit*, in which the images of two-dimensional shadow puppets are projected on to a screen. In Sunda in western Java, though, the tradition of *wayang golek* has prevailed, in which richly painted and colourfully costumed wooden marionettes are used.

The subjects are the same: long re-enactments of episodes from the Hindu epics, the *Ramayana* and *Mahabharata*. As we have seen, the island of Java has not followed Hinduism since the fifteenth century: today Indonesia is considered the world's largest Islamic country. Yet it was multicultural from the first: tradition has it that the earliest Muslim missionaries or *wali* used the *wayang* puppets to preach their message to the people. The *gamelan* orchestra has always been used to accompany performances in the *wayang* theatre: its sound suggests the voice of divine inspiration; the shape of its gongs is reminiscent of the female sexual symbol, the *yoni*. But this traditional music too has been given an Islamic turn, by its use each year to celebrate the birthday of the prophet Muhammad.

CREATED

Sunda, Java, Indonesia

MEDIUM

Painted wood

PERIOD/SERIES/MOVEMENT

Nineteenth century

Thailand

Dasakantha

Thailand has its own version of the shadow puppet theatre and its own version of the *Ramayana*, known as the *Ramakian*. The traditional Hindu epic tells the story of Prince Rama and his heroic quest to rescue his beloved Princess Sita from the clutches of her evil abductor, Ravana, wicked king of Ceylon.

The *Ramakian* is a quarter as long again as its original Indian source, with a good many extra episodes woven into the main narrative. The main difference in emphasis is the attention lavished on the life and character of the irresistible arch-villain, in this case renamed Dasakantha. Here, his eyes darting malevolence, the stiff leather cut to give a far greater fluidity and expression than might have been imagined, the evil genius is seen with two (literally inseparable) wives. As in Indonesia and Malaya, the puppets for use in Thai *Nang* theatre are cut out of stiff-dried buffalo or cowhide. This one was made during the nineteenth century.

CREATED

Thailand

MEDIUM

Dried leather

PERIOD/SERIES/MOVEMENT

Nineteenth century

Tibet
Seal of the Dalai Lama

Two dragons intertwine; above them a single lotus flower opens to heaven, below them a square base surrounded with some mesmerizing scrollwork. This is the gilt-iron handle for the seal of the Dalai Lama.

Tibet's spiritual leader is believed to be a reincarnation of the Buddha; as each one dies, he is reborn in another boy. There have been fourteen Dalai Lamas since the title was first conferred on the leader of the Geluk or 'Yellow Hat' school in the fifteenth century, but these are regarded as fourteen successive apparitions of the same individual. The system may be spiritual in justification but it works from a worldly point of view, as an official explained to the Italian anthropologist Fosco Maraini in the 1940s: it has all the advantages of a hereditary system in guaranteeing stability, but also those of election in assuring new blood at every stage. The Great Fifth Dalai Lama, for instance, was a humble peasant's son: this seal is a modern copy of one given to him when he visited the Qing court in 1653.

CREATED

Tibet

MEDIUM

Gilt iron

PERIOD/SERIES/MOVEMENT

Nineteenth century, based on seventeenth-century design

Asian Art

Textiles & Accessories

China

Ksitigarbha, Judge of Hell

This popular *bodhisattva* gave hope as his radiance could illuminate every corner of hell, it was said. Here he guides and consoles the dead on their way to the underworld. The *bodhisattva* was defined as an individual who had succeeded in attaining the divine state of nirvana, and so escaped *samsara*'s endless swirling cycles of life and death, but who had elected to forego that bliss in order to help other living creatures along the way. His specific association with death and the underworld, however, give Ksitigarbha a special status as saviour, especially in the early Tibeto-Chinese tradition, and his role is analogous to that of Christ in the medieval tradition of the 'Harrowing of Hell'.

Buddhism reached China in the first century AD, but its real spread came later, through a succession of invasions from the steppes. It brought with it central Asian influences then, and if there is much that is stiff and stilted in this tenth-century painting on silk from Dunhuang, a northwestern pilgrimage centre, there are also pointers to new possibilities in Chinese art.

CREATED

Dunhuang, northwest China

MEDIUM

Paint on silk

PERIOD/SERIES/MOVEMENT

Tenth century

336

China
The White Eagle

The Song dynasty (AD 960–1279) has had the reputation of representing a golden age for Chinese embroidery. This magnificent white eagle gives an idea why and it is not just the detail of the (slightly ruffled) plumage, although that is staggeringly lifelike. The skill is in the simple-yet-striking composition: the dramatic contrast between foreground and deep, dark background; the stark right-angle made by bird and perch; and the unexpected looping grace of the green and yellow leash and jesses of the eagle and in the touch of colour they introduce.

We tend to associate the sport (should that be art?) of falconry with medieval Europe and the Middle East. A Hittite frieze from the ninth century BC shows that it was practised in Mesopotamia, although it was certainly ancient even then. China can boast the first written reference to falconry (seventh century BC) and it was probably imported from central Asia. The eagle is not the best of hunting birds: it is lazy in its lordliness and can fast for long spells so is hard to keep keen, but there is no doubt that it makes a splendid status symbol!

CREATED

China

MEDIUM

Embroidery on silk

PERIOD/SERIES/MOVEMENT

Song dynasty, AD 960–1279

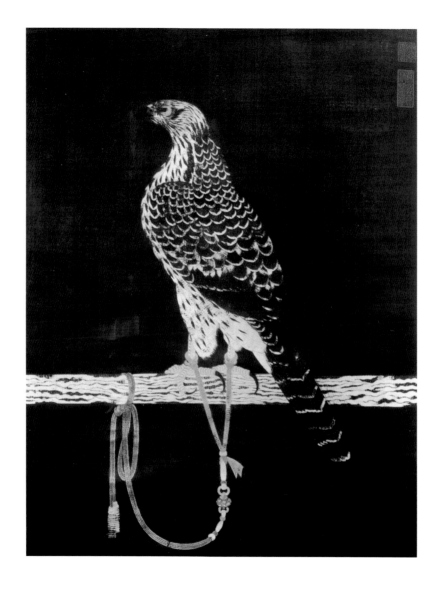

Tibet

Portrait of the Great Thangpa

Taglung Thangpa (1142–1210) founded the Taglung Monastery in 1180 and with it an important lineage of lamas (monks) of the *kagyü* school of Tibetan Buddhism. The word *kagyü* literally means 'oral tradition', and the practices of this school have been handed down through an unbroken line of followers since the first yogi sat immovable in meditation for a dozen years. Such teaching dynasties are all-important to Tibetan Buddhism, so much so that, as we saw with the example of the Dalai Lama (see page 330), they are not seen as representing successions of separate lamas but as the continuance of a single inspirational voice.

Taglung Thangpa is still very much a presence, and so eminent a *bodhisattva* fully merits this splendid textile portrait done in the decades after his death by an unknown follower in opaque watercolours and gold leaf on a cotton background. The portrait shows him sitting meditating in his monastic robes, framed by an archway and mandorla and surrounded by mythical beasts and major *bodhisattvas*.

CREATED

Tibet

MEDIUM

Opaque watercolour and gold on cotton

PERIOD/SERIES/MOVEMENT

Thirteenth century

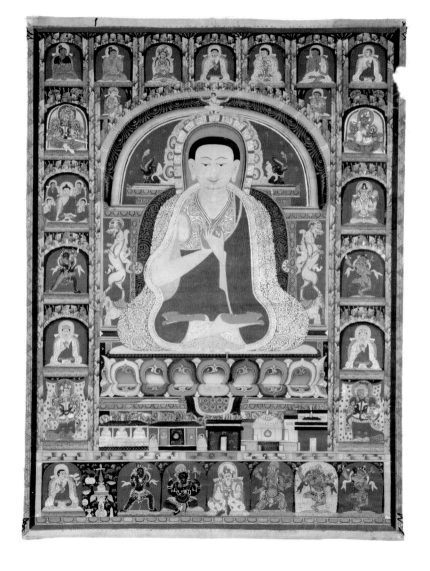

China
Rain and cloud *K'ossu*

Many western preconceptions have to be put aside for a proper understanding of eastern art, among them the association of dragons with fire. Also to be suspended is the assumption that a fine day is a sunny one, and the idea that there is something dismal and depressing about clouds and rain. On the contrary, the phallic dragon and feminine cloud are both associated with life-giving water, which makes this marvellous tapestry a joyful work indeed. *K'ossu* or *kesi* (silk tapestries) became the quintessential Chinese textile form in the tenth century, but this one dates from the late Ming period (sixteenth century).

Twin phoenixes fly across the top of this *K'ossu*, framing a happy sun: a pair of birds such as this signals success in marriage. Typical of eastern art is the dissolution of figurative into ambiguous, semi-abstract forms, the clouds becoming mountain tops, for example, or are they waves? There is an element of artistic *esprit* here, but also, in the oneness of creation implied, what the western viewer might see as a more serious philosophical point.

CREATED

China

MEDIUM

Weave with silk and peacock feathers

PERIOD/SERIES/MOVEMENT

Late Ming dynasty, *c.*1600

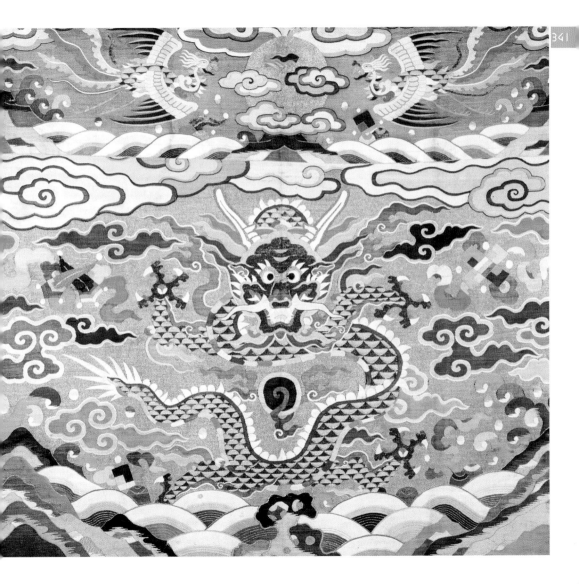

China
Bird and flower *k'ossu*

The palette used in traditional Chinese tapestry or *k'ossu* tends to be subdued, but effects of the utmost warmth and colour may still be achieved. This remarkable tapestry, created in the fifteenth or sixteenth century (early Ming), never strays far beyond the realm of russet and brown, yet it remains arresting and strikingly modern in its impact. Flowers and birds alike have been cunningly incorporated into the overall decorative scheme: they are part of the pattern first, a figurative subject only second.

Faced with a fabric of this beauty it is easy to understand why in the western mind for so many centuries, the Orient should have been above all a dream of silk. In ancient times it was the most exotic of imports, brought via the 'Silk Road' through central Asia; not until the sixth century did two monks risk their lives to smuggle silkworm eggs and mulberry leaves back to Byzantium. By the time this tapestry was made, Europe had its own silk-making industry centred on Italy, but textiles of this stupendous quality lay out of reach.

CREATED

China

MEDIUM

Embroidery on silk

PERIOD/SERIES/MOVEMENT

Ming dynasty, fifteenth/sixteenth century

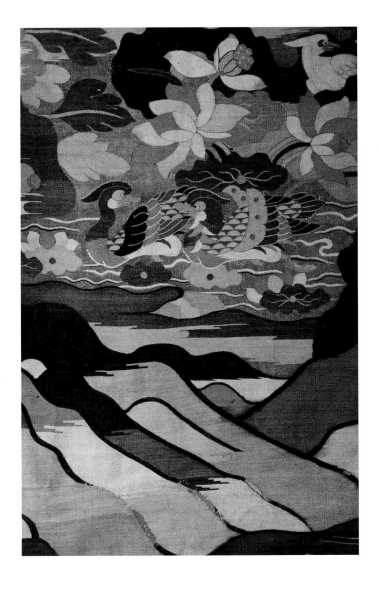

Tibet

Hevajra

The god known to Indian tradition as Hevajra was known to Tibetan Buddhists as Kye Dorje: his image is to be found very widely in religious art. Adding to the maelstrom of flailing hands are those of his *shakti* ('spirit of feminine energy'), locked in ecstatic sexual union with the deity even as he dances. Their congress was held to represent the fusion of feminine wisdom with male compassion that was central to a true understanding in the Tibetan Buddhist scheme. Together such a couple was called a *yab-yum* ('father-mother').

The dynamism of this image is striking, even in its now clearly degraded state. It was made in gouache on silk, the central couple framed by a richly ornamented wheel of life. This was a widely recognized symbol of *samsara* and of eternal change in continuity. Around the edges of this *thankga* or temple hanging, made some time during the seventeenth century, are the figures of various *bodhisattvas*.

CREATED

Tibet

MEDIUM

Gouache on silk

PERIOD/SERIES/MOVEMENT

Seventeenth century

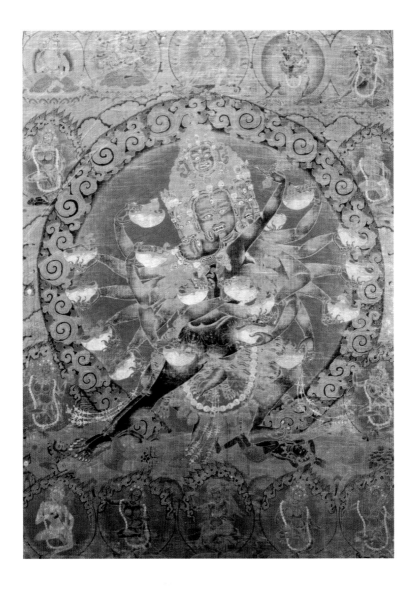

Japan

Kabuto

The Japanese art of armour-making merits attention in any consideration of Oriental textiles, given the ingenious use of silk and leather that was involved. Silk strips were laced together cunningly with leather strips to produce both flexibility and strength, a technique beautifully displayed in the construction of this imposing *kabuto*, or helmet, made in the seventeenth century.

Forty-two *suji-bachi* or 'ribs' were used to make the crown in this case; further strips were laced in rows to form the *shikoro* or neck protector. Additional protection against downward blows was afforded by the *tsunomoto* (a pair of curved plates), which rises above the peak or *mayezashi* on either side. The *mayezashi* was important not only in warding off blows and glare from the sun: frequently it was lacquered bright red on the underneath so as to cast a lurid and intimidating glow on the face and the iron visor with which it would have been covered. Above is the *mayedate* or fore crest: this showed the warrior's *mon* or family badge.

CREATED

Japan

MEDIUM

Silk and leather

PERIOD/SERIES/MOVEMENT

Early Edo period, seventeenth century

Tibet

Ritual apron

Beads of bone strung in double strands between square plaques representing deities, auspicious symbols and stylized flowers make up this extraordinarily exotic apron from Tibet. Ringing the red belt at the top are larger pointed plaques, whilst along the lower edge, above the blue-black tassels, is a row of elaborately ornamented lion masks.

An object such as this one transports us immediately into the exotic and even slightly unsettling world of the Tantras, a series of mysterious texts written down in India in the sixth and seventh centuries AD. Basically the Tantras set down the dialogues between the great god Shiva and his feminine *shakti*, Durga ('The Inaccessible'). Tantrism was an unabashedly mystic cult whose aim was to tap into the spiritual energy believed to be generated by this divine coupling. Not surprisingly it is one of the least understood aspects of Buddhism; to the outsider its *gyu* or rituals sometimes smack a little of sorcery. Aprons of this sort were worn by tantric priests for certain ceremonies. This one was made some time between the seventeenth and nineteenth centuries.

CREATED

Tibet

MEDIUM

Bone

PERIOD/SERIES/MOVEMENT

Seventeenth–nineteenth century

Tibet

Tapestry depicting Chenrezik

Chenrezik or Avalokiteshvara had 11 heads and 1,000 arms with an eye on each hand, which gives some sense of just how multifaceted a figure he was and how complex the ideas that surrounded him. He is usually described as the *bodhisattva* of compassion, which, while true enough as far as it goes, gives no hint of the range of attributes he encompassed in addition to omniscience and all-powerful strength. No figure appears more often in Tibetan art than the *bodhisattva* seen as a sort of 'patron saint' by the people of the country. It is ultimately he who is believed to be incarnated in the Dalai Lama.

This eighteenth-century Tibetan tapestry shows him being adored by devotees. Palms together before his heart, he makes the *anjali mudra* gesture of offering with his foremost hands; others hold a wheel, a *mala* ('prayer beads'), a lotus flower and a bow (whose arrowhead symbolized spiritual concentration). The remainder of his arms have not been forgotten but, as is often the case, have resolved themselves into a blur, which here suggests a splendid silver halo.

CREATED

Tibet

MEDIUM

Silk embroidered tapestry

PERIOD/SERIES/MOVEMENT

Early eighteenth century

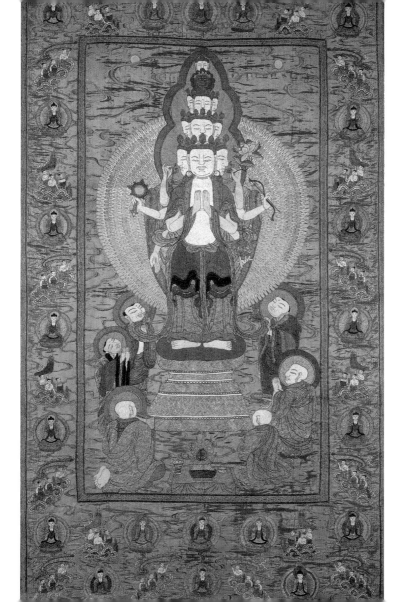

Burma (Myanmar)
Tapestry depicting figures in a garden (detail)

Burma (Myanmar) has a long and distinguished textile tradition: praises were lavished on its weavers by visitors from Tang China (AD 618–906). In the eighteenth century, however, craft workers, who had been brought as captives from northwest India, introduced new and extra-prestigious techniques for making tapestry. It was at about that time that this fine fabric was produced. It shows figures kneeling and bowing in a beautiful garden; its magnificence suggested with great economy by multicoloured strips. A sprinkling of sequins completes the splendid scene.

The peaceful scene shown here gives no clue to the tumultuous times in which it was made: the eighteenth century saw one empire fall and another rise in Myanmar. After rotting away through division and unrest through a century and a half, the Tougou dynasty, with its base in the centre of the country, was brought down by a rebellion of Mon southerners in 1752 and Alaungpaya established the Konbaung dynasty. Myanmar's power now grew so quickly that in 1767 Alaungpaya's son and successor, Hsinbyushin, could sack Ayutthaya, Thailand, thus making Myanmar the major power of Southeast Asia.

CREATED

Burma (Myanmar)

MEDIUM

Tapestry

PERIOD/SERIES/MOVEMENT

Eighteenth century

China

Emperor Afloat

The dragon-prowed junk of the emperor Yang Ti is manoeuvred by labourers on the bank of the Grand Canal in this scene painted on silk in the eighteenth century. A ruler of the short-lived Sui dynasty (AD 581–618), Yang Ti did more than any other ruler to open up this 1,600-km (994-mile) waterway, creating a clear north-south route between Beijing and Hangzhou. He intended it as an economic artery, rather than as a playground for pleasure cruises of the sort the craft workers of the Qing dynasty envisage here.

Here, indeed, we have a floating emperor who would not have been out of place in Japan's 'floating world', though works of the *Ukiyo-e* tradition tend to favour intimacy over this sort of panorama. The wider field of vision also offers a more general social prospect: we have the sense of an ordinary, workaday life going on in the background and see sweating, toiling men having to haul on the imperial vessel. Even so this is a delightful work, as fine in its overall design as in its detail, in the best tradition of classic Chinese art.

CREATED

China

MEDIUM

Painting on silk

PERIOD/SERIES/MOVEMENT

Qing dynasty, eighteenth century

遊幸江都

Tibet/China

Chuba

The *chuba* is a traditional garment worn by both sexes in Tibet and dating back at least until the eighth century. This sumptuous yellow-ground brocade gown is far more recent, having been made by Tibeto-Chinese hands in the eighteenth century, but conforms to the classic styling in every way. Characteristically, an excess of fabric is allowed for tucking underneath the arm and tying behind, leaving a large area for decoration, exploited here to the full.

The exact age and origins of any Tibetan *chuba* are often difficult to establish with absolute certainty, as many were adapted from earlier gowns cut in the Chinese style. Either origin, Tibetan or Chinese, would be possible here, given a design that draws on a Buddhist iconography well established in both countries at this time. Rising above the waves of a sea of suffering, the dragons clutch at flaming pearls, symbolic of the soul's striving for wisdom. Other auspicious symbols are also visible.

CREATED

Tibet/China

MEDIUM

Brocade

PERIOD/SERIES/MOVEMENT

Eighteenth century

Tibet

Kalachakra dance mask

In certain rituals conducted under the Kalachakra tradition of Tibetan Buddhism, lamas wear masks such as this one made in gilt-copper *repoussé* from the eighteenth century. Ornate as they often are, the purpose of these masks is actually to simplify, to reduce the complexities of the individual face to its conventionalized, even caricatured, outline. This, in other words, is the face of 'everyman'; the essential form of that common humanity in whose name all such rites are ultimately taking place.

Kalachakra means 'the wheel of time', the name of the most mysterious of the Tantras, reputedly brought to Tibet by Tsi-lu-pa in AD 966. The text appears to have originated in India, but Tsi-lu-pa supposedly claimed to have brought it from an earthly paradise beyond the Himalayas called Shambhala. This land is described within the Kalachakra too, although clearly in what we would see as an allegorical symbol for a stage just short of complete enlightenment and nirvana. Nevertheless belief in its existence still survives, not just in Tibet but also in the West, where it inspired James Hilton's *Lost Horizon* (1933) with its famous land of Shangri-la.

CREATED

Tibet

MEDIUM

Gilt-copper *repoussé*

PERIOD/SERIES/MOVEMENT

c. Eighteenth century

China/Japan
Embroidered panel

There is a distinctly Disney-style look about this nineteenth-century embroidered panel, clearly made for export, so much so that its origins are difficult to pin down. Executed in what appears to be an all-purpose 'Oriental' style, it is not even clear whether it comes from China or Japan.

Notwithstanding its uncertain origins and a tone that seems, to modern tastes, over-charming, this is undoubtedly an admirable piece of needlework. A variety of different techniques are employed to impressive overall effect. The multicoloured leaves have the look of sequins, so closely are the stitches clustered; the figures in the foreground stand out bold and clear and there is a quirky sense of movement and life about them. The pure white chalk lines of the clouds are discreetly echoed by broader but dimmer bands of grey in the background: depth is produced by hints and suggestions in the best tradition of Oriental art.

CREATED

China/Japan

MEDIUM

Embroidery on panel

PERIOD/SERIES/MOVEMENT

Nineteenth century

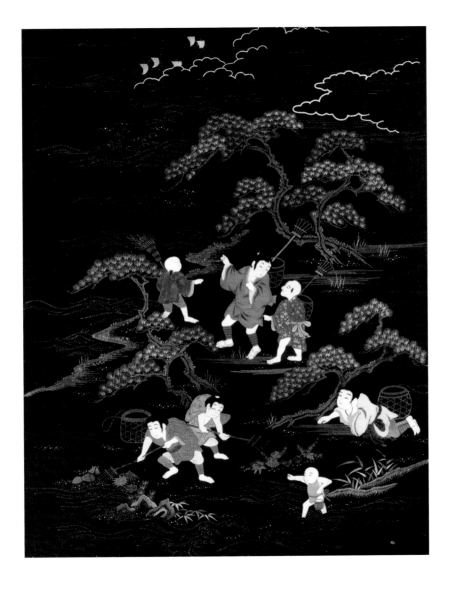

Japan
Netsuke

The kimono of the Japanese gentleman did not traditionally have pockets, so he had to carry anything he wanted to keep with him some other way. Hence the long history in Japan of little bags for this and cases for that, all generally having to be hung from a belt about the waist.

The cords used for doing this, and the drawstrings used to close and open bags and purses, were loosened and tightened with little toggles called *netsuke*. Over time these developed into one of the most distinctive forms of Japanese art. They come, if not in all sizes (generally speaking, they're just a centimetre – about half an inch – or so across), then certainly in all shapes, with craftsmen apparently vying to produce the most ingenious and improbable they could think of, as in these nineteenth-century examples. If Japanese art has had a fault historically, it has been its tendency to be constrained by convention: with *netsuke* the craftsman had free rein.

CREATED

Japan

MEDIUM

Ivory

PERIOD/SERIES/MOVEMENT

Nineteenth century

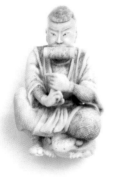

Japan
Furisode kimono

By the standards of a strongly traditionalist Japanese culture, the kimono is a comparative newcomer. Not until the tenth century did upper and lower undergarments start being sewn together and one of the world's most distinctive costumes came into being. The elegant style we see today dates from the sixteenth century: a time of bitter civil conflict and, paradoxically, prosperity.

In the last generation or so, Japan has been re-stereotyped in western perceptions, from mysterious Land of the Rising Sun to Tiger Economy. So familiar has the sight of the Japanese male in his business suit become that the kimono is widely assumed to be a women's garment. In fact both sexes wore these gowns and both men's and women's versions could be stunningly beautiful, although those designed for women were more likely to be 'pretty'. A kimono in the *furisode* style was worn by a girl at her coming of age: its full-cut sleeves hung down impressively, marking it out from the usual *kosode*. Kimonos are handed down as heirlooms. This one adorned with bamboo leaves and plum blossoms is relatively modern, dating from the nineteenth century.

CREATED

Japan

MEDIUM

Silk damask

PERIOD/SERIES/MOVEMENT

Nineteenth century

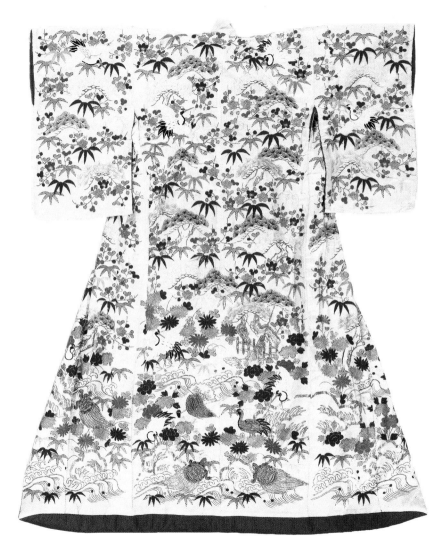

Japan
Tobacco pouch and pipe holder

Tobacco reached Japan even more recently than it did Europe, brought by Portuguese traders in the 1570s. By the eighteenth century, however, the fashion was well established and every well-born gentleman had his own set of accoutrements. The pipe, or *kiseru*, was comparatively slender, its tiny bowl holding only a pinch of tobacco, so its case, though some 20 cm (8 in) long, was only about 2 $\frac{1}{2}$ cm (1 in) in diameter. It was clipped to an ornate purse, which might be made of leather or, as here, a richly ornate textile weave.

It says much about Japanese art in general that the maker of this pipe case was Ikeda Taishin (1825–1903). He was a distinguished painter, so much so that he was made a member of the Imperial Fine Arts Academy with his place at the Meiji imperial court. Yet he still found time for craftwork, which he valued highly, especially work in lacquer, an art whose previous decline in Japan he and his circle did a great deal to arrest.

CREATED

Japan

MEDIUM

Textile purse, lacquer-work pipe holder

PERIOD/SERIES/MOVEMENT

Nineteenth century

Ikeda Taishin *Born* 1825 Japan

Died 1903

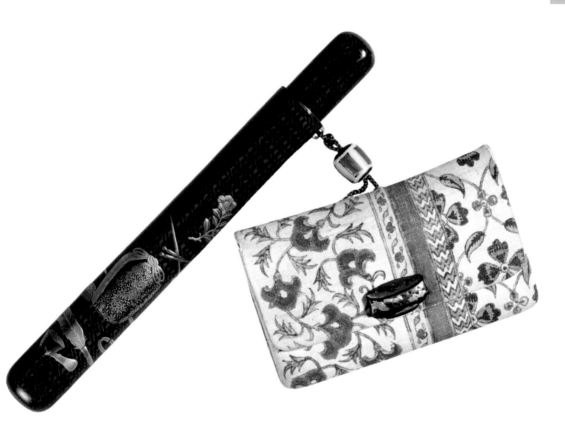

China
Ikat robe

Culturally, Xinjiang province belongs to central Asia, its natives the steppe nomads that the Chinese spent centuries learning to fear. Successfully subdued now, it is still seen as a wild frontier, but if it is a place of menace, it is also a place of romance. From Persian carpets to Mongol felts, the steppe nomads have always had a way with textiles: *ikat* is the Xinjiang speciality. Versions of this ravishing resist-dyed silk fabric are found from Yemen to Indonesia, but those of the steppe have a glamour all their own.

The affinity between steppe women and work in textiles is as old as the nomadic pastoralist lifestyle, and not just because of the use of sheep and goat wool for some of the oldest fabrics. With no permanent home, the nomad has no building to represent wealth or social status, so such things must be readily portable and ideally they can be carried about the person, as fine textiles or costume jewellery can be.

CREATED

Xinjiang, northwest China

MEDIUM

Silk, cotton and cotton lining

PERIOD/SERIES/MOVEMENT

Early nineteenth century

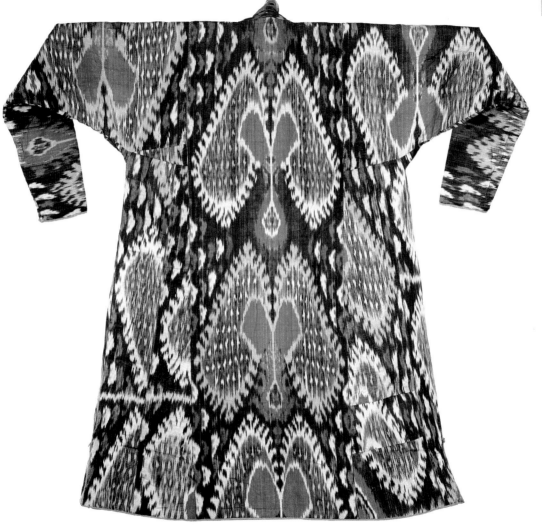

369

Japan

Octopus *tsuba*

The Japanese sword was a surprisingly complicated piece of work, often with a dozen different components, designed to be dismantled and pieced together, perhaps even swapped over from one weapon to another. The various fittings were fiddly to make, yet, as with everything from the pipe-holder to the *netsuke*, their manufacture gave the Japanese craftsman just the sort of challenge he seemed to like.

The guard that protected the hilt of the sword, the *tsuba*, became a traditional test of the maker's art and smiths summoned up all their creativity and skill when it came to making it. By the nineteenth century the sword was as much a ceremonial object as a weapon, and a certain artistic extravagance is often to be found. This octopus is a *tour de force*: not just for the detail of its swirling tentacles, but the way the body spontaneously seems to take form from the metal of which it is made.

CREATED

Japan

PERIOD/SERIES/MOVEMENT

Nineteenth century

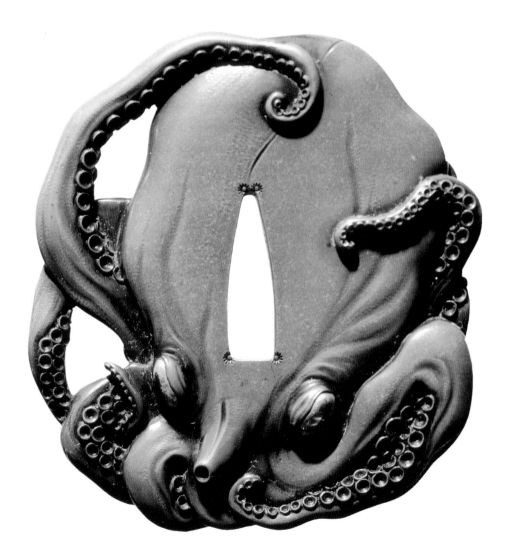

Thailand

Feather fan

Manohra, half-woman, half-bird, is blamed when a disaster befalls her city: she is condemned, but asks to be allowed one final dance before she dies. Permission being granted, she takes to the floor, bows, turns and struts and soon she is dancing and the watching audience is utterly entranced. Faster and faster she wheels and dances: all are mesmerized as her performance reaches its climax. Before their bewildered eyes, the birdwoman flies away to freedom. So concludes one of Thailand's most beloved myths. As such it has become the subject of favourite traditional dance, one of several to be performed with feathered fans. This one dates from the nineteenth century: the handles are made of dried, pressed loofah wood, the feathers from maribou stork, duck and parakeet.

The Manohra dance is just one of an astonishing range of cultural activities, which although not framed for exhibition like a painting or set up like a sculpture, still clamour for consideration in any study of Oriental art. From a Japanese tobacco pouch to a Javanese puppet, from a snuff bottle to a drum, art enters into every aspect of eastern life.

CREATED

Thailand

MEDIUM

Duck, maribou, parakeet feathers, dried loofah wood

PERIOD/SERIES/MOVEMENT

Nineteenth century

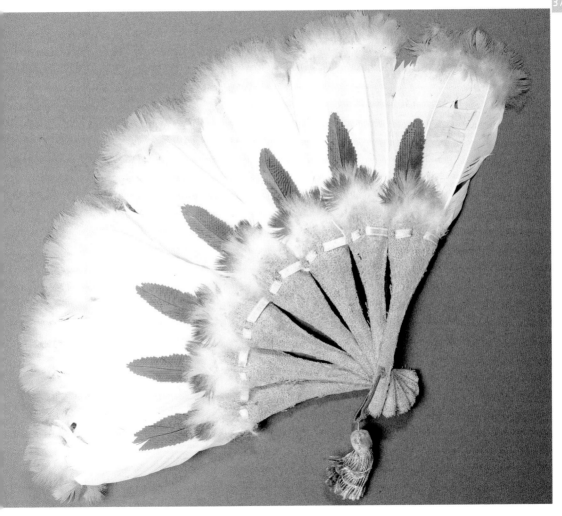

China

Headdress

A feathered headdress, but not the sort any Native American would ever have recognized, this one was made for an important lady at the Qing court of nineteenth-century China. Even by the standards of the imperial court, this would have been made for a special occasion, and generally such items were made as part of the bridal dowry. Here, iridescent blue kingfisher feathers have been inlaid into a filigree crown of gilt metal and glass, along with pearls, coral and semi-precious stones. These feathers were used in Chinese jewellery and decorative arts at least as early as the Tang dynasty (AD 618–906) but wearing them was very much the prerogative of an elite.

Unfortunately the Chinese kingfisher has now been hunted to extinction, having paid the price for an increase in social mobility in nineteenth-century China. As we have seen, China opened up to foreign trade through that period and for the first time a successful bourgeoisie emerged, which felt entitled to claim all the privileges of wealth and rank.

CREATED

China

MEDIUM

Kingfisher feathers, gilt metal, pearl, coral and glass

PERIOD/SERIES/MOVEMENT

Qing dynasty, nineteenth century

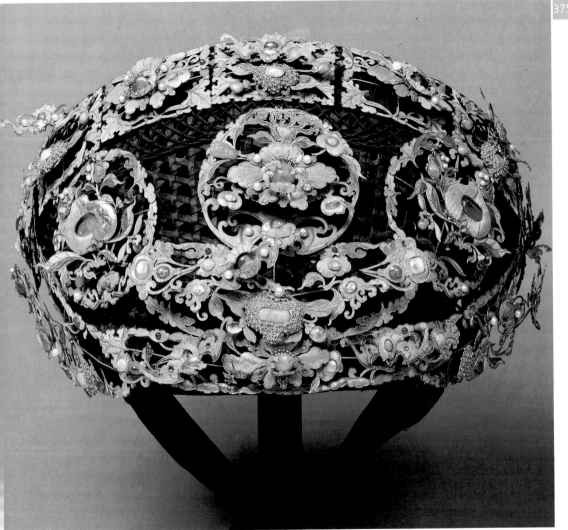

Korea

Plumed helmet

This fine helmet was made in the nineteenth century for one of the warriors of Korea's Choson dynasty. It would not have been out of place when the dynasty took power in the fourteenth century, with its lacquered iron crown and the studded leather flap for nape and ears. Japan too took pride in its medieval traditions, but was also busily preparing for modernity, industrialization and regional dominance.

By 1910, the Choson dynasty would be at an end and Korea a Japanese colony; the next year the Chinese empire would collapse. A generation later, in 1937, Japan invaded China, and was now set firmly on the collision course that four years later would plunge the East into the Pacific War. Hiroshima, Nagasaki, Korea, Cambodia, Vietnam, the annexation of Tibet, Chinese Communism and military dictatorship in Myanmar: the twentieth century brought an apparently unending succession of horrors to the Far East, and for many the suffering is clearly far from over. Yet as this book has shown, the creativity and imagination of this region's peoples have historically been limitless: there is every reason to look forward to a brighter future.

CREATED

Korea

MEDIUM

Lacquered leather and iron

PERIOD/SERIES/MOVEMENT

Choson dynasty, nineteenth century

Author Biographies

Michael Kerrigan (author)

Michael Kerrigan has written widely on every aspect of history, but has taken a special interest in developments in art, literature and culture, contributing the entries on these areas to the Starfire *Illustrated Encyclopedia of World History* (2001). His full-length books include histories of *Greece and the Mediterranean* and *Ancient Rome* (both BBC Publications, 2001) as well as studies of *East and Southern Africa* (Reader's Digest, 2001) and *The Middle East* (Reader's Digest, 2002). His extensive work on literature includes the Shakespearean compilations *To Be or Not to Be: Shakespeare's Soliloquies* (Penguin, 2002) and *Shakespeare on Love* (Penguin, 2003). His articles and reviews have appeared in the *Times Literary Supplement* and in the *Guardian* and *Scotsman* newspapers. He lives in Edinburgh.

Michael Robinson (foreword)

Michael Robinson is a freelance lecturer and writer on art and design history. Originally an art dealer with his own provincial gallery in Sussex, he entered academic life by way of a career change, having gained a first-class honours and Masters degree at Kingston University. He is currently working on his doctorate, a study of early modernist period British dealers. He continues to lecture on British and French art of the Modern period.

Picture Credits: Prelims and Introductory Matter

Further Reading

Allen, C., *The Search for Shangri-La: A Journey into Tibetan History*, Little, Brown, 1999

Boger, H. B., *The Traditional Arts of Japan: A Complete Illustrated Guide*, W. H. Allen, 1964

Bowker, J. (ed.), *Religions*, Cambridge Illustrated Histories, 2002

Chu-hwan, SON (ed.), *Korean Cultural Heritage, Volume 1: Fine Arts*, Korea Foundation, 1994

Dowman, K., *The Sacred Life of Tibet*, Thorsons, 1997.

Gillow, J. & Sentence, B., *World Textiles: A Visual Guide to Traditional Techniques*, Thames & Hudson, 1999

Goeper, R. & Whitfield, R. *Treasures from Korea: Art Through 5000 Years*, British Museum Press, 1984

Griswold, A. B., Kim, C. & Pott, P. H., *Burma, Korea, Tibet*, Methuen Art of the World, 1964

Harris, J. (ed.), *5000 Years of Textiles*, British Museum Press, 1993

Jackson, A. & Jaffer, A. (ed.), *Encounters: The Meeting of Asia and Europe 1500–1800*, V&A Publications, 2004

Kerlogue, F., *Arts of Southeast Asia*, Thames & Hudson World of Art, 2004

Kidder, J. E. Jr., *The Art of Japan*, Century, 1985

Kruger, R., *All Under Heaven: A Complete History of China*, London: Wiley, 2003

Lee, S. E., *A History of Far Eastern Art*, Thames & Hudson, 1964; 4th edn. 1988

Lowry, J., *Tibetan Art*, HMSO/Victoria and Albert Museum, 1973

Maraini, F., tr. Mosbacher, E. and Waldman, G., *Secret Tibet*, Harvill, 2000 (Originally published 1951)

Mason, L. E., *Asian Art*, Antique Collectors' Club, 2002

Miksic, J., *Art of Indonesia*, Tauris Parke, 1993

Noppe, C. & Hubert, J., *Art of Vietnam*, Parkstone Press, 2003

Smith, L., H., V. and Clark, T., *Japanese Art: Masterpieces in the British Museum*, British Museum Press, 1990

Stanley-Baker, J., *Japanese Art*, Thames & Hudson World of Art, 1984, revd. 2000

Sullivan, M., *The Arts of China*, University of California Press, 1967

Tregear, M., *Chinese Art*, Thames & Hudson World of Art, 1980, revd. 1997

Tuzawa, Y., *Biographical Dictionary of Japanese Art*, Kodansha/International Society for Educational Information, Inc., 1981

Index by Work

General Index